PHOTOGRAPHING BUILDINGS INSIDE AND OUT

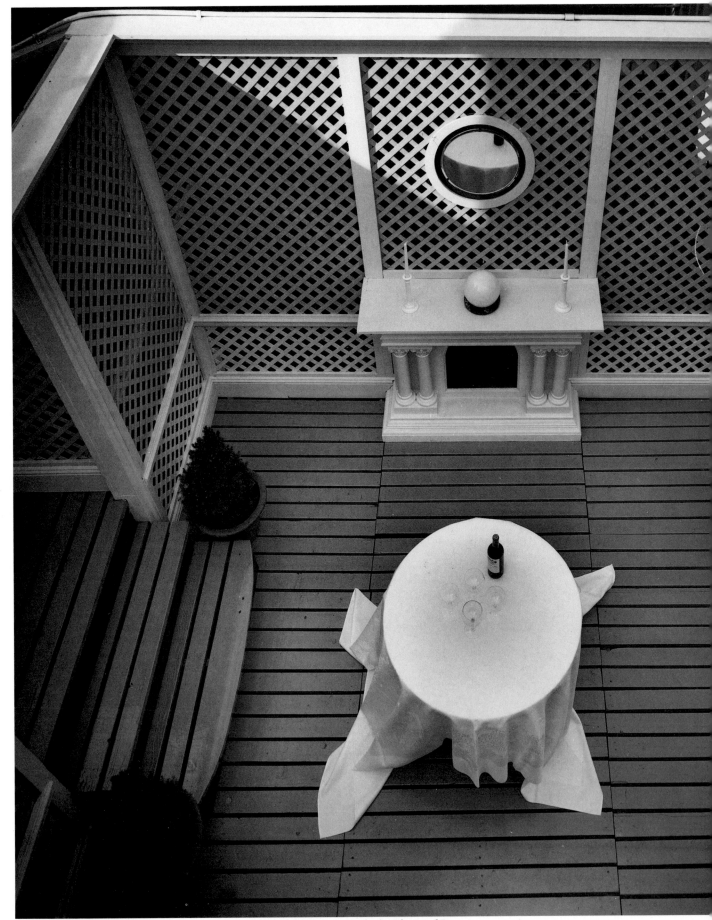

Kramer apartment rooftop terrace, New York City. The architect was Machado-Silvetti of Boston.

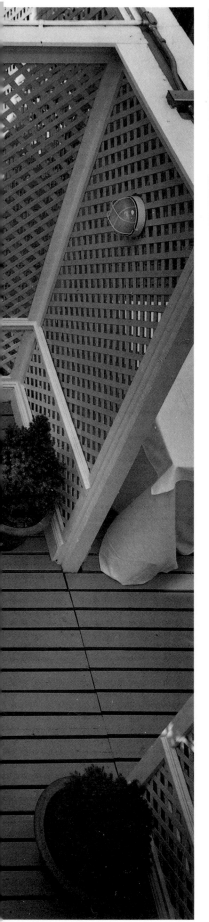

PHOTOGRAPHING BUILDINGS INSIDE AND OUT

NORMAN McGRATH

WHITNEY LIBRARY OF DESIGN
an imprint of Watson-Guptill Publications/New York

To four true Renaissance men: Raymond McGrath, my father;
Serge Chermayeff, architect, painter, teacher, and writer;
Ove Arup, philosopher, structural engineer, and architect;
and Alexie Brodovitch, artist, art director, and teacher.

All photos in this book are by the author unless otherwise noted.

Senior Editor: Julia Moore
Associate Editor: Victoria Craven-Cohn
Designer: Bob Fillie
Production Manager: Ellen Greene
Set in 11-point Garamond Light

First published in New York by Whitney Library of Design
an imprint of Watson-Guptill Publications
a division of Billboard Publications, Inc.
1515 Broadway, New York, NY 10036

Library of Congress Cataloging-in-Publication Data

McGrath, Norman.
 Photographing buildings inside and out.
 Includes index.
 1. Photography, Architectural. I. Title.
TR659.M38 1987 778.9′4 87-8149
ISBN 0-8230-7413-7
ISBN 0-8230-7410-2 (pbk.)

Published in Great Britain by The Architectural Press Ltd.
9 Queen Anne's Gate, London SW1H 9BY

Manufactured in Japan

First Printing, 1987
3 4 5 6 7 8 9 / 92 91 90 89 88

Acknowledgments

In recognition of the help that has been rendered to me, I would like to thank the following: Stephen Kliment, formerly senior editor with Whitney Library of Design, who first encouraged me to write this book; Julia Moore, my editor, who worked closely and tirelessly with me on all aspects of the work. Thanks to Phyllis Sanfilippo, Amy Rubinger, and Bridget Leicester for typing and to the latter for juggling my schedule to enable me to complete the writing. Thanks to my wife, Molly, for general encouragement and for the tedious process of proofreading and editing for which her professional background was invaluable.

I owe grateful appreciation to the following photographers who supported this endeavour by providing information or photographs: Ezra Stoller, Cervin Robinson, Jaime Ardiles-Arce, Jon Naar, Hedrich-Blessing, and particularly to Wolfgang Hoyt for his photographs of models.

For early encouragement and help in my photographic career, special thanks to Hans Namuth. And finally, to someone without whose assistance many of my photographs would have been much more difficult, if possible, Frank Zimmermann.

The following manufacturers were also helpful: Olympus, Pentax, Sinar, Fuji, and Kodak.

Thanks, finally, to all my architect and designer clients for so much wonderful subject matter, and to *Architectural Digest* for permitting me to use a good deal of its material in this book.

CONTENTS

Entrance to the Galleria,
New York City.
The architect was
David Kenneth Specter.

PREFACE

Until the age of nine, I lived in England and thereafter, for sixteen years, in Ireland. Much of my youth was spent visiting great houses and gardens with my architect father, Raymond McGrath. For the most part, these were designed in the classical manner.

Some of my most vivid memories—from fifty years ago—are of time spent at two very modern houses, Serge Chermayeff's 1934 house at Bentley, Surrey and St. Anne's Hill, in Chertsey, Sussex, which my father designed in 1937. The landscaping of the latter was by Christopher Tunnard, who later headed the Yale University Department of Landscape Design. As a young child, I was particularly impressed by the streamlined reflecting pool, complete with penguins, at the top of several levels of sweeping concrete steps. This exposure to the modern idiom certainly kindled my early interest in the subject and influenced my ultimate move toward the architectural photography field.

A precise definition of architectural photography is more complex than might be supposed. As soon as rigid criteria are established, exceptions arise. A photograph in a particular context might be considered "architectural," and in another situation, not.

A reasonable approach suggests that if the primary objective of the photographer is the straightforward documentation of a subject—interior or exterior—conceived or designed by an architect, then the result will be an "architectural photograph." The photograph *per se* is not what is important here, but the clarity with which the design is recorded.

The skill of the architectural photographer will determine whether or not the resulting work can be considered anything more than straight documentation. A camera guided by an artist's eye can produce images that not only fulfill the documentary objectives, but achieve a greatness not dependent on the quality of the subject matter. Aesthetics, art, expression, communication, ethics, imagination, abstraction, reality, emotion, harmony, relationships, drama, time, humanism, and honesty are but a few of the dimensions to be explored. Mastery of the practical aspects of creating photographs of architectural subjects should open the door to these more philosophical elements.

St. Anne's Hill, in Chertsey, Sussex, England. Designed by Raymond McGrath

...and landscaped by Christopher Tunnard. This old photograph was probably taken by Herbert Felton in 1937.

CHAPTER 1

WORKING WITH THE PROFESSIONAL

Ideally, the photographer-client relationship is a professional arrangement between professionals. It should also be said that while the usual arrangement on any one project is between the architect or designer (the client) and the photographer, other clients exist. These can include real estate development firms, engineering firms, contractors, property owners, and magazine and book editors. To work well, the relationship needs to be a two-way, fully reciprocal partnership, and that can happen only when both the client and the photographer know and understand each other's needs and objectives.

FINDING THE RIGHT PHOTOGRAPHER

Once the various objectives for an architectural photography project have been carefully analyzed and clarified, the client must decide whether or not to retain a professional. (The alternative is to do the photography on one's own.) If the project demands a professional, there are several ways to find a good photographer. Seeing examples of a photographer's work is a paramount criterion. Someone who has experience in working with photographers can usually recommend a good one. If no leads appear, then a call to a respected publication can often yield some suggestions.

Another means of locating a photographer is through the American Society of Magazine Photographers (A.S.M.P.) which makes its membership directory available, free of charge, for the asking. (A.S.M.P. is located at 205 Lexington Avenue, New York, N.Y. 10016.) Worldwide in scope, the directory lists the addresses and telephone numbers of more than 400 member photographers and includes the specialty of each member. Anyone wishing to find an interior or other specialist in a particular area of a country can do so through the directory's geographic listing. Membership in A.S.M.P. is dependent on the attainment of a certain level of competence in conjunction with recognized publication for a period of not less than three years, and many of the world's leading photographers are members. There are A.S.M.P. regional chapters in a number of locations in the United States.

Some photographers, like Esto Photographics Inc. of Mamaroneck, New York, for example, have much better organized back-up service than others and are very businesslike in their dealings. They also have a stock photo service with architectural emphasis, as I do. This can be a factor when hiring a photographer. It's nice to be able to call up many years after the completion of an assignment and find access to old material. I was able recently to provide a client with photographs of a job shot more than twenty-five years ago, before I was a full-time professional.

After a photographer has been selected, the client and photographer should meet, if they haven't already. Personal contact should be established to ensure and promote mutual understanding. This will also present a good opportunity for everyone to examine a portfolio of the photographer's work that relates directly to the upcoming project. Much time and effort will have been expended completing the project so the client should feel confident that the right photographer has been chosen to document it.

TIMING AND SCHEDULES

Availability of the photographer may be a crucial factor. The more time allowed for photography, the more likely that the many variable conditions and everyone's schedules will synchronize, thereby promoting the least stressful completion of an assignment. When tight timetables dictate the scenario, compromises must frequently be made. These may adversely affect the results,

leaving everyone unsatisfied. Therefore, as much time as possible should be allowed for the photographer to produce a quality job. This leeway will enhance the photographer's goodwill toward the project.

When a really good set of photographs is produced in spite of unavoidable deadlines, the designer should be particularly appreciative. A photographer may have to juggle schedules and a client may have to exercise much patience in order to complete a project successfully. So my advice is to plan ahead, anticipating when the best conditions for such a project are likely to prevail.

Here are two timing scenarios that any architectural photographer would recognize. One: A new hospital facility is scheduled for completion on a certain date. The architect's client does not officially take possession for a week after completion, allowing the hospital staff members to familiarize themselves with the new facility before patients are admitted. This is probably a good time to take photographs. The new quarters will be in top condition, and miscellaneous items have not yet appeared to sully the clean look of things. The photographer can take liberties that would be impossible once full operation has commenced. Two: A new house has been completed for a client who is out of the country. Some last-minute compromises on furnishings have disappointed the architect, but the client has agreed to permit photography before the offending items arrive or else to substitute others chosen by the designer for documentation purposes.

Depending on their function, certain types of buildings or interiors quickly lose their fresh appearance and should be recorded as soon as possible after completion. On the other hand, many projects rely heavily on landscaping, which is inevitably one of the last-completed aspects of a design. If a building's budget has become a problem, there may be insufficient funds available to accomplish the original landscaping objectives. Only time will make up for the reduced outlay. A house or a suburban corporate center may look a lot better a year or two after plantings have had a chance to grow and fulfill the landscaper's objective. All these factors should be considered. Alerting the photographer to this kind of situation can avoid embarrassments all around.

There are certain seasons when an architectural photographer may be highly in demand. For me, these times tend to be in the spring and autumn. That brief period in spring when things begin to look green but before full leaves appear, can be critical in exterior photography. The winter look has gone, and the hint of green is flattering. These ideal conditions may prevail only for a short time. The autumn also produces nice in-between situations when the leaves are brightly colored and their density makes visible hitherto unseen portions of the subject. Autumn coloring can produce very dramatic photographs. Fallen leaves blanket the ground, perhaps concealing incomplete landscaping. So I find that September and October are particularly busy for me, and clients have to book well in advance to avoid disappointment.

The other major seasonal consideration is the angle of the sun. When the sun is lower in the sky, shadow details may be more flattering. On the other hand, a critical location may only receive full sun during summer months when the shadows of adjacent structures don't interfere. An exterior facade with few projections may not need sunlight to record it effectively. A highly articulated facade will probably require a certain angle of light to best describe it. A tall building on a narrow city street is particularly difficult to record, even when the right vantage point can be found, because the building's illumination probably varies tremendously from top to bottom. If the building's facade is also dark in tone, the problem is even more critical. The photographer must try to solve such problems within a given time frame. An experienced photographer will warn the client if the documentation is likely to be compromised by an insufficiently flexible schedule.

The weather is the one factor over which no one has control, and therefore a certain amount of luck is involved. Schedules with more leeway enable the photographer to wait for just the right conditions. Regarding rain dates, photographers have various policies. Once a mutually agreeable shooting date has been established, some photographers will charge a cancellation fee if the shooting date is changed at the last minute. A rain-date policy should be established when scheduling the shoot, so there is a clear understanding that if weather or other conditions are unfavorable and require rescheduling, a fee will be charged. Typical postponement fees vary depending on the amount of advance notice given. Some photographers don't charge if at least forty hours notice is given, but they may levy a fee equal to fifty percent of their daily rate if only twenty-four hours (or less) warning is given.

Does the decision to go ahead and shoot rest with the architect or the photographer? An architect assigning a project may have enough deadline flexibility to permit the photographer to wait for ideal working conditions. If the assignment then has to be rescheduled, there may be fees involved. Weather forecasts are more reliable in certain parts of the country than in others. A photographer may have to depend on an on-the-spot client to make the final decision for out-of-town work.

An experienced photographer can come up with

Frank Zimmermann.

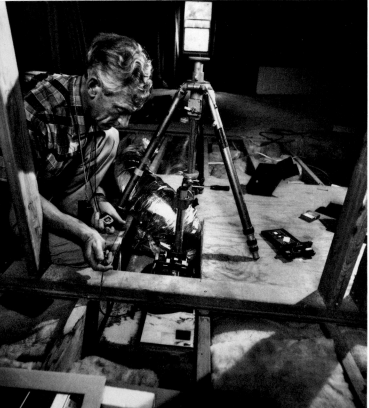

Author setting up to shoot through ceiling.

satisfactory results even without ideal conditions. Direct sunlight is not always essential. A house set in the woods may look a lot better in soft light than in bright sunlight. Trees and foliage may cast shadows with unflattering shapes that destroy or compromise the design's forms.

Though perhaps less critical, weather conditions can also affect interior photography. However, before the designer or client cancels a shoot, the photographer should be consulted, because some degree of control is often possible. Levolor blinds, or those of a similar design, can be adjusted to influence not only the amount of natural light admitted but also the clarity of the outdoor view if it is to be included in the composition. While there is no substitute for sunlight, it may be possible to approximate it by placing a strobe unit outside a window. If the photographer is shooting a building's interiors and exteriors, and if more than one day's work is involved, then the weather won't be quite so critical. Invariably, interiors take longer to photograph than exteriors, so careful planning of multifaceted projects helps a great deal.

COSTS, FEES, AND CONTRACTS

Assuming that the architect or designer has determined that everyone's schedules are mutually compatible, the next matter is cost. The basic fee a photographer charges will vary according to the type of rights the client requires. (See the section on rights in this chapter.) These rights should be determined in advance so there are no misunderstandings. When all rights or exclusive rights are essential (this is unusual, I might add), the cost may be double that for the normal limited rights most designers need. Although some photographers quote rates for particular jobs, most have daily rates. These can vary substantially according to both location and reputation. A photographer with experience in this field is unlikely to charge less than $500 per day, and a range between $750 and $1,250 is currently more typical.

The architect or designer should have certain points clarified before working with a photographer. The policy regarding overtime, for example: What constitutes a photographer's day? And, what flexibility there is, if any? What about postponements or cancellations? How is travel time charged? What are the photographer's rates for driving his or her own car? What happens if bad weather delays or prevents a shoot? What do the reimbursable expenses include, and how are they billed?

Does the day rate include an assistant? If not, how much will the assistant cost? Who makes necessary travel arrangements? What is the per diem for out-of-town standby when no photography can proceed? Does

the photographer provide the client with originals or duplicates? Does the fee include a basic number of photographs in the required format? Will negatives, either color or black-and-white, be released? If so, is there an extra charge? Are materials included, or will they be billed as an extra (the usual practice)? Does the photographer require an advance to cover out-of-pocket expenses? Perhaps many of these situations will not arise, but it's important to a good working relationship to know how you stand if they do.

I charge strictly on the basis of time, but my day may be quite long. If the job is local, I may scout the project ahead of time without additional charge. Other photographers may charge for preliminary site visits and consultation, but this varies according to circumstances. I charge extra for an assistant, a practice which is well worth the extra expense and is really essential except, perhaps, when requirements are limited to small-format equipment. Even then an assistant will always improve productivity.

My method is to charge at cost plus a percentage for overhead and handling. The designer is informed in advance what the overhead and handling will probably run and how they are worked out. Time getting to the job may or may not be included in the basic rate, but when substantial distances are involved, a half-day rate for travel time is used. Out-of-pocket expenses are added, and when required, receipts are furnished. These expenses include transportation, meals, and accommodations when necessary. The present cost of running a car is pretty high, particularly in big cities. I charge fifty cents per mile when I use my own car, and I think that barely covers my costs, but it is probably less expensive than an equivalent rental.

When the architectural photographer works for a client other than the designer or architect, the rate charged may be different. Publicity and promotional photography is deemed to be somewhat more commercial in nature and therefore worth higher rates than documentation done directly for the architect or designer or for straight editorial use. (Assignments done for the design press are considered similar to work done directly for design professionals. Thus when fees are split between an architectural magazine and an architect, there is usually no complication with variable rates.)

The American Society of Magazine Photographers publishes an excellent, regularly updated guide, *Professional Business Practices in Photography*, which is relatively inexpensive and available to anyone. It is very comprehensive and includes information on suggested rates for use of photographs in books and for a variety of other purposes. The society takes pains to point out that the guide does not establish rates or fix terms but is merely a guide.

How many pictures can a photographer shoot in a day? This is a difficult question to answer and depends on how fast a photographer works. The nature of the project, its complexity, and the variables involved all influence the number of images produced. The photographer's set-up time and supplementary lighting when necessary may not take as long to accomplish as preparing the space to be recorded and arriving at a consensus on how best to interpret it.

Sales Tax

Both client and photographer need to be aware of local and state sales tax regulations. Photographers for New York City-based clients, for example, are obliged to charge and collect sales tax on both their services and expenses. The rate depends on the client's location, not the address of the project. Even though the expenses include some items on which a state tax has already been paid, the sales tax must be calculated on the total billed amount. When airline tickets and hotel bills are paid directly by the assigning client, these items will not be included among the photographer's overhead expenses.

Further, a completed assignment delivered to a New York City-based agent for an out-of-town client will also be subject to sales tax. When uncollected, the photographer will be liable for the tax. In New York City, the only exception to the above occurs when the client has a legitimate resale certificate, the number of which must be provided to the photographer for his or her records. New York City-based photographers have resale certificates which enable them to purchase materials which are physically transferred or billed to the client, without sales tax, thus avoiding double taxation of these items.

Contracts

Some architectural photographers have contracts, which they require their clients to sign before they undertake an assignment. Personally, I don't favor this approach but prefer a certain degree of trust and flexibility. While the relationship between a photographer and a client may be strictly business, ideally it may be something more. The subtle interpretation of a sophisticated design goes beyond some legal document. Many architectural photographers, especially those with established reputations, work without contracts for the same reason. This custom is certainly an exception to many photographer-client arrangements and would probably horrify most lawyers. But the fact that most commissions are accomplished without involving elaborate legal documents would indicate that the system works.

RIGHTS

Most architects and designers have predictable objectives in mind when photographic assignments are being considered. Likewise, the majority of professional photographers are familiar with these needs. Although the details of the rights offered will vary from one photographer to the next, the typical client uses are likely to be covered.

When working with a professional for the first time, the architect or designer should list the purposes for which the photography is required ahead of time, even if they have been discussed. This prevents misunderstandings. The majority of architectural photographs taken today fall under the category of limited rights. This permits the client to make any direct use of the material including portfolio use, display, office reference, slide presentations, local and national A.I.A. competitions, printed brochures, and certain other competitions, when the release of copyright is not required.

If the client is preparing a book, reproduction rights for this may also be included. However, the right to publication by parties other than the assigning client is frequently not part of the agreement. Practices on this matter differ.

Having to cover the potential value of an image for all publication purposes would mean charging a substantially higher initial fee to be fair to the photographer, who is the copyright holder. I feel it is unreasonable to expect the architect or designer to pay an inflated fee since such use may not occur. If and when it does, most publishers are able and willing to budget for reproduction rights. When the would-be publisher is a nonprofit organization—a university or other worthy organization—then exceptions can be made.

Most of the New York City photographers with whom I have spoken work with limited-rights arrangements. When unlimited rights are required, the fee may be fifty to one hundred percent higher. In the advertising field, rates tend to be much higher, so even an all-rights purchase is likely to exclude advertising rights. These normally have to be negotiated on an individual basis.

The Hedrich-Blessing Studio in Chicago is one of the largest pools of architectural photography anywhere. Their rights policy in this field is a bit different from most of their East Coast cousins. They normally include full reproduction rights as part of their normal fee. Any publication use of which the architect or designer approves is all right with them, including books, magazines, and brochures. The distribution of material is up to the client. Hedrich-Blessing does forbid resale of their photographs by architects or designers. Their rates are somewhat higher to cover the unlimited (except for advertising) rights, but probably are less than most East Coast professionals would charge for similar services.

One of the reasons why architectural photographers limit the rights granted to their clients is that in proportion to other photographic fields, the fee structure for work that has to be of the highest quality is relatively low. Young clients may not agree, but a comparison of fees for architectural photography with a number of other specialties confirms this. Few interior or exterior photographers get wealthy from doing just that.

Some photographers will grant designers permission for unanticipated uses without additional fee. But the photographer should always be approached first. Unauthorized uses make everybody unhappy and can lead to surcharges nobody wants to pay. For example, when the photographer has not included reproduction rights in the fee and the work is used in a professional publication which refuses to pay, then the architect or designer will be responsible. (This assumes that such publication was not initiated by the photographer in the first place.) This sort of situation can be avoided if the design professional directs the photographer to supply material to the periodicals and deal with them directly regarding fees. Magazines tend to assume that when they receive photographs directly from an architectural or design firm they are free to use them without payment. This is particularly true when the submission is unsolicited.

I allude elsewhere to the A.I.A. competitions. These do not require the photographer to relinquish all rights, but some other competitions do. So beware, and read the rules carefully.

One stipulation that is universally enforced, regardless of the rights granted, is against resale. No architect or designer may sell the work of the photographer to a third party. This might be compared to a homeowner selling the plans of his architect-designed house to somebody else.

COPYRIGHT

Copyright laws are extremely complex, very confusing, and frequently ignored. On January 1st, 1978, a major revision to the law was made which resulted in the transfer to the photographer of many photographic rights that previously would have belonged to the assigning party. The present situation is that the photographer can relinquish ownership only by consciously signing an agreement to do so. This can be done either before or after an assignment is completed. When a photographer signs an agreement which uses the term "work for hire," then the copyright is transferred to the client or assigner.

From the architect's or designer's point of view, copy-

right ownership should not present any particular problems. This assumes that the client makes normal use of the photographs as previously discussed. Abnormal or unanticipated uses should be brought to the photographer's attention to avoid copyright infringement. The seriousness of infringement will depend on the circumstances—whether it was willful or inadvertent, for example. For more details, including how to copyright material, write to Register of Copyrights, Library of Congress, Washington, D.C. 20559.

THE WELL-PLANNED SHOOT

The more time a photographer can devote directly to shooting pictures, the more satisfactory the results will be. Unnecessary delays can be avoided by exercising common sense and caution. Special arrangements for transporting equipment to the job can be arranged prior to the shoot. Some establishments have time-consuming security procedures that can be short circuited by making a call in advance. If freight elevators must be used, are they available at the scheduled starting time? Removing equipment may require a signed building release. To prevent ruffled feathers, all the people involved should be notified as to whether the architect (or designer) or the photographer should handle the contacts with the appropriate building manager or house owner. It may be better if the architect handles communications, since presumably a degree of respect and familiarity already exists between designer and client.

When photography is being done for a competition, the photographer should be told what the relevant rules are and just what is needed. For example, showing views of all a building's elevations may be a stipulation, not just showing the front or main view. The photographer might have some suggestions on how to include, but not necessarily feature, a less important side. After the assignment is completed, enough time should be budgeted to meet the deadline for finished prints or whatever is required. Rush charges for last-minute changes can substantially increase the competition budget. The selection process is just one of a number of intermediate steps that should be allowed for prior to the assembly of the completed submission.

The photographer must have a clear idea of the design objectives to be portrayed. Once these objectives have been discussed and established, some photographers prefer or even insist on working alone or unsupervised. I personally have no problem shooting with and consulting the architect or designer as I go along, but I feel quite comfortable with either approach. I like to show my 4×5 Polaroid tests to the designer who comes along on a shoot, since viewing through a large-format camera is not comfortable for everyone. Sometimes seeing a 4×5 test prompts the design professional to question a photographer's approach, and an alternative is tried. Often the designer decides the alternative is less successful than the initial view. Setting up alternatives takes time, so once some rapport is established, trusting the photographer's experience and judgment is beneficial. When the photographer feels strongly enough, shooting the subject both ways can be insurance against having to do double work should there be a subsequent change of mind.

Circumstances may not permit the client to be present during the shoot. How much direction should be given to the photographer in this case? This depends, at least in part, on the measure of confidence the architect or designer has in the photographer. But even when considerable trust exists, insufficient flexibility can result from overly detailed instructions. For instance, I once followed the architect's instructions too literally on an out-of-town shoot. Assuming that the objectives were well thought out, I recorded each area stipulated to the best of my ability but ended up with no overviews and no overall documentation that would provide a complete impression. Due to the nature of the subject, an overview would have been difficult to achieve. Since the assignment had to be accomplished in a single night, and there was no on-the-spot representative to correct what I felt was the designer's oversight, I didn't deviate from the explicit instructions. Unfortunately, the client was quite unhappy with the result.

Clear directions for getting to the job are frequently essential. When these instructions include approximate distances and typical travel time, they are even more helpful. And the photographer should always have an appropriate phone number in case emergencies arise.

Publishers of house magazines normally have liability insurance, but not all photographers do. Accidents do happen, so it may be important to know if a photographer does have such a policy. The architect or designer may have adequate coverage to meet the requirements. Gaining access to particular vantage points may be conditional on the photographer having liability insurance or at least on the signing of a waiver of liability of the building owner or management.

When paying an advance visit to the site is practical, most photographers will give advice on props and accessories. I prefer that my client provide flowers, but I have on occasion had to work with very stiff, formal arrangements that were doubtful assets. Floral arrangements shouldn't be moved from one room to another, as the reuse will be evident in the photographs but if there's no alternative at least use a different container for the flowers.

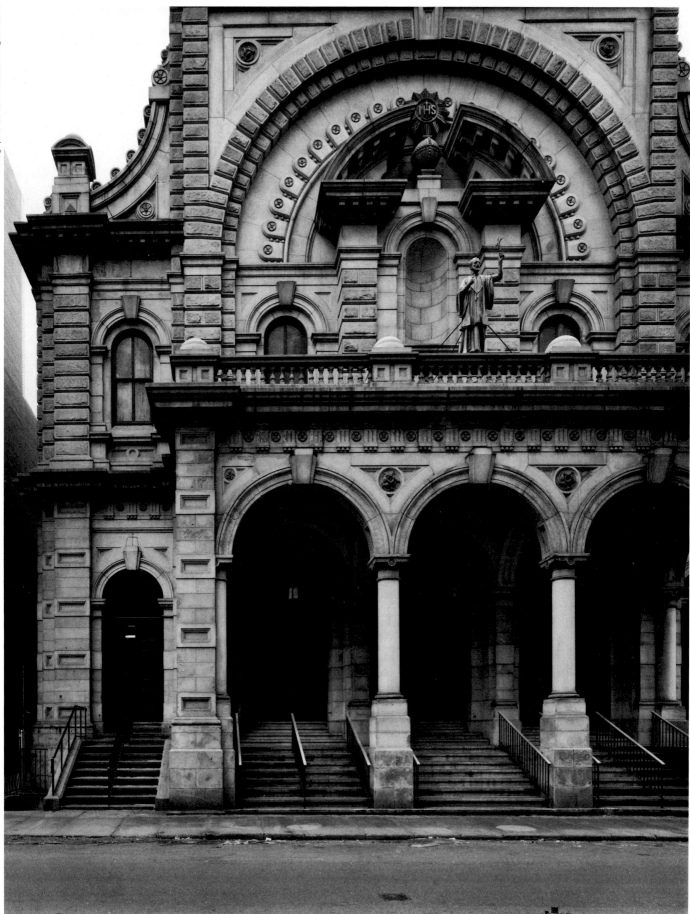

A photographic documentation can only be successfully accomplished when the designer's philosophy is fully understood and appreciated by the photographer as well. To establish this understanding may require some detailed explanation by the designer. There may be aspects of the completed project that are only apparent after considerable familiarity with the design, and these should be brought to the photographer's attention. Design features that are very obvious to the designer may elude the photographer.

Finally, the question of taste cannot be ignored. Any visually oriented person is bound to have certain preferences and dislikes when it comes to pictorial images. One architect may like dramatic views that sweep upward with exaggerated perspective, while another designer may hate this style. Occasionally, a client who associates wide-angle lenses with unwanted distortion might ask me not to use them. As a photographer experienced at interpreting three-dimensional subjects in a two-dimensional medium, I feel it is my job to correct misconceptions about various photographic methods and precepts, while at the same time respecting my clients' taste and perceptions about the way they want their work documented.

Two contemporary masters of architectural photography who have very different approaches to composition are Cervin Robinson and Ezra Stoller. An example of Robinson's black-and-white documentation is seen here in this photograph of a neo-Baroque facade in New York City. Having to work without the strong, raking sunlight he prefers, Robinson produced an image that is classical in feeling and recalls the great early tradition of architectural documentation.

Stoller's photograph of Le Corbusier's 1955 Chapel of Notre Dame du Haut, at Ronchamp, is both abstract and animate. Stoller writes that "It is architecture which is of primary interest to me, with photography being simply the medium for communicating its idea."

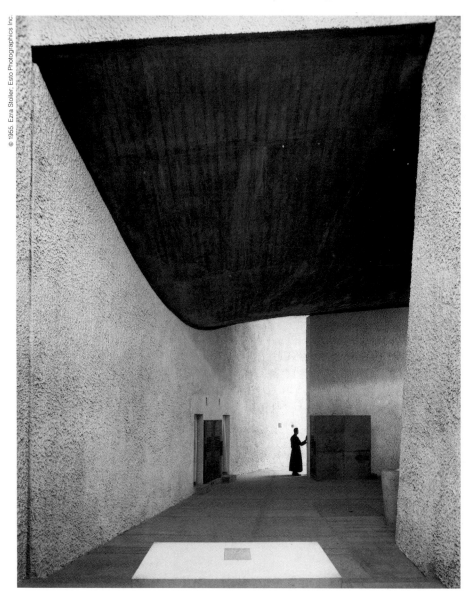

Church of St. Francis Xavier in New York City (left), photographed in 1982 by Cervin Robinson and designed in 1882 by P.C. Keely.

Chapel of Notre Dame du Haut, at Ronchamp, France (right), photographed by Ezra Stoller in 1955. Designed by Le Corbusier in 1955.

FITTING THE PHOTOGRAPH TO ITS PURPOSE

Architectural photographers have many publishing opportunities today. The market for architectural subject matter is bigger than ever before and extends well beyond the design press—to publications like airline magazines and specialized periodicals for the medical profession and the real estate industry, to name a few.

The ultimate purpose to which a photograph will be put has considerable bearing on its quality as well as how it is taken and by whom. Obviously, photographs taken for personal record or to test equipment, lighting, angles, and the like needn't have the high quality of those submitted for publication. Likewise, the standards of photographs taken strictly for documentation may not be adequate for publication purposes. But regardless of the ultimate objective, it is to the photographer's advantage to show a prospective client high-quality work.

PUBLICATION

Not infrequently, clients ask me for recommendations about which magazines to approach with a particular project. When publication is the purpose for the photograph, I point out that while I can give advice and possibly put the designer in touch with the appropriate editor, there is no guarantee of success in getting a project accepted. It's extremely difficult to second-guess an editor.

Design professionals are likely to have preferences about where they want to be published—usually magazines they read regularly and respect—and, assuming the project is appropriate, these should be the first targets. Many times I have had a client with a high-quality office design say, "Wouldn't this look great in *Architectural Digest*?" and I have to point out that that publication seldom features commercial projects.

Submission and Acceptance Practices

There are no hard-and-fast rules for submitting material for possible publication. Popular and professional magazines and newspapers each have established submission procedures, and a phone call to the editorial department may be the simplest way to find out what they are. For example, the architect or designer, not the photographer, must be the one to submit photographs to *Architectural Digest*.

Whoever handles the submissions must decide if preliminary scouting photographs are, in fact, adequate. Will an editor unfamiliar with the design be able to make a reasonable evaluation of it? Poor photos may result in premature rejection of a good project. Plans, renderings, and isometrics should be submitted in addition to photographs when available. Any material that helps convince a publication to feature a job is relevant.

Sometimes an editor will ask for more photographs before making any commitments. This puts the architect/designer on the spot, since it may require costly additional photography. Occasionally, a visit by the editor to the project site can be organized to avoid this situation, permitting the editor to make a first-hand appraisal. If the quality of the scouting or preliminary photography is not up to the standard of the design or the publication, this latter approach is recommended where practical.

A photographic record of a building or house prior to its remodeling may also prove publishable. Some magazines like to publish before-and-after views to indicate the extent of the changes made and how preexisting conditions influenced the final design.

Magazines such as *Architectural Digest* and *House and Garden*, and also *Metropolitan Home* and *House Beautiful*, among others, are known as shelter publica-

tions. (*Architectural Record* and *Progressive Architecture* are examples of the professional design press and these magazines have their own preferred submission procedures.)

Architectural Digest and *House and Garden* are in a class by themselves as shelter magazines. Both regularly run features with architectural content, if not emphasis. Both are prestigious publications in what might be termed the "up market." Projects included in their pages frequently lead to new work for the designers, and thus are considered plum spots in which to be published.

When *Architectural Digest* accepts a house or apartment for future publication, it rarely uses existing photographs, even when they are of high quality. The magazine prefers to assign or reassign the photographer it feels is most suited to record the particular design in question. The architect/designer can request a particular photographer, but unless he or she has worked for the magazine before, there is usually reluctance. All photography and related costs are, of course, the responsibility of the magazine. Once *Architectural Digest* has made a publication commitment, I have not known it to renege on its decision—something that cannot be said of some other magazines.

Each magazine has its own practices for commissioning a photographer, and these arrangements tend to be very restrictive for both photographer and architect/designer, allowing only limited or no future access to the submitted materials. This presents everybody with a dilemma. Should an architect go to considerable trouble and expense taking preliminary scouting shots, or commission a photographer to do so in order to have a favorite project published, but subsequently have no access to the published material or even out-takes? Restrictions become more critical after the project is accepted for publication but prior to release. The architect/designer is often deeply involved in the making of the photographs that are used for publication and, in fact, frequently gives vital input during this final phase of the photography. Before publication commitments are made, the architect/designer and the photographer should fully understand the magazine's practices on future use and the resulting ramifications.

Multiple submissions of a project—meaning sending the same proposal to several publications at the same time—is risky and should be undertaken with caution. It can lead to awkward situations if a project is accepted by more than one publication. Only occasionally, with very newsworthy designs, will publications agree to simultaneous release dates. Unexpected or unauthorized publication of a previously accepted project can cause a periodical to drop plans for a feature entirely, even after the expense of photography has been incurred. Likewise, once a commitment has been made, any approaches to other publications must first be cleared with the committed publication.

Another matter to consider is the fact that every publisher has its own list of competing publications. If a competitor on this list has already featured a design, it is unlikely that they will also. For example, *The New York Times Magazine* will normally accept only previously unpublished work. For a newspaper, this policy is not unreasonable. Most shelter magazines, however, do not regard professional design press publications (such as *Architectural Record*) as competitors.

Media: Prints, Slides, or Transparencies

From the photographer's standpoint, small size, machine-made color prints are very convenient and are used for a wide variety of purposes. But for publication purposes, 35mm slides are more useful because most color reproduction is done from transparencies rather than from prints. This is not the case with black-and-white reproduction, which is best done from prints that have a semi-gloss or glossy surface rather than a textured finish.

Most publications will use 35mm slides—though they may prefer not to—if nothing else is available. Some actually use slides by choice. Variety is the spice of life, and many editors claim that 35mm photographs look less stiff. The character of the periodical or book is what ultimately determines the type of image selected.

Many newspapers now use color photographs, particularly in their special supplements or Sunday magazines. Though staff photographers take a lot of these pictures, newspapers also use outside sources. The quality of newspaper images is frequently poor, partly as an inevitable consequence of the newsprint process. Black-and-white photographs tend to degrade more than color images. One of the reasons for this has to do with the inherent difficulty in handling a high-contrast print. The printers in a newspaper plant normally reduce a contrasty print by screening it, making the blacks dark-gray and the whites pale-gray, which reduces the impact of the original. Photographers who understand this can supply newspapers with images that can be better reproduced by this medium.

As a general rule, nothing sent as a publication feeler should be irreplaceable, particularly photographs. Whenever possible, only send prints that can be remade, duplicate slides or duplicate transparencies, especially to overseas journals where submissions can easily go astray. Many periodicals only return materials when a stamped, self-addressed envelope is included. Damage frequently occurs in the mail.

I should make one particular point in connection

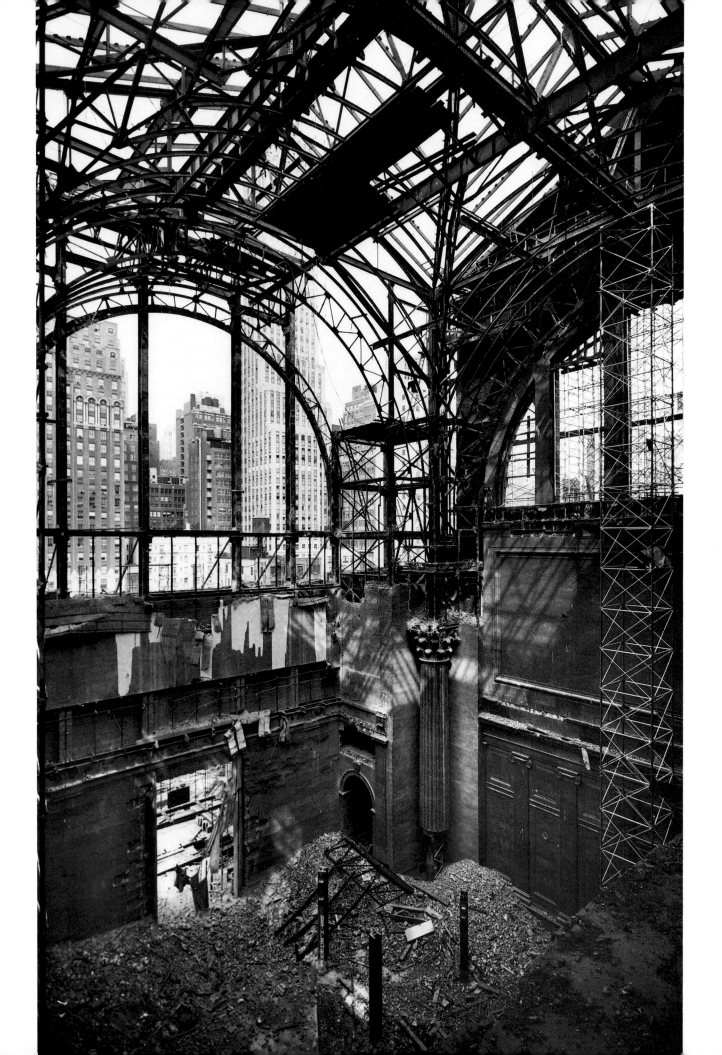

with book publication. Most books take a long time to put together, sometimes years. The photographic research involved in doing books on architecture and design starts early in the editorial process. Preliminary photographs may be chosen long before the final selection is made. The photographer should be prepared not to see any work selected in the first edit for a long time. For this reason it is advisable to submit duplicates or perhaps color prints initially and only release originals for the actual printing stage, if then. Reproduction-quality duplicates can be made and released as an alternative, but these are expensive.

DESIGN DOCUMENTATION

When it comes to company records, the standards for what different firms retain vary widely. Some design-firm files contain little, if any, photographic documentation. Instead, those companies rely solely on blueprints and renderings to record their completed projects, which has obvious disadvantages. There's many a slip 'twixt the plan and the finished product. Nothing can document the culmination of a good, successful design as well as a photograph can. This type of photograph may be taken by someone within the design firm, or a professional photographer may be hired, depending on the picture quality required and the degree of expertise available.

These file photographs can be an invaluable reference source for the company. During the design process, the ability to refer back to similar completed projects may be a crucial advantage. Image clarity may determine a photograph's usefulness from a reference standpoint, but a file photograph doesn't have to be very sophisticated.

Work-in-progress photographs are frequently used in order to determine payment allocations to building contractors. These progress photos become part of a permanent record of a job's rate of completion. Their use is strictly informational, and they are usually taken once a month from the same vantage points. A 4×5 camera is commonly used since detail and clarity are paramount concerns. Aesthetic considerations are not a factor. Progress photos are not normally classified as architectural photography; however, the vantage points from which they are taken (especially if from an adja-

cent building in a confined situation) may prove useful when it comes time to shoot the finished project.

When proposed changes are being designed for a building in a historic district or a restricted area, photography is probably the clearest and most direct way of presenting just how the proposals would change the existing structure. This type of work can be quite involved, perhaps using combinations of art work (overlays), renderings, and photographs of design models.

Design firms can use 35mm slides for in-house presentations, for design studies, and—if their quality is good enough—for client promotion. Many design firms use slide presentations as their primary selling tool. Needless to say, the higher the standard of photography, the more effective this method becomes. Careful editing is essential. Closeups and long views should be intermixed to vary the pace and enliven the show. No apologies should be necessary for any shortcomings in photographic quality.

Photographs are increasingly popular for display purposes. Display photos range from large photomurals covering entire walls to small, framed photographs hung as art. There are few, if any, rules for displaying photographs because the criteria involved vary enormously. If a high degree of enlargement is required for an architectural subject and maximum sharpness is desirable, that almost certainly dictates the use of a 4×5 or 8×10 camera, for the greatest resolution. Sometimes a soft or grainy look is preferable, making the use of a 35mm camera perfectly feasible. Producing large-scale photomurals is a highly specialized field, and only a handful of laboratories are capable of performing this task well.

As an architectural photographer, I always strive to make a maximum-quality photograph, regardless of its intended use. At the time a photograph is taken, I may not even know what its ultimate use (or uses) will be, and so I try to make a photograph that will be at least technically first-rate. There is nothing worse than having an editor or an art director reject an otherwise acceptable image because "it's not sharp," or "the color is off," or large format quality is what is needed. Maintaining high standards across the board for all my work means that I can confidently submit to anyone a photograph that survives *my* editing.

Work-in-progress photograph, in this case the 1962 demolition of McKim, Mead and White's Pennsylvania Station in New York City.

CHAPTER 3

SELECTING EQUIPMENT AND FILM

To take the most basic photographs of either interiors or exteriors, a photographer needs the right equipment—cameras, lenses, accessories—and film. Simple cameras with normal lenses are inadequate for architectural photography. Most readers of this book have probably recognized this fact already if they have ever attempted architectural documentation at any serious level.

35MM CAMERA SYSTEMS

Nothing smaller than the 35mm format should even be considered. For the beginning photographer a single-lens reflex (SLR) camera is a good starting point. A quality rangefinder camera such as the Leica could do the job, but the rangefinder system has limitations, and there is a definite advantage in being able to see the image through the lens rather than through a separate viewfinder, however accurate. Only when shooting at very low levels of illumination might a rangefinder camera have an advantage over an SLR camera.

There is currently an astonishing array of sophisticated 35mm SLR cameras on the market. Architectural photographers can substantially reduce this list by eliminating brands with limited accessories and, most important, too few available wide-angle lenses. Also, automated-exposure cameras that fail to provide a manual override capability can be ruled out. There are just too many situations in which the photographer must have full control. Although a number of manufacturers incorporate a wide range of methods for determining and setting correct exposure, I prefer to use a separate exposure meter to determine my exposures. I verify those readings with a meter built into the camera body, and use it to warn me of unnoticed variations in the light level.

Some photographers may already have a 35mm camera; so they must decide whether to add to their existing equipment or to start afresh. Those who doubt their camera's suitability may need advice from a good professional camera store or from a friend who is a professional photographer. The better manufacturers can also provide help, but naturally, they tend to favor their own products. It doesn't make sense to spend money on expanding questionable equipment unless doing so eliminates its shortcomings.

My advice is to start out with a high-quality camera system that incorporates a good range of wide-angle lenses. Some of the best systems include: Nikon, Canon, Pentax, Olympus, Minolta, Leica, Rollei, Chinon, Contax, Yashica, Ricoh, and Konica. I will point out the features that I consider important, if not essential, when selecting a particular brand or model within that particular family. The top camera manufacturers offer a variety of models for different purposes, some models being more suitable than others for interior and architectural work. The reasons for my own preference for Nikon equipment will become evident as you continue reading. But first, a word of warning about camera equipment bought in the so-called gray market. Rigid, sometimes unrealistic pricing policies have led to the unofficial importation of certain camera equipment. Beware, however, of this less expensive, brand-name equipment not imported directly from the manufacturer. Gray-market equipment is not normally guaranteed, particularly in the United States. If something goes wrong, many establishments refuse to repair or service such items. Perhaps a photographer saves a little money initially, but my advice is to make sure all camera purchases have legitimate guarantees, wherever bought.

Only the following 35mm camera manufacturers of-

fer perspective-control lenses specifically designed for architectural use: Nikon, Minolta, Canon, Pentax, Zeiss for the Contax, and Olympus. (Schneider does make one, but it is not widely available, and I have no information on it.) A perspective-control (PC) lens, sometimes called a shift lens, enables the 35mm photographer to offset the lens either horizontally or vertically or a combination in relation to the film plane. This rise, fall, or lateral shift of the lens gives a 35mm camera some of the perspective-control advantages of a view camera. There is no substitute for these movements when they are needed. The compromises that have to be made in their absence produce less-effective photographs, which is why any 35mm camera system planned for architectural photography must include PC lenses. They are not inexpensive, but for the serious photographer, they are indispensible.

Nikon, Canon, Zeiss, Minolta, and Olympus produce 35mm PC lenses. Only Nikon, Olympus, and Pentax market shorter focal-length, PC lenses—the Nikkor 28mm *F* 3.5 PC, the newly released Pentax 28mm PC, and the Olympus 24mm PC. The 35mm focal length is only moderately wide-angle, but the 28mm and 24mm lenses are extremely useful. While each is made for its particular system, conversion rings are available to permit, for example, the use of a Nikon lens on a Canon body. I should point out that PC lenses are not automatic in operation so not all the built-in automated features work with them. The Canon 35mm lens also offers tilt movement for depth-of-field control; however, this is not important in most interior and architectural work. In addition to their PC lenses, these four manufacturers offer wide-angle lenses from 15mm or so to 35mm, and some offer wide-angle zoom lenses as well.

Obviously, the basic camera must be sturdy and reliable and be able to perform in a wide variety of situations without problems. I use Nikon FE-2 cameras for my 35mm work. This all-electronic system relies on batteries for operation. I carry spare batteries and find I get a long life from each one. The camera cannot accidentally be left on causing battery drain, as was the case with earlier models. The camera is light, quite compact, and comparatively quiet in operation. (The Olympus OM-4 is even quieter.) This latter feature is useful when photographing in a concert hall or any situation where noise is objectionable.

Since I use my Nikon FE-2 cameras in interior situations with low light levels, it is extremely useful having an extended range of shutter speeds at the low end of the scale. Long exposures on my old Nikon F-2 are much more awkward to set. The FE-2 has speeds to 8 seconds on the regular shutter dial, and I use such settings more frequently than one might expect. On the

other hand, I hardly use the very fast speeds at all.

Another feature that I require is double-exposure capability. This enables me to do two-part exposures when noncompatible light sources requiring separate filtration occur. The Nikon FE-2 system is reasonably easy to use for double exposures without the possibility of making them accidentally. I found it impossible to make accurately synchronized double exposures with the Olympus OM-4. (Perhaps they have corrected this omission by the time you read this. The older Nikon F-2 was not good in this department either.) I haven't used the top model Nikon F-3 that has features galore, many of which I don't need.

The serious photographer needs more than one camera body for convenience as well as "insurance." Having two camera bodies permits the use of a daylight film as well as a tungsten-balanced, a black-and-white, or a color-negative film simultaneously. The second body should be compatible with the first so that their lenses are interchangeable; however, the camera model doesn't have to be the same. The small Rollei 2000 F system is an exception to the rule, since it is the only 35mm camera offering interchangeable film magazines. This makes it unnecessary to have a second camera body to accommodate more than one type of film. An unorthodox design, the Rollei 2000 F looks totally unlike any other single-lens reflex camera in the field.

A photographer should choose a camera with a viewfinder and focusing system that feels comfortable. One particular brand may feel better than another depending on the individual. For instance, the size of the camera's eyepiece may be critical to a photographer who wears glasses. Most camera systems offer corrective optics for their viewfinders, which may solve the problem but which requires the removal of glasses. The Nikon F-3 does offer an unusually large opening with its high eyepoint finder system for solution of this problem. Also there are special viewfinder screens available with a super-imposed, squared grid that makes precise alignment with wide-angle lenses an easier task. I have used the Olympus as well as the Nikon viewfinder screens and I can recommend both. Though slightly tricky, both may be installed by the user and are interchangeable with the normal screen.

Camera controls should be clear and easy to set. On the Nikon system all the controls are visible from above the camera, which is convenient when it is mounted on a tripod unless it is positioned very high. Aperture and shutter speeds are also visible in the viewfinder. On the Olympus OM-4 some controls are on the front around the lens and are not visible from above. As with the Nikon FE-2, the Olympus OM-4's exposure settings are indicated in the viewfinder. Where the camera controls

Olympus OM-4 with 24mm shift lens.

Nikon FE-2 with 28mm *F* 3.5 PC lens.

are located may influence the convenience of handling but doesn't affect performance. Personal taste and financial wherewithal play a large part in choosing the right camera system for any photographer.

Lenses for 35mm Cameras

As previously mentioned, PC lenses are usually non-automatic. If the photographer has only had experience with automatic lenses, working with PC lenses requires some practice as well as a tripod. First, the camera should be set exactly level without any lens offset. During setup, a PC lens is opened up to maximum aperture for viewing purposes. This makes focusing easier and more accurate, and it is essential when the lens is substantially offset in relation to the film plane, since there is considerable reduction in the brightness of the image when the lens is shifted. Before the actual exposure, the aperture must be stopped down manually, or overexposure will result. Also, if a through-the-lens (TTL) metering system is used to determine the correct exposure, this has to be done before offsetting the lens, not afterward. This is known as stop-down metering because the shutter speed is selected first and then the lens is stopped down manually until the correct exposure is indicated. The Olympus system is an exception. With the automatic mode engaged, an Olympus camera will expose correctly when the lens is shifted even though the exposure indicators in the viewfinder show otherwise.

There are several mechanical methods for accomplishing a shift with PC lenses. The Zuiko lenses for Olympus cameras are offset by applying pressure in the direction desired. The camera should be firmly mounted to ensure that it remains level. A small button on one side of the lens stops the aperture down to a predetermined setting prior to exposure. A Nikkor PC lens has a rotating ring at the front of the lens barrel for the same purpose. To offset the lens, the Nikkor PCs employ a screw adjustment. The screw control rotates around the barrel and makes precise offset somewhat easier and more precise with the Nikon system.

The Zuiko 24mm PC lens is large and quite heavy—18 ozs. (510g). The front element is 3.3 inches (84mm) across and has a built-in lens shade. Extreme care must be taken to avoid damaging the lens surface since its special low-diffusion glass is rather soft, and the curvature of the front element makes the surface very vulnerable. This lens has built-in filters, and its focusing movements are entirely internal. At the maximum 10mm shift, its angle of view is 100 degrees; it is 84 degrees unshifted. The lens can be focused to 14 inches (35cm) from the subject and can be stopped down to *f*/22 if necessary. I have described this truly remarkable

lens in detail because it is so unique, and its optical quality is excellent.

The Nikkor 28mm *F* 3.5 PC, is also superb optically, and its offset mechanism is easy to adjust. In a horizontal position the lens may be offset 11mm, but the offset should be somewhat less in the other directions if maximum sharpness on the edges of the composition is essential. The critical maximum offset is marked on the lens barrel every 30 degrees. (In practice, I often ignore this rule of thumb because its effects are somewhat influenced by the aperture selected. Also, the extreme top of a vertical composition may well be sky area or perhaps an undetailed ceiling and therefore not be critical in terms of focus.) To fully appreciate this lens, it must be used. A standard 24mm lens may provide similar coverage to an offset 28mm PC lens, but in order to maintain the standard lens in a level position, the composition will probably include much more foreground than desired. Without cropping, the resulting photograph would be compromised.

For architectural use, I find that my Nikkor 35mm and 28mm PC lenses and the 24mm cover most of the situations I face, with the 28mm lens being used most frequently. I don't use standard 50mm or 55mm lenses very often. I have a 20mm and an 18mm lens for extreme cases and a 16mm full-frame fisheye lens for real emergencies or unusual circumstances. The 18mm and the 20mm lenses, both Nikkors, can be lifesavers in confined spaces or when vantage points are limited. For recording details, or for more distant work, I use a Nikkor 105mm *F* 2.5 and a Nikkor 200mm *F* 4.

For most photographers, this array of lenses is not essential, but my having it allows me to tackle almost any situation with a minimum of compromise. Over the years I have built up my Nikon system, and I appreciate the fact that, unlike some other systems (Leica, for example) Nikon's older equipment is still largely compatible with its current models. The latest Nikkor lenses can be used with my sturdy old 1960 Nikon F. (The Leica system, though superb in quality, cannot make the same claim.) In addition, the range of Nikon accessories available is second to none.

120 ROLL-FILM CAMERA SYSTEMS

The variety and styles of current 120 film cameras are even greater now than in the 35mm field. The frame sizes of cameras using 120 roll film vary greatly: 2¼ × 1⅜ (6 × 3.5cm), 2¼ × 1⅝ (6 × 4.5cm), 2¼ × 2¼ (6 × 6cm), and 2¼ × 2¾ (6 × 7cm). The last size is the so-called "ideal format" because it has the same proportions as 4 × 5. 2¼ × 3¼ (6 × 9cm) is the largest of the regular 120 formats. Roll-film camera systems fall into a number of different categories. Though it isn't as familiar now as it once was, the twin-lens reflex camera is still available and its best-known models are the Rolleicord, the Rolleiflex and, more recently, the Yashica. These cameras aren't really suitable for architectural work because they usually have fixed lenses.

The single-lens reflex (SLR), however, is another story. One of the earliest and most revered SLR systems is the Swedish Hasselblad, which has a superb range of Zeiss lenses and removable film magazines. The standard camera comes with a downward viewing groundglass on top, but there are several accessory prism viewfinders that permit eye-level use, which I much prefer. Polaroid backs are also available for the Hasselblad, making on-the-spot testing one of its many useful features. This camera is a 2¼ × 2¼ format, and though some subjects lend themselves to square compositions, many do not, which is the camera's major drawback, as well as its lack of any PC lenses. In practical terms, these limitations mean the negative or transparency must be cropped to obtain verticals or horizontals. This is rather tedious where transparencies are concerned, but it is not a problem when enlargements are made.

One model of the Hasselblad, the Super Wide C, has a fixed Biogon 38mm lens and a separate viewfinder, but it is not a reflex. This camera gives very wide coverage, uses the same interchangeable film backs as other Hasselblad cameras, and is very compact. The Biogon 38mm lens is regarded as one of the best ultra-wide-angle lenses ever manufactured. Only fisheye lenses have greater coverage in the 2¼ × 2¼ format. The Super Wide C also has a convenient bubble level that can be seen through the viewfinder, which is a useful feature. Of course, Hasselblads are not inexpensive, but they are a sound investment since they have such high resale value.

The 120 roll-film category also includes the Bronica camera which uses Nikkor lenses, and is a somewhat less expensive alternative to the similar Hasselblad. Like the Hasselblad 2000, the Bronica uses a focal-plane shutter. The advantage of this system is that having the shutter in the camera body reduces the cost of the lenses since they needn't incorporate diaphragm shutters as do the lenses for the Hasselblad CM series.

Slightly smaller are the 2¼ × 1⅝ rectangular-format SLR cameras, such as the Pentax 645, the Mamiya 645, and a smaller Bronica. There are wide-angle lenses of various focal lengths available for them, as well as a PC lens and interchangeable film backs. These cameras are very appealing because they are compact and have a negative size that is 2.7 times larger than 35mm negatives. Kodachrome 120 will doubtlessly boost the popularity of this and all formats using roll film. The much larger Mamiya RB67 doubles the negative size to

6×7cm and is a multi-feature camera. With a wide range of accessories, including interchangeable film magazines, this is a versatile piece of equipment with an enthusiastic following. Compactness, however, is not its major attribute.

Also in the "ideal-format" category is the Pentax 6×7cm. This camera looks for all the world like a scaled-up 35mm camera and is similarly easy to hand-hold. Its mechanism is entirely electronic and won't even permit viewing without a battery. It has a good range of wide-angle lenses starting at a 45mm focal length, a particularly good 55mm lens, and a 75mm PC lens that I haven't tested. Long focal-length lenses are also available, TTL-exposure metering is provided along with an interchangeable viewfinder. I find the quality of the lenses excellent and like the camera, particularly for aerial use. I have two Pentax 6×7cm bodies in order to make up for the absence of interchangeable film magazines. The camera is not light-weight and makes quite a resounding clunk when the shutter is released, but I've had good results using it without a tripod even at comparatively long exposures. For limited applications, there is an excellent full-frame fisheye lens.

VIEW CAMERAS

All the cameras previously discussed are, despite their adaptations, secondary in importance compared with the view camera, the architectural photographer's basic tool. Consisting essentially of a monorail supporting a front standard on which the lens is mounted and a back standard containing a groundglass for viewing, the view camera has a flexible bellows connecting the two standards, which permits extremely precise placement of the lens in relation to the film plane. Focusing is achieved simply by moving the standards until the image of the subject appears sharp on the groundglass. The focusing principle couldn't be simpler, and, in fact, in its most basic form, the view camera is much less complex than a 35mm SLR camera. The view camera offers an unparalleled opportunity to control the lens-to-film-plane relationship and thereby the image, enabling the photographer to manipulate shape and limit distortion on the groundglass. This degree of flexibility in recording the subject, as well as the ability to expose and process via Polaroid individual sheets of film, make the view camera the architectural photographer's first choice.

A view camera must be set on a tripod; it cannot be used handheld. After an appropriate lens has been put on the camera, the shutter must be opened and the maximum aperture set. The inverted image of the subject is then focused on the groundglass sitting precisely in the film plane. In order to view the image on the groundglass, it must be shielded from any strong light. The old-fashioned black cloth under which photographers regularly disappeared served this purpose. Though the black cloth is still used by some die-hards, monocular and binocular viewfinder systems that attach to the back of the camera are becoming the norm. The most sophisticated viewfinders render an upright though reversed image for viewing with both eyes (binocular) and also incorporate a magnifier for critical focusing. This is quite a contrast to struggling beneath a piece of black fabric in order to view the subject upside down, particularly on a hot day! It takes considerable practice to design and manipulate a composition when the image is inverted.

The view camera's front and back standards can be shifted up, down, and laterally, tilted forward and backward, and swiveled from side to side. These movements are respectively called the rise and fall, the shift, the tilt, and the swing, and they allow the photographer to adjust the size and shape of the objects in the image according to the assignment's objectives. When the photographer is satisfied with the image, the shutter is closed, and the aperture is set for the appropriate exposure. A film holder is inserted in front of the ground-glass, and after removing the safety slide, an exposure is made. The length of the entire setup and exposure procedure depends on the complexity of the composition and other relevant factors, but it is never just a moment's work. So if speed or spontaneity is important, the view camera may not be the answer.

Occasionally it is advantageous to watch the subject through the camera's viewfinder until the exact moment of exposure. This is not possible with a view camera. In cramped quarters the sheer bulk of a large camera may make using it impractical. Also, the types of film available for the 4×5 format are more specialized and more limited than for smaller formats. Nevertheless, in spite of all its disadvantages, the view camera remains the basic work horse of the architectural photographer.

The principal view-camera manufacturers sell a variety of models for such different purposes as studio use, location work, and for using long focal-length lenses with extended monorails. For architectural and interior work, a camera should be reasonably compact for transportation, not overly complex (since normally only limited lens movements are required), sturdy and rigid, and designed to accept wide-angle bellows that permit lateral and vertical shifts with short focal-length lenses. Special reflex viewfinders for viewing noninverted images are particularly welcome. A view camera's locking mechanisms should be positive, secure, and easy to

operate. Nothing is more annoying than having the camera move after it has been carefully adjusted. There should be provisions for holding filters and a lens shade. Flat, as opposed to recessed, lensboards are preferable since checking and adjusting aperture settings is much easier with the former. Changing a vertical to a horizontal format should be quick and easy; rotating backs are convenient for this purpose. Inserting the film holders should be straightforward, and a locking feature for them is helpful. And it is sometimes essential to be able to reverse the ordinary film-loading position from right to left if there is inadequate clearance on the right side of the camera. Bubble levels should be accurate and easy to see, so the camera can be quickly and easily leveled until the film plane is truly vertical in both directions, which will prevent unwanted distortion, particularly with wide optics. Groundglass screens with squared markings make alignment easier. Fresnel screens should be available to brighten the image, which makes viewing the edges of a wide-angle composition easier. Extendable monorails permit the use of long focal-length lenses that require greater extension used for closeup work. The camera's finish should be nonreflective. View cameras come in different formats that range from very simple and quite inexpensive to very elaborate and costing thousands of dollars. Many makes suitable for architectural photography are available for under $1,000.

Why have I devoted so much space to alternatives to using the view camera? The demands and objectives in this field of photography vary enormously. As a working professional, my assignments dictate a wide variety of approaches. No single piece of equipment can meet all my needs. To cope with the different situations, I regularly use 35mm, 120, and 4×5 film formats, not usually on the same job but frequently in combination. Various factors influence my choice of format and the equipment I use. Every system, including the view camera, has limitations and it is important to be aware of them.

Small-Format View Cameras
In addition to the 4×5, 5×7, and 8×10 view cameras, there is a smaller format, $2\frac{1}{4} \times 3\frac{1}{4}$ (6×9cm). This format used to be quite popular, and sheet film for it was readily available. Nowadays, one of its main advantages is its compatibility with 120 roll film that can be loaded in full daylight without requiring a changing bag or access to a darkroom. The variety of films used with a $2\frac{1}{4} \times 3\frac{1}{4}$ camera is limited only by the number of roll-film backs at hand. This format's proportions are a bit longer than those of the 4×5 format, so the $2\frac{1}{4} \times 3\frac{1}{4}$'s vertical pictures are a bit more vertical, and its horizontals are also more extreme.

There are three $2\frac{1}{4} \times 3\frac{1}{4}$ cameras currently available,

the Cambo, the Arca Swiss, and the Linhof Technikardan 23. The Cambo is a conventional, scaled-down version of its larger sister. It looks just like a 4×5—in fact, it doesn't seem that much smaller, nor is it less expensive. It provides more than ample amounts of rise and fall as well as lateral shifts—the movements needed for architectural work—in addition to swings and tilts for other studio applications. Its all-metal construction is rigid and strong, its movements are all calibrated for easy replay, and positive detents (easily felt notches at the neutral position and at one centimeter intervals to facilitate accurate adjustment), simplify accurate zeroing. The widest lens available for this format is 47mm, and it is used in conjunction with wide-angle bellows, which I discuss later. When travelling and working without an assistant, architectural photographer Ezra Stoller uses a small Cambo.

The small Arca Swiss is in the tradition of precision craftsmanship associated with the Swiss. It has U-shaped front and back standards and a sturdy monorail of the same section as their 4×5 models. Polaroid backs are available and also a reflex viewfinder attachment. The rise and fall adjustments are not geared, which is also the case for the Cambo and Technikardan models.

The Technikardan 23 is the smaller of the two Linhof models designed for maximum compactness and full view-camera versatility. The front and rear standards are sturdy L-shaped brackets attached to a multifunction, triple–telescoping monorail. This ingenious design permits the camera to be folded, via some slightly tricky maneuvers, into an 8-\times6-inch rectangle that is $3\frac{3}{4}$ inches high. A full 13 inches of monorail extension is available for long focal-length lenses. In addition, Linhof has installed a control module in certain lenses in order to permit all aperture settings to be made from the rear of the camera. Many accessories are available, including a reflex viewfinder. The only feature the Technikardan is missing is the ability to reverse the position of the film magazine when a horizontal composition is needed. In constricted interiors where clearance to the right side of the camera is limited, this could present a problem.

All three cameras are expensive; however, if 4×5 transparencies are not mandatory, careful consideration should be given to this smaller format. The recent release of Kodachrome film in the 120 size makes the $2\frac{1}{4} \times 3\frac{1}{4}$ transparency very viable. Add to this the simple film-loading procedure and the reduced film cost, and the 6×9 format looks very attractive.

4×5 Camera Systems
The 4×5 transparency has long been the standard for quality among the publishers of interior and architectural design. Shooting in this format is directly related

to obtaining superior print quality. Good reproduction is simply easier to achieve; for example, an 8×10 print requires only 2:1 enlargement from a 4×5 negative but 8:1 enlargement from a 35mm negative. The tonal values from the larger negative have a much extended range. Very few professional architectural photographers use the 5×7 or 8×10 formats because they are too cumbersome for location work. The place for an 8×10 camera is the studio. In over twenty years in the field, I can count on one hand the number of times I've been asked to supply 8×10 transparencies.

In the less expensive $250 to $650 category, Calumet manufactures good-value cameras. The Calumet 540 camera performs all the basic functions without any frills. A special Calumet wide-angle kit includes a flexible bag bellows, a short monorail, and an easy-viewing Fresnel screen for $180. Originally American-made, Calumet cameras are now manufactured by Cambo in Holland. In addition to the 540 4×5 model, Calumet lists and markets the Cambo and the Horseman view cameras. The Cambo SCIIRS is almost identical to the Calumet 540—in fact, it is a refined version of it. All the movements are calibrated with positive locks. The system of detents makes accurate alignment swift, and four bubble levels make leveling easy. The Cambo SCX is a much more elaborate model. This camera has geared movements that enable one-handed adjustments. The monorail design permits unobstructed movement of the front and back standards over the entire length of the monorail without interference from the tripod-mounting clamp. This model weighs 13½ pounds, about 4½ pounds more than the basic Cambo SCIIRS.

Slightly upscale is the Omega View 4×5 camera marketed through Berkey, Incorporated. This camera does have geared rise and fall, but it is not all constructed of metal, and recent experience suggests that spare parts are scarce and repair is slow though the price is modest. At the upper end of the price scale are the Sinar and Linhof 4×5 cameras. Similarly, the Horseman 450 is sophisticated in design and is the top line marketed through Calumet. Sinar upgraded its least complex model, the Sinar F to the F-1 and F-2.

The beauty of the Sinar line is that every model is part of an expandable, interchangeable system. Thus, one model may be easily upgraded to another, and the 4×5 cameras can be transformed into larger formats. The basic models are the Sinar F, the C, and the P. The Sinar P is the ultimate view camera. I bought one when they were first introduced but found it too heavy for location use. Ezra Stoller is the only active professional I know who uses one but only when he has assistance. Currently, the Sinar F seems to be the camera most favored by my colleagues.

Thanks to the modular approach, I was able to convert my Sinar P to an F fairly painlessly (they were a lot less expensive then). I've found the camera to be sturdy and reliable; it takes considerable abuse when necessary. The locking systems are positive, though the camera lacks the geared rise and fall and the geared lateral shift featured on the P model. The camera is lightweight and folds compactly for transport. The levels do tend to require periodic adjustment, but they have been improved on the latest F-1 and F-2 models. The working aperture for depth-of-field control is most useful. This device determines the widest aperture at which both foreground and background objects will be sharp. The movement calibrations are clear and easy to read. The binocular, magnifier viewfinder is a godsend because it makes high camera positions easily accessible and, conversely, it permits very low ones too. The groundglass and the lensboards may be switched to position the camera's controls on the left rather than the right. Extension rails are easily attached when longer lenses are used. The current models are mat black. I don't use the Sinar behind-the-lens shutter or the electronic shutter system, but both are available. And Sinar's flat lensboards permit easy access to lenses that are as wide as 65mm.

View Camera Lenses

Even more critical than the type of camera is the photographer's choice of lenses. If the camera selected represents a compromise, the lens should not. A photographer needs the best lenses affordable. With care, they will last indefinitely. If the photographer diligently searches for a particular lens, a used one can often be found at a lower cost. The shutters on used lenses are easily serviced if there is a problem. Older lenses are not usually multi-coated, making their color rendition less accurate. Color rendition may, in fact, vary substantially from one lens manufacturer to the next. For consistency, it is best to stick to one manufacturer's lenses, or at least to check them out first. In a project series of photographs, it is undesirable to have color variations due to different lens characteristics.

My most frequently used lens is the Super Angulon 90mm F 5.6 made by Schneider, followed closely by the Super Angulon 120mm and 75mm lenses. These focal lengths are approximately equivalent to 28mm, 35mm, and 24mm lenses for a 35mm camera, and cover most of the photographic situations I confront. The basic characteristics of these view-camera lenses make them particularly suited for architectural and interior work, and the reader should develop some understanding of these attributes.

The first sight of a wide-angle view camera lens

comes as quite a surprise to anyone familiar with only 35mm camera lenses. Lenses for the different formats appear to have little in common. View-camera lenses are typically symmetrical in design, having two groups of four elements, the largest of which are at the extreme front and the back of the lens. The shutter is located right in the middle where all the light rays converge. Thus, the view-camera lens is shaped like an hourglass; it is not barrel-shaped like a 35mm lens. When a view-camera lens is focused at infinity, its rear element projects back into the space between the front and rear standards of the view camera. When no lens movements are necessary, usually no problems with the rear element occur unless a very short focal length, wide-angle lens cannot be focused at infinity because no further movement of either the front or the rear standards is possible. The restricted movement may result from limitations in the camera's design or because a regular bellows in its fully collapsed position doesn't permit further adjustment.

The solution to this problem is to use wide-angle, or bag, bellows. Large and flexible, this device is substituted for the regular bellows and enables the front and back standards to be moved to their closest possible position. When the distance between them is still too great for the lens to be focused at infinity, using a recessed lensboard becomes necessary. It positions the lens closer to the focusing plane or groundglass, but it also hinders access to the lens settings.

When listing specifications for particular lenses, manufacturers frequently use the term "angle of view." This term usually means the horizontal angle covered by that lens in a particular format. For example, a 28mm lens on a 35mm camera has a 65-degree angle of view measured on the horizontal. The closest equivalent lens in 2¼ × 3¼ format would be a 65mm lens with a 66-degree angle of view; on a 4 × 5 camera, a 90mm lens would create a 68-degree angle of view. Occasionally, a lens manufacturer quotes an angle of view that is measured on the diagonal of the scene which would, of course, be considerably greater than the horizontal figure. The angle of view for a particular focal-length lens relative to a single format will always be the same, regardless of the lens design. A change in format, however, alters the angle of view for that lens. For example, a 135mm lens has a 15-degree angle of view on a 35mm camera, but it has a 48-degree angle of view on a 4 × 5 camera. All the above figures are calculated with the lens focused at infinity, which is how manufacturers also calculate angle of view.

Image size is also determined by focal length. An object photographed from a fixed distance yields an image size on film determined by the focal length of the lens used; this image size won't change regardless of the format used or the optical design of the lens. Why, then, do manufacturers sometimes produce two and three lenses of the same focal length? The answer is that lenses are used for such different purposes and have such variable characteristics that a single optical design is incapable of meeting the exacting needs of all photographers.

One of the major camera requirements for photographing buildings inside and out is the necessity of using generous lens movements. In cameras that have a fixed lens-to-film-plane relationship, the image circle projected by the lens on the film plane needn't be much larger than the diagonal measurement of the frame size. In view cameras where the lens-to-film-plane relationship is often substantially adjusted, the image circle projected must be correspondingly greater to maintain the necessary sharpness no matter what part of the image circle is recorded on film. Hence, view-camera lenses must exhibit a wide "angle of coverage," which is why these lenses have much larger image circles than those produced by all-purpose lenses of similar focal length.

The highest quality wide-angle lenses usually have the greatest angles of coverage. Optically, they are the greatest challenge to manufacture, so these lenses are likely to be the most expensive. The angle of coverage is also affected by the aperture of the diaphragm, and it is usually optimum at $f/22$. An examination of the specifications for the Super Angulon series of lenses indicates they have a 105-degree angle of coverage for the 65mm, 75mm, and 90mm F 5.6 focal lengths. Their corresponding image circles are 170mm, 198mm, and 235mm in diameter. As the focal length increases, the image circle does, too. That is why lens movement is most limited with the shortest focal-length lenses in any particular format.

The fastest wide-angle, view-camera lenses in the Caltar line (marketed by Calumet) and in the Schneider, Nikkor, Fujinon, and Rodenstock lines have remarkably similar specifications, and all are excellent. The second class of lenses made by these manufacturers are somewhat slower, having maximum apertures of F 6.8 or F 8. Their image circles and angles of coverage are usually smaller (Nikkor lenses are an exception), and their price is lower. One can buy two Super Angulons 90mm F 8 lenses for the price of one 90mm F 5.6, but the image circle of the latter is 20mm greater, allowing for substantially more lens shift. All the lenses I've mentioned come with Copal shutters that are very reliable and have a range of shutter speeds from 1 second to 1/500 second plus B and T.

Calumet's *The Photographer's Catalog* is a handy ref-

erence and comparison text, and Sinar has very comprehensive literature available on request. Sinar periodically runs seminars on view-camera technique, and Calumet publishes a videotape, "Large Format— the Professional's Choice," with an accompanying workbook. Both publications are helpful to the beginner.

ACCESSORY EQUIPMENT

Once the right combination of camera and lenses is assembled, the question of camera support must be addressed. A sturdy tripod is a must. Some units come complete, but many have detachable heads for mounting the cameras. A tripod head should rotate and tilt in any direction (pan, double tilt). A tripod's dimensions when folded and its weight are also factors to consider. Its locking mechanism should be positive and secure. Choosing a very light tripod for convenience is a mistake, since the odds are it won't provide the necessary rigidity for the heavy camera. The tripod should have rubber feet to prevent slippage and to protect fragile floors and carpets. Dark-colored tripods tend to cause fewer reflections, but this depends on the background. I personally use the Gitzo range. Keep the tripod clean. Sand and salt, especially, can be very damaging. If a tripod is immersed in sea water or used on a beach, it will start to corrode rapidly if not cleaned immediately.

Not infrequently a special situation demands an unusual approach. A tight space may necessitate a very high-angle shot, or a plan view may be the only way of showing what is necessary. Conversely, a very low camera angle will diminish the floor or make the ceiling appear much higher than it really is. The first situation may require a particularly high tripod or some sort of clamp for mounting the camera onto a convenient support, existing or makeshift. A stepladder may be essential. For the very low shot, a small but solid tripod or perhaps a side-arm attachment for a tripod might do the trick. The sidearm permits cameras to be mounted at or near the floor level, depending on the particular tripod setup. Some tripods have a special feature that enables the photographer to splay their legs outward permitting unusually low viewpoints.

Of course, 35mm cameras can simply be placed carefully on a flat surface—even on the floor—if care is taken not to move them during exposure. This can be done with cable releases or by utilizing the delayed-action feature incorporated in most sophisticated 35mm cameras. A long cable release is sometimes useful, enabling the photographer to shoot remotely, perhaps to avoid making an unwanted reflection.

A very tight situation may necessitate backing the camera right up against a wall making it difficult, if not impossible, to see the subject through the eyelevel viewfinder. The Nikon F, F-2, and F-3 cameras have interchangeable viewfinders including a right-angle viewfinder for tight corners. Otherwise, an angled mirror may do the trick. Cameras with Polaroid testing capability can rely on the tests to indicate exact framing. Also, there is a little dental mirror now available at drug stores; using this mirror will permit the photographer to check exposure settings in situations where the camera controls would otherwise be invisible.

About electronics. Many of today's sophisticated smaller cameras rely entirely, or at least partially, on batteries to operate. Because battery-related problems account for the largest single category of 35mm camera failure, my advice is always to carry spares. On some cameras, certain shutter speeds work without current, since they are mechanical rather than electronic. But if you are not completely familiar with your equipment, it is comforting to keep the instruction booklet at hand. Keep in mind that temperature will affect battery performance. Cameras that are likely to be subjected to extreme cold should be winterized by a reputable repair/service establishment. Batteries lose efficiency as the temperature drops. Finally, there are two pocket-sized tools that can be lifesavers for some exposures: a stopwatch can be most useful, particularly if your camera lacks shutter speeds longer than 1 second, and a pocket flashlight that can be clipped in position may be invaluable in low-light situations.

Exposure Meters

As I have already mentioned, many 35mm cameras come with sophisticated built-in systems for determining and setting correct exposure. Working only in small format, a photographer could possibly rely only on a built-in meter, but I feel that having a separate meter is more convenient and permits greater flexibility. Exposure determination can be quite tricky, particularly with interiors that frequently include light sources within the composition. I want a meter that reads a limited area; I find meter selectivity of about twenty degrees or so to be ideal. This allows me to choose an area of my composition that I know will give me an exposure reading I can use for the entire photograph. With the aid of a reflex viewfinder (another must) I can purposely avoid overly bright or unusually dark areas that would otherwise influence the exposure.

An exposure meter should be able to determine exposures that vary from snow scenes in bright sunlight, to dimly lit interiors with dark surfaces, and to night scenes. The latter sometimes require extremely long exposures, running to several minutes. This degree of sensitivity should be combined with a broad range of film speeds from ISO 10 to beyond ISO 1000 in

order to accommodate the fastest films now available. The meter must be able to make reflected- and incident-light readings. A number of new models can double as flash meters and have a digital readout; other models display analog readings. What is ultimately used is a question of personal preference.

The meter should be simple to use and not require tedious dial turning to obtain the readings. The more compact and easier to use, the better. The dial numbers should be easy to read even in low levels of light. Film-speed settings should be clear, and once set, they should resist accidental alteration. An exposure meter that retains the reading after use is helpful. If the meter has a mechanism that must be unlocked to obtain readings, this will probably protect it if it is accidentally jarred. Battery checking should be straightforward, and the photographer should always carry spares. Also the ability to check zero readings is, at times, a useful feature.

The top manufacturers of exposure meters are Minolta, Gossen, and Sekonic. They sell a wide range of meters for all purposes. Pentax produces good spot meters, too. One-degree spot meters are occasionally invaluable for determining the correct exposure of very distant objects or small important areas that are perhaps surrounded by subject matter of varying brightness. Spot meters require some skill to use, and a meter that averages exposures from a larger area is more useful for general purposes. I presently use a Gossen Luna Pro SBC with a variable reflex viewfinder attachment that adjusts to either a 7½-degree or 15-degree field of view. It is a rather large unit, so I am currently looking at the new digital variable-angle Sekonic meter.

In addition to the above mentioned meters, there are a couple designed specifically to take readings off the view camera's film plane. The exposure values obtained by this method automatically include adjustments for any filters and bellows extension affecting the normal exposure. This type of exposure meter is inserted into the back of the camera like a film holder, and readings are obtained after the lens has been stopped down to its appropriate *f*-stop. Horseman makes a meter of this type for 4×5 cameras; it has three ranges and very good, low-level sensitivity for shutter openings as long as thirty minutes. Sinar makes two similar, though more expensive and elaborate, meters: the Sinarsix-digital and the Profi-select TTL.

Special Aids for Prepping the Subject

I always carry a small tool kit along to a shooting session in order to make on-the-spot repairs or adjustments to equipment and for any other eventualities. Window cleaner, wood and floor polish, and other cleaning aids are sometimes required. Some of these items shouldn't really be the photographer's responsibility, but often there isn't anybody else to provide them.

A variety of tape is invariably handy. So are a small supply of picture hangers, both the small pin type as well as the stick-on variety that doesn't leave a visible hole but needs adequate time to set before bearing any weight. Fine nylon wire has many uses and is often invisible to the camera. Also nylon wire is excellent for precise positioning of tree branches as well as large leaves on exotic plants. Double-stick or carpet tape is good for preventing or eliminating unevenness in rugs and carpets. A simple pair of scissors can cut paper or cardboard shapes to conceal or disguise some overly-prominent item. An eraser is good for removing scuff marks from baseboards and other woodwork if other cleaning methods are unavailable. A small level to square up picture frames on a wall, and a tape measure can also prove helpful.

To prevent unwanted reflection in a composition, strategic placement of black paper or fabric may do the trick. In other situations, white paper may be required instead. When using supplemental lighting, the glare from shiny objects is sometimes a problem. A can of dulling spray may be the solution. This simple spray-on liquid is inert and dries very fast, leaving a thin, non-reflective coating on the offending object. Before using dulling spray, the photographer should read directions for its use carefully and make sure that it won't damage any delicately finished surfaces. It can be tested on a small area first. Marketed by Krylon, the product is available through art supply stores.

FILM SELECTION

There are four basic categories of film: black-and-white film (negative), reversal film for color transparencies (positive), color negative film for prints, and Polaroid instant film. I have spent considerable time selecting the films that I like and that meet my requirements. The more familiar I become with a film, the better I am able to guess the right exposures. Therefore, I can spot and correct mistakes before they are made. My primary objectives for the films I use are quality, predictability, and consistency.

Black-and-White Negative Film

I use Kodak Tri-X film for my black-and-white work. Tri-X is about as close to a universal film as has yet been developed. It has an excellent combination of speed, latitude, tonal range, and fine grain. There are a number of top-quality alternatives, including films made by Ilford and Agfa, but I prefer to use Tri-X 4×5 film packs. These packs each contain sixteen sheets, are compact, and avoid time-consuming individual sheet loading that would otherwise be necessary. The majority of my non-

color work is done on a 4×5 camera; it is simple to make an additional exposure once the basic setup has been accomplished. And I still advise my clients to let me shoot black and white, even if they don't anticipate use for it.

Color Transparency or Reversal Film

Color transparency films come in all sizes but some are available only in roll-film formats, 35mm, or 120. Virtually all reproduction is from transparencies. Kodachrome is probably the best all-around film ever developed; I use Kodachrome 64 almost exclusively for daylight shooting. Few photography labs other than Kodak's have the necessary facilities to process Kodachrome. When quick results are essential, this can be a problem, particularly in nonurban areas or overseas. So for rush purposes, Kodak Ektachrome may be preferable. The E6 processing it requires is widely available; Ektachrome can even be developed in a regular darkroom without complex machinery. Daylight-balanced Ektachrome, available in several film speeds, and tungsten-balanced Ektachrome 50 come in all formats. Tungsten Ektachrome 160 comes only in the roll-film sizes. In addition, 35mm Ektachrome is marketed in a professional as well as a regular emulsion. (The former includes slightly more precise exposure and filtration data.)

Until recently, only Ektachrome film was widely distributed for 4×5 cameras. Now, however, Fuji and Agfa are marketing sheet film for E6 processing in the United States. Fujichrome and Agfachrome offer somewhat different characteristics than Ektachrome. I tested Agfachrome 50 RS Professional and found it to have extremely fine grain with accurate color rendition, but its greens and blues are a little dull compared to Ektachrome 64. Only a daylight-balanced Agfachrome is marketed for 4×5. Fujichrome 50 D and 100 D are excellent films, and the former gives particularly pleasing results in daylight situations where Ektachrome film requires considerable filtration to prevent an unflattering bluish cast. The Fuji product seems much less sensitive to ultraviolet light which causes this than the Kodak film. Under clear blue skies in open shade, Fujichrome 50 D produces satisfactory transparencies without use of filters. This film's ability to tolerate long exposures without reciprocity failure (a shift of color balance and reduction in film sensitivity that occurs with extremely long or short exposures) is another plus.

I still prefer Ektachrome 64 for shooting interiors when I use supplemental electronic-flash lighting. Both Ektachrome 100 and Fujichrome 100 D are excellent all-around films (the latter exhibits slightly less recipro-

ity). For tungsten lighting I like to use Ektachrome 6118 Type B, although its film speed varies from one emulsion to the next. As a professional sheet film, it comes with a specification sheet giving the exact ISO ratings and filter requirements for that particular batch. I try to buy the film in bulk when I find a batch I particularly like, since they can vary substantially. Although tungsten Fujichrome 64 is quite a bit faster, I find it has a very yellowish cast compared to tungsten Ektachrome.

Color Negatives for Prints

Many design firms use color prints in their portfolios. There are two types of color prints: the so-called "C" print that is made from a color negative (either an original or an internegative made from a transparency); I prefer original negatives and the Cibachrome print, made directly from a positive transparency. The latter is very vivid in color and has excellent stability, or resistance to fading. Type C prints are somewhat less contrasty and are quieter in color.

There are many different color-negative films available. I use Kodak Vericolor II Type L and Vericolor III Type S. The former is balanced for tungsten light sources (3200°K) and longer exposures, 1/50 second to 60 second; and the latter for daylight and exposures of a 1/10 second or less. These emulsions are available for the large formats and in some roll-film sizes too. For 35mm use there are also some very fast color-negative films now on the market. These faster films are useful for certain low-light-level interior situations, but they are more grainy and therefore may not yield acceptable results.

Polaroid Instant Film

I use Polaroid film for advance, on-the-job testing. I have a Polaroid back for my 4×5 camera. This back accepts individually packaged sheets of film, either color or black and white. While the color is quite seductive, it has different characteristics from the transparency material for which it is a test. Black-and-white Polaroids are more economical and give me all the exposure information I want. I use type 55 P/N film that produces not only a black-and-white print but also a negative, when necessary, from which enlargements can be made. The instant negative must be soaked and washed right after development to avoid staining. This is usually inconvenient, so I discard the negative. Type 55 P/N film has an ISO rating very close to that of tungsten Ektachrome or Fujichrome 50, so no changes are necessary between the test and the final exposure, which is why I use it.

Polachrome film, daylight or tungsten, is not an instant film but a packaged reversal film made for Polaroid by Fuji. Polachrome does not require darkroom loading

and is exposed with the aid of the Polaroid back. Following exposure, it is sealed in its envelope and delivered to a regular processing lab for development.

An ingenious 35mm Polaroid back has been developed by Marty Forscher, Professional Camera Repair Service, 37 West 47th Street, New York, NY 10036. For professionals working only in this small format, the Forscher Pro-Back produces an image 24 × 36mm on Polaroid 668 or 669 film. Though the print is very small, it can be a useful tool in complex lighting situations. I also make Polaroid tests with my Hasselblad when I am working in 120 format.

PROCESSING AND PRINTING

Depending on location, there will be the question of finding a lab to process color transparencies and prepare prints. In a large city, your choices are likely to be numerous, but in more remote areas there may be little to choose from. In the latter instance, professional photographers may opt to do their own processing; most manage to avoid this complication. I have established a very personal relationship with a freelance black-and-white printer who develops and enlarges all of the work I produce. Because of the volume of my assignments, I have him on a retainer to ensure his availability. He has his own facilities, thus making it unnecessary for me to have them. And yet we are both independent. I established this setup in part because of the difficulty of finding a lab that could consistently produce the high-quality work demanded by my clients.

Color processing is different, since it relies on a lab's ability to regularly turn out predictable work, which can only be achieved by careful quality control at every stage. Mechanization and electronics make such control possible.

Color printing is another matter. My experience has been that clients are frequently disappointed with color prints. One of the reasons for this is that the prints are compared directly to transparencies, which is unfair to the latter, since the range of highlight to shadow is many times greater for a transparency than for a print. When the original to be printed is contrasty, the quality of any prints made from it is likely to suffer. Photographs of low or average contrast translate more successfully into prints.

When prints are being commissioned from a lab, it is essential to provide detailed instructions of what is required. This is particularly true if there are any shortcomings in color or exposure in the original. When only color negatives are supplied to a lab, the technicians will need a guide as to the correct color. When available, send another print or transparency showing the color desired, particularly with interiors. If you lack a good guide but still want a quality print, ask to speak directly to the technician—who can usually explain just what changes are feasible. If instructions are not followed, have the lab make the prints over. But allow enough time for this when placing the order in the first place. When prints are required on a rush basis, prices escalate wildly. Keep in mind that color prints are substantially less expensive when ordered in quantity, so always order extras to anticipate future uses.

SERVICE AND REPAIR

Sooner or later, virtually every piece of equipment, however good its quality, will need service or repair. To forestall trouble, check equipment thoroughly before important trips. Take backup equipment if possible. And never take untested or new equipment on an assignment when no alternate exists. It helps to build up a file of good repair services in all the localities where you work and to take along the telephone number of a local service when shooting on location.

Marty Forscher, with Harvey Shaman, wrote a detailed article titled "28 Ways to Prevent Camera Breakdowns and Cure Them When They Happen," which originally appeared in *Modern Photography*. Divided in three parts, the first discusses advance preparation, the second deals with common field problems, and the last with preventive maintenance. If you are interested in obtaining an offprint copy write to Professional Camera Repair Service, 37 West 47th Street, New York, NY 10036.

CHAPTER 4

MASTERING FUNDAMENTALS OF INTERIORS PHOTOGRAPHY

In this book I divide the photographing of interiors into three basic categories. First, in Chapter 5, I discuss domestic spaces, which include all living situations. Next, in Chapter 6, comes the commercial or office space, the contract interior. Chapter 7 considers public spaces—restaurants, stores and showrooms, auditoriums, churches, and museums. An in-depth study of each category of interiors is neither practical nor possible here, but a careful analysis of the common problems that arise at each stage of the photography process does reveal an approach that makes sense. The common denominator may be sheer size, scale, the mixture of light sources, or some other characteristic.

COLOR VERSUS BLACK-AND-WHITE PHOTOGRAPHY

There was a time when all architectural photography was black and white. Now the pendulum has swung the other way and most published material in the design field is in color. There is something very basic and I think quite satisfying about a good black-and-white print of an architectural subject. With filtration and good printing techniques, black-and-white images can be very dramatic. Enlarging from black-and-white negatives enables the photographer to control the degree of contrast as well as the overall tonality. Nevertheless, I am assuming that the majority of readers will find the discussion of color photography in the case studies that follow more pertinent to their needs. When I am doing an assignment, I frequently shoot both color and black

and white. I recommend the use of Tri-X film for architectural work, either exterior or interior, and use it exclusively.

Once the basic angle has been established and the camera set up—and also, perhaps, the lighting—it is easy to shoot a black-and-white negative with nothing more than an adjustment in exposure to accommodate the higher sensitivity film. This assumes shooting with a 4×5 camera. I usually shoot black and white only on the larger formats, because it is always easier to produce a quality print from a larger negative. This does not preclude the use of 35mm for black-and-white shooting, but it does require a highly skilled printer to come up with consistent, quality prints from smaller negatives.

If 35mm slides are required for projection, these will almost certainly be color. Very occasionally, I am asked to take black-and-white slides. Color slide film can be used to photograph a black-and-white print, producing a black-and-white slide. Black-and-white positive film, known as diapositive, is available and can be used to produce slides directly without having to go through the black-and-white print stage. Diapositive film is not widely available and may be hard to get.

If you have a color transparency, of whatever format, you can make a black-and-white print from it, but the quality is always inferior to that of a print made from an original black-and-white negative. The reason is that black-and-white copy negatives are always more con-

trasty than the original and therefore more difficult to print. A copy negative cannot match the tonal range of a properly exposed and developed original negative. Therefore, most good quality prints are made from negatives. This is true of both color and black and white.

SIZING UP THE INTERIOR BEFORE PHOTOGRAPHING

Unless tight schedules do not permit it, professional photographers should make a preliminary visit to a job site prior to an assignment. There are a number of reasons for this. Unpleasant surprises on the day of shooting can often be avoided. Elements of the space that will have a major impact on the photography but are not considered by the designer to be important must be worked out in advance. The photographer must also know if the space still conveys the designer's original concept. Perhaps some unwanted addition has been introduced without the designer's knowledge; a large plant, a strident piece of art, a rug at odds with the design scheme, an unplanned piece of furniture, unspecified window coverings, graphics that cannot easily be moved or changed, and so forth. So an advance visit should be mandatory for the designer too, to ensure that the space is in an appropriate condition to be recorded.

If the designer is also doing the photographing, then undesirable items may be eliminated during the photo session. If somebody else is doing the photography, it is up to the designer to make clear just what items are to be removed, moved, added, or otherwise modified. Alternatively, these decisions may be left to the discretion of the photographer, with photographic considerations outweighing other factors. These decisions should be made at the time of the preliminary visit, allowing any necessary arrangements to be completed in advance of the shoot. This will save time and money.

Another objective of the preliminary visit is to allow the photographer to get the feel of the space and select the most flattering angles for capturing the design. The sensitivity of the photographer to the design objectives is of the utmost importance. The degree to which the interior reflects the philosophy of the designer is also highly relevant. In situations where the design concept has been compromised in one way or another, the photographer is presented with the task of bridging the gap between reality and the unrealized objectives. The photographer can exercise "photographic license" to vary the moods of photographic images by using careful lighting, unusual camera angles, balanced composition, and a host of other methods and approaches. Only the more skilled interior photographer is likely to be able to achieve this.

A full check of the existing light sources and their control is paramount during the preliminary visit. The

Boettcher Concert Hall, Denver, Colorado. Designed by Hardy Holzman Pfeiffer Associates.

photographer can spot missing or inoperative light bulbs or perhaps mismatched fluorescent lamps. Also, window blinds and curtains should be checked. The controls for mechanically operated window shades or curtains may be cleverly concealed, sometimes in the locked credenza of an executive desk, so you should arrange to have access as needed. On this preliminary visit the photographer should also decide whether to have dining tables set or not, with tablecloths or without. Tablecloths must be clean and it may be necessary to iron or steam them to remove creases and wrinkles. Likewise, bedsheets and pillow cases, when shown, may require ironing. It is vital that these details be worked out in advance. Arrangements should be made for last-minute on-site prep work.

The condition of plants or trees should be noted. Are there blemishes on the walls or is the ceiling going to be a problem? Are there missing ceiling tiles? Spots on the carpet? Empty bookshelves? Look for anything that might detract from the impact of the final photograph.

Props

The preliminary visit will help you decide what additional props may be needed to enhance a photograph. These may vary from finding an alternative for a piece of sculpture to adding a large tree, perhaps rented for the shooting.

Reception areas and conference rooms frequently lack well-designed ashtrays, which can make a surprising difference. Suitable note pads and pencils may make good accessories to the large expanse of a conference table. Perhaps some beautifully leather bound books can be arranged on a work surface that may otherwise look too bland. Suitable magazines with appropriate covers will usually enhance a reception area table. Bring books if none are available on the job site, but select titles appropriate to the situation. An open book on a bed or chair may add a personal touch but may also be regarded as something of a cliché. A tray with glasses and a bottle of wine may provide just the right touch on a coffee table or sideboard. A filled wine glass beside a suds-filled Jacuzzi can add a titillating element. It is sometimes the unexpected that makes a good photograph really come alive.

When it comes to selecting props, the watchwords should be suitability and appropriateness. The wrong cutlery or flatware may be worse than none at all. Poorly designed vases, ashtrays, appliances, or lamps may seriously compromise an otherwise satisfactory picture.

Art is a delicate subject. The client's taste may vary considerably from the designer's. When this is the case, the photographer must be careful, lest feelings be hurt. When properly explained, sensitive clients will usually understand that the changes are being made strictly for the photography. I have been involved in jobs where the owners are perfectly willing to have items removed for documentation but are adamant about introducing others that are not of their choosing.

Flowers can make or compromise a photograph. A prim, traditional arrangement of mixed blossoms from the corner florist placed on a contemporary reception desk can be disastrous. Different varieties should be combined with great care. I find that a large mass of a single kind of flower is frequently much more effective. The arrangement should be the right scale for its location and the container is often as important as its contents. Make sure the water in a glass vase is perfectly clean and change it if in doubt. Cut glass is suitable for some dining tables but is wrong for a contemporary waiting area. A single, airy sprig of apple blossom may provide just the right softening effect when a more dense display would be too obstructive. Color selection is also important and must be coordinated carefully with the design scheme. The designer should make any preferences or dislikes known in advance. Some magazine editors dislike the use of certain flowers and plants in their photographs. However, since most magazine editors are usually involved in the shoots, these pitfalls can be easily avoided.

Out-of-focus foreground flowers have become something of a cliché in interior photography but nevertheless can be effective in the right circumstances. Apart from the added depth this technique suggests, plants and flowers can be used to conceal unwanted elements in a room. That might be the reflection of the camera or of the photographer.

The use of large trees as decorative elements in interiors has become virtually synonymous with the Modern Movement. Some interiors have literally become greenhouses, with plants widely used as an integral part of the design. Photographers should be careful not to include unhealthy or drooping plants. Also remember that trees or flower arrangements may have to be rotated to display their best sides to the camera or provide the required balance.

Tall vertical elements like trees can provide just the right exclamation point in a strongly horizontal scheme. Trailing vines can break and soften the hard edge of a balcony or other overhead element. The container in which the tree or plant is growing should be coordinated with the design theme. Small-leaf trees like the popular *Ficus benjamina* will have a much different effect than a cactus or a large-leaf philodendron. Exotic orchids can sometimes provide just the right touch. Some plant stores will rent trees or plants for photographic assignments.

PEOPLE IN PHOTOGRAPHS

Traditionally, most architectural photography has not included people. I think this was based on the assumption that documentation devoid of human figures was purer. The design could be studied and analyzed in photographic form with greater ease when uncluttered by distracting occupants. But taste has changed, or is changing. Since buildings are designed to be lived in, worked in, played in, slept in, prayed in, depending on their function, does it not make sense to depict them in use?

When working with interiors, scale may determine whether people should be included. In a small room in a house or apartment, for instance, it is almost impossible to include a person without having that person dominate the photograph. Since the documentation of the design is the primary objective, any elements that distract the viewer are counterproductive. If the photograph is taken to illustrate how a famous person lives or works, then including that person both becomes appropriate and adds authenticity to the result. As always, the purpose of the photo must be carefully considered.

With large spaces, people may be included without dominating the areas they occupy. Without figures the scale is sometimes ambiguous. The photographer must ultimately be the judge. A beautiful woman sitting behind a reception desk will certainly enhance most entrance lobbies and, may be appropriate, even if other photographs in that series do not include inhabitants. Polaroid tests during the photography session will help in making on-the-spot decisions about whether or not to include people.

The problem with including people in photographs is having them appear natural. Subjects frequently become very self-conscious and uneasy when they know they are being photographed. Try a dry run—going through the motions of taking the picture without actually doing so. People get tired of assuming unnatural poses and eventually begin to relax. Successful photographs of interiors with people may ultimately depend on the personality of the photographer and his or her ability to put the models at ease.

When long exposures of several seconds or more are involved, blurred movement may cause an even greater distraction. However, there are some circumstances when the inclusion of blurred moving elements, be they human or otherwise, will add an intriguing element to an otherwise dull subject or perhaps explain the function of what appears to be a static object.

One other factor should not be overlooked. Styles change and they tend to date photographs, limiting their usefulness. The miniskirt or the so-called "new look" immediately pinpoints the period of the photograph in which they are included. My general advice, therefore, if documentation is the primary objective and you really want to include people, is do so with care and to avoid closeups. Always shoot a couple of alternatives without people in case you change your mind.

A final word of caution. Permissions should always be obtained in advance. This is particularly true if the photographer is professional and if the photography is in a public place. Only when photographing members of a family or individuals at home, when arrangements have to be completed in advance and the planned use of the photographs is clearly understood, might it be redundant to obtain releases. In such a situation it is assumed, from a legal standpoint, that the photograph could not have been accomplished without the knowledge and cooperation of the subjects nor could they fail to be aware of the ultimate purpose of the session. However, even in such a situation, if the objective is material to be used for advertising, model releases are mandatory. Model releases may be obtained at any good business stationer. However, if model releases are not available, the standard A.S.M.P. release form provides typical wording for such a document. Even a copy, when signed, is legally binding.

AVAILABLE LIGHT

The most important single factor to be considered when documenting interiors is lighting. In the absence of light, there can be no photograph. Subtle changes in lighting establish mood and become an intrinsic element of the composition.

The term "available light" is used to describe all the light, from whatever source, both natural and manufactured, that is not introduced by the photographer. Daylight, tungsten light, and fluorescent light are the three light sources most commonly encountered by the photographer.

Daylight

The major source of available light that photographers encounter is daylight. While the photographer cannot make substantial changes in natural daylight, he or she may have more influence over this source than might be realized.

The most obvious way to control the effect of daylight in an interior is by carefully selecting the time of day during which to photograph. What may determine this will be the exterior view, seen from within. At different hours of the day this view will change as the sun moves. Sunlight also may penetrate into the room, which may or may not be desirable. The lack of sunlight can be a prime consideration and often makes rescheduling the photo session necessary.

Hard Rock Café in Stockholm, Sweden, with and without people.

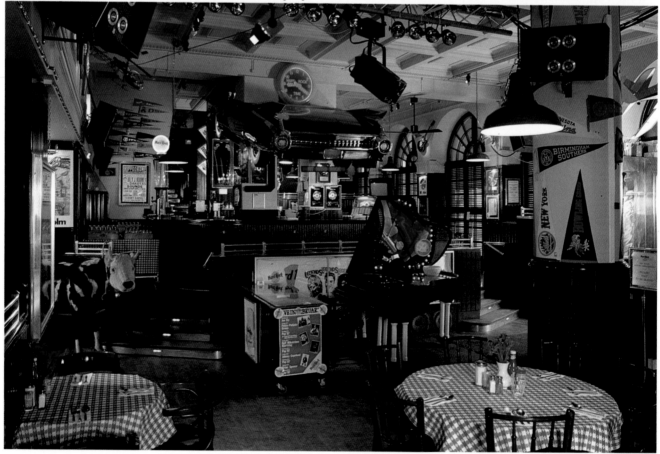

Perhaps the single most important aspect of direct sunlight in an interior is contrast. When evaluating the illumination of any space, it is the evenness of the distribution of the lighting that will determine the photographer's basic approach. Direct sunlight will certainly produce a much greater range of brightness than will indirect natural light. It is also quite likely that a bright but overcast day will produce a softer, more evenly distributed light than a sunny day with blue sky, even in the absence of direct sunlight.

Natural light that bounces off light exterior surfaces, such as snow or sand, is another factor that can be a major influence. Also keep in mind that illumination, natural or otherwise, that bounces off a colored surface is going to alter the tones of other areas. Film seems to exaggerate this effect causing unexplained color shifts, some undesirable.

Daylight has a complex personality. One aspect of this has to do with whether it is warm, yellow/red or cool, blue/green. A scale has been developed for this that categorizes different light sources in degrees Kelvin. This is sometimes referred to as "color temperature." It arranges various frequently encountered light sources, in order, from warm to cool. Candlelight, which is very warm, has a very low 1930°K. Household bulbs are normally about 2900°K, depending on wattage. Most floodlights and quartz halogen bulbs used by photographers for supplemental illumination are 3200°K.

Noontime sunlight is about 5500°K. An overcast day is cooler and may be 7000°K. A bright but partially sunny day may yield a reading of 8000°K or more and a clear blue cloudless day might be as high as 10,000°K or 12,000°K. The range of daylight varies considerably. Sunset and sunrise would be even warmer, around 4000°K. (In their Kodak Professional Photoguide, Kodak prints an excellent color temperature dial which I highly recommend.) The variations in daylight quality emphasize the fact that under certain circumstances the atmospheric conditions may have a very direct influence on the photograph where daylight is its primary source of illumination. Once this is fully appreciated by the photographer, the necessary allowances can be made.

Film does have a nasty habit of emphasizing variations in color temperature when you least expect it. The human mind makes all sorts of adjustments to compensate for variations in the color temperature of light, so that after a few moments in any particular situation it quickly responds to the color observed, uninfluenced by the color of the light illuminating it. Film is unable to make these mental adjustments, so the photographer must compensate for this.

The season also influences the character of the daylight. In winter, when the sun is lower in the sky, the light tends to be somewhat more diffused, since it travels through more of the earth's atmosphere at lower angles, as it does earlier and later in the day. Sunlight will penetrate much further into a space through window and other side openings in the wintertime. Conversely in summer, sunlight will reach further down into an atrium as it passes through skylights overhead.

The direction of the light relative to the direction of the view to be taken is another important consideration. The way in which the natural light enters the space will probably determine what angles of view are feasible with available light only. In most instances a room with a window to the right or left of the camera and another behind will have a combination of side and frontal light. This is an easier situation to handle photographically. Single-window illumination, unless it is large, is likely to be more difficult.

The shape of the room is as important as its general brightness. A long room with a window at one end will be difficult, since the area nearest the source of illumination will be much brighter than the opposite end. The way in which the light bounces around in the room will make a lot of difference too. For instance, white ceilings with light walls and floors will help disperse the light more evenly. A dark room with somber walls and deep-colored furniture and fabrics will be more of a challenge. But even here the most important factor will be the evenness of the distribution rather than the total quantity of light.

The photographer may be able to diffuse the lighting in a space by means of adjustable blinds or perhaps paper roller blinds. Direct sunlight can be intercepted, diffused, and redirected in this manner. This is true both for skylights as well as windows. The narrow-slatted Levolor blind is particularly useful in this respect and can be used like a neutral-density filter on a window. Simple white reflectors, even white towels or sheets, can sometimes be used effectively to bounce window light into the dark areas of a room. Surprising results can be obtained in this manner.

Controlling the mood of the interior is more difficult when the photographer uses natural daylight exclusively. With some spaces it will not be possible at all, but by being sensitive to the variations attainable by diffusion and other methods, experimentation and experience should yield results.

Tungsten

Color film balanced for tungsten (or incandescent) light sources is readily available. Type B film is designed for use with 3200°K light sources, Type A for 3400°K. Slight variations in color temperature from one incandescent lamp to the next, particularly if they are warmer,

are normally not critical. Daylight and tungsten are what I term "compatible," meaning that when photographing with these light sources, the film will record them in much the same way as we perceive them. In a room with predominantly natural illumination, the area around an incandescent light source will appear yellow to the eye when photographed with daylight film. Conversely, within a space primarily lit by tungsten lighting, a small area of daylight will appear blue when photographed using a tungsten-balanced film. When color accuracy is paramount, as in art reproduction for example, and the sources do not precisely match the color temperature of the film, some corrective filtration will be necessary.

A regular 100-watt incandescent bulb, approximately 2900°K, will give a warmer than normal color rendition using an unfiltered Type B film (balanced for 3200°K). This added warmth may or may not be acceptable to the photographer. Higher-wattage domestic bulbs have higher Kelvin ratings, particularly those in the tungsten-halogen or quartz family and are even closer to the rating of a Type B film.

There are two disadvantages with tungsten lighting. One is the generation of heat. Even low-wattage bulbs can get extremely hot and, if not properly ventilated, can ignite or scorch inflammable materials that are inadvertently placed too close. Quartz iodide bulbs, which are also in the tungsten category, get even hotter. For the quantity of light they put out, the quartz bulbs of either the long, double-contact variety, or the shorter, single-socket type are very small. However, the heat built up when they have been in operation for only short periods is considerable. Light fixtures designed for these bulbs can handle the heat, but the wattages used should never exceed the manufacturer's recommendations. This is equally true for photographer's quartz lights. The other disadvantage of tungsten lighting is that it is a fairly high energy user. Some of the more recently developed low-voltage systems are more energy efficient.

Tungsten light sources left on in daylight situations or with electronic flash will be rendered yellow, or warmer, by daylight film. Their relative strength and distribution will determine if this is likely to be a problem. Some magazines object strenuously to running photographs of obviously daylight situations which include light fixtures turned on. One of the few photographic situations where a dimmer can be used without causing problems is a chandelier with small bulbs, included more for atmosphere than illumination which, when dimmed, will create a candlelike appearance.

There may be instances when neither daylight nor existing incandescent illumination predominate and the photographer will have to decide which approach to take. If the balance between the two different sources seems visually reasonable and flattering to the subject, then a double exposure may be the answer. A daylight-balanced film or Type B tungsten film with daylight conversion, (85B) may be used for one part of the exposure with the lights switched off. The second part of the exposure will be with the incandescent sources switched on and unfiltered, if the film is balanced for that light or appropriately filtered if it is not. For the second part of the exposure the daylight should be eliminated, if possible. If it is not, a compromise approach would be a double exposure, one with corrective filtration and the other without and no adjustments to the lighting at all.

When the two types of lighting are well mixed, this approach will give surprisingly pleasing results. Variations of the ratio of daylight to tungsten may suggest different lengths of exposure for the filtered and unfiltered segments. If a Type B film is used and the photographer overestimates the amount of daylight present by giving a longer exposure with the 85B filter, then the resulting photograph will tend to be over-warm in tone. Conversely, underestimation in the same situation will yield overly cool results. So experiment a bit and try a couple of approaches.

Fluorescent

The other commonly encountered available light source is fluorescent. This is more difficult to deal with photographically since film is normally not balanced for this type of lighting and makes corrective filtration mandatory. Fluorescent light is not compatible with either daylight or tungsten; that is, a film balanced for either source will record fluorescent illumination in a manner completely different from the way the human eye perceives it. Both films will render fluorescent bilious green if unfiltered. Correct filtration is essential.

Here we begin to run into problems. There is a wide variety of fluorescent tubes in use. The light they produce is very linear and very diffused depending on the type of fixture used. When the tubes are visible they can produce quite a glare.

Known also as discharge lighting, the tubes contain mercury vapor in combination with a fluorescent coating on the inside of a glass tube. Depending on the nature of the coating, the quality of the light can vary substantially. The wavelength of fluorescent light is totally unlike that of either daylight or tungsten, which is the basic reason that film sees it so differently. A rough classification of fluorescent tubes exists that categorizes the light they emit in various degrees of warmth or coolness. Though roughly equivalent to the Kelvin scale in terms of appearance, it cannot be directly compared

because of the basic difference of the source. Most tubes have the designation warm white or cool white. A table developed by Kodak for recommended filtration for daylight and Type B films is reproduced here. Because of variations in manufacturing, there may be some differences between warm white tubes or similar classifications produced by other companies. These filtrations should only be used as a general guide and whenever possible advance tests should be made.

When other lighting, tungsten or incandescent, for example, is mixed with fluorescent, a two-part exposure using appropriate filtration for each part may be the solution. To do this successfully, each different light source must be switched on independently of the other. If incandescent and fluorescent types are controlled by the same switches, that will make it necessary to unscrew and disconnect individual bulbs for the corresponding exposure. This can be extremely tedious and time-consuming. In situations where a substantial amount of daylight is combined with fluorescent, it may be impossible to control the daylight sufficiently to make double exposures feasible. This presents the photographer with a real dilemma. If a single exposure is made and no filtration is used for the fluorescent lighting, then the result will certainly have a greenish cast, depending on the proportion of that illumination to the daylight present. On the other hand, if the filtration required to correct the fluorescent lighting is used, then those areas where daylight predominates will be rendered with a reddish or magenta cast—certainly not natural or logical in appearance. Either the photographer must wait for nightfall, when the natural light will not be a factor, or the fluorescent light will have to be switched off and supplemental electronic flash used in its place. It is very difficult, if not impossible, to approximate the effect of built-in fluorescent lighting by other means without its being very obvious.

Another approach is the use of the large sheets of gelatin filter that are obtainable through movie supply houses. A filter which converts fluorescent to daylight and another which makes daylight compatible photographically with tungsten are two of the many variations

FILTERS FOR FLUORESCENT AND HIGH-INTENSITY DISCHARGE LAMPS

Fluorescent Lamps	Daylight Films		Tungsten and Type L 3200° K Films	Type A 3400° K Films
	Group 1	Group 2		
Daylight	40M + 40Y + 1 stop	50M + 50Y + 1 1/3 stops	No. 85B* + 40M + 30Y + 1 2/3 stops	No. 85* + 40R + 1 1/3 stops
White	20C + 30M + 1 stop	40M + 2/3 stop	60M + 50Y + 1 2/3 stops	40M + 30Y + 1 stop
Warm White	40C + 40M + 1 1/3 stops	20C + 40M + 1 stop	50M + 40Y + 1 stop	30M + 20Y + 1 stop
Warm White Deluxe	80C + 30M + 2 stops	60C + 30M + 2 stops	10M + 10Y + 2/3 stop	No Filter, None
Cool White	30M + 2/3 stop	40M + 10Y + 1 stop	60R + 1 1/3 stops	50M + 50Y + 1 1/3 stops
Cool White Deluxe	20C + 10M + 2/3 stop	20C + 10M + 2/3 stop	20M + 40Y + 2/3 stop	10M + 30Y + 2/3 stop
Unknown Fluorescent†	10C + 20M + 2/3 stop	30M + 2/3 stop	50M + 50Y + 1 1/3 stops	40M + 40Y + 1 stop
High-Intensity Discharge Lamps				
LUCALOX	70B + 50C + 3 stops	80B + 20C + 2 1/3 stops	50M + 20C + 1 stop	55M + 50C + 2 stops
MULTI-VAPOR	30M + 10Y + 1 stop	40M + 20Y + 1 stop	60R + 20Y + 1 2/3 stops	50R + 10Y + 1 1/3 stops
Deluxe White Mercury	40M + 20Y + 1 stop	60M + 30Y + 1 1/3 stops	70R + 10Y + 1 2/3 stops	50R + 10Y + 1 1/3 stops
Clear Mercury	80R + 1 2/3 stops	70R‡ + 1 1/3 stops	90R + 40Y + 2 stops	90R + 40Y + 2 stops

Sodium vapor lamps are not recommended for critical use. Daylight film gives realistic yellow-amber appearance, tungsten film more neutral appearance.

*KODAK WRATTEN Gelatin Filters No. 85B and No. 85. Other filters are KODAK Color Compensating Filters (Gelatin), sold by photo dealers.

†For emergency use only, when you don't know the type of lamp. Color rendition will be less than optimum.

‡For KODAK EKTACHROME 400 Film and EKTACHROME P800/1600 Film, use CC25M + CC40Y filters and increase exposure 1 stop.

Group 1 Films: KODACOLOR and KODAK VERICOLOR Films, Type S, designed for exposure to daylight.

Group 2 Films: KODACHROME (Daylight) and KODAK EKTACHROME (Daylight) Films.

Film references include professional versions of films.

Note: Increase calculated exposure by the amount indicated in the table. If necessary, make corrections for film reciprocity characteristics, both in exposure and filtration. With transparency films, make a picture test series using filters that vary ± CC20 from the filters suggested in the table. Usually test filter series ranging from magenta to green and yellow to blue are most useful.

available. The filter must be cut in strips and wrapped around the tubes. If the number of tubes to convert is not excessive, this approach may be practical. It is certainly useful in locations where just a few tubes need conversion, such as an interior where the primary illumination is from other sources. Double exposure will then be unnecessary.

The large rolls of gelatin filter will enable a photographer to cover an entire window, converting the daylight to a tungsten equivalent. This permits the photographer to record a space with interior tungsten lighting, 85B filtered daylight, with the windows included in the photograph but without supplemental electronic flash. To reduce the contrast between inside and outside it may be necessary to use a neutral-density 85B combination filter. 85B filters are available in 30-foot rolls with either one- or three-stop neutral-density combinations.

One last approach when daylight and fluorescent are combined is the use of super high speed roll film. Ektachrome 400, when used to photograph interiors where there is a combination of daylight and fluorescent, will give quite acceptable results unfiltered or perhaps with very light magenta filtration (10M). Of course this will only permit the use of cameras using either 35mm or 120 film since this emulsion is unavailable in the sheet film form required by 4 × 5 cameras or larger.

Other Types of Lighting

Though only occasionally encountered in office interiors, another form of discharge lighting, mercury vapor, is frequently used in large spaces, such as shopping malls, atriums, sports facilities, factories, and other situations where a large amount of light is required. Like fluorescent, this type of lighting requires special filtration and if ignored will yield unpleasant and unanticipated results. It is absolutely necessary to identify the exact type of lighting you are dealing with. This category includes metal halide, high intensity discharge (HID), and also sodium vapor. This last type is most widely encountered in street lighting, is uncorrectable by filtration, and will yield a yellow result due to its almost entirely yellow wavelength. The other kinds are correctable, but many require heavy filtration and correspondingly long exposures.

Like fluorescent, mercury vapor lighting is photographically incompatible with either daylight or tungsten. Because it is usually so much brighter than most alternatives, it is not frequently found in conjunction with other systems of illumination, and when it is, it usually overpowers them. Due to the types of interiors in which mercury lighting is used, I think it is true to say that accurate color rendition is likely to be less critical than with offices or homes.

I have encountered mercury lighting in offices mixed with other types that might suggest the double exposure technique. However, mercury vapor bulbs normally take a considerable time to reach operating temperature and maximum efficiency. For this reason, it is inadvisable to switch them on and off frequently, making double exposures difficult. Test whenever possible with this type of lighting. As a last resort, use fast color-negative film and have corrected prints or transparencies made afterward by the lab.

Controlling Existing Lighting

Sometimes the photographer can sufficiently control the available sources to avoid the use of supplementary lighting. Whether or not this is practical may depend on the location of light fixtures relative to the picture area. A ceiling with track lights, even quite bright ones, may easily be included within the frame of the photograph without causing any problems. Track lights often have housings which prevent glare by recessing the bulb or perhaps incorporating waffle grids for the same purpose. As long as there is no direct glare into the camera lens, the photographer need not be concerned. A strong light source, even outside the area depicted, should not be permitted to strike the camera lens or it will diminish the quality of the resulting image.

If there is an area lit by a track light that is too bright, either the fixture should be delamped using a lower-wattage bulb or redirected to a less critical spot. Even if the track is on a dimmer, its use should be avoided since it will change the color temperature of the light, making it appear overly warm in tone. An alternative to relamping is to turn off those fixtures which appear too bright for a portion of the exposure. Unless long exposures are involved, this will require a double exposure. Sometimes the use of aluminum foil wrapped around part of the bulb can sufficiently reduce the output to the desired level. Remember to remove it afterwards because overheating it will probably reduce the life of the bulb if left in position.

Standing lamps with translucent lampshades, included in a photograph will almost certainly have to be modified to avoid overexposure. These lamps may have two or three separate bulbs so it is easy to remove one or more or apply the double-exposure method, switching off for part of the exposure. When lampshades are positioned close to a wall, simply moving them further away may adequately reduce their brightness.

Can lights, when appropriate, are excellent sources of illumination. Frequently out of sight, they can brighten up an otherwise dark corner or highlight an indoor plant when placed beneath, projecting leafy shadows on the ceiling or accenting window openings. They may be used with either reflector floods or spots.

SUPPLEMENTAL LIGHTING

Supplemental lighting falls into two basic categories: electronic flash (strobe light) and tungsten lamps. These two types have distinctive characteristics and specific uses.

Electronic Flash

Even simple automatic cameras now frequently include a winking strobe light. Only the most elaborate of these would be capable of photographing a room and then only in combination with a very sensitive high-speed film. Most of these cameras are automatic and are primarily used for taking snapshots of people or groups. More often than not, the resulting snap will show light-colored figures silhouetted against a dark, gloomy backdrop. Foreground subjects may be well illuminated at the expense of the background. This is a shortcoming with any on-camera light source used directly. For the interior photographer the most useful attribute of the electronic flash is its compatibility with daylight. The average color temperature is in the 6000°K range but may vary somewhat from one unit to the next. This means that the photographer can mix this type of illumination in a space partially lit by daylight without it being apparent. This type of flash will also permit the photographer to balance interior and exterior brightness, including the view outside in combination with the space inside. With the possible exception of blue flash bulbs, this is the only method by which this can be achieved during daylight hours.

Suitable electronic flash units can be subdivided into two basic categories: handheld portable units and large, floor-mounted studio units. Portable electronic flash units do not have to be mounted on or even near the camera. But if they are not, a sufficiently long synch cord must provide the link between the camera and the flash. Only the more powerful portable units may be capable of lighting a room and then only in combination with a small or intermediate format camera, 35mm or 120mm. Powered usually by dry cells or rechargeable batteries, some types may also be capable of using AC sources. These units are now much more sophisticated than they used to be and can be used in a variety of modes—direct, bounced, open flash, or perhaps a combination of these, all producing different effects. In addition, there are varying degrees of automation from the unit-mounted electric eye which cuts down the duration of the flash based on the amount of reflected strobe light returning to it, to the fully integrated electronic flash designed for a specific camera. Sometimes termed "dedicated," this takes light measurements directly at the film plane, curtailing the length of the flash when sufficient light has fallen on the film for correct exposure. With this system, no allowance need be made for filter factors, focusing range, or angle of view since the light has already traveled through the lens and filters to reach the film. Some units also have interchangeable or adjustable heads for use with telephoto, normal, or wide-angle lenses, varying the angle of the flash to match lens coverage.

With the advent of quite inexpensive portable models, blue flash bulbs have become much less widely used. When the absolute maximum intensity of flash illumination is required in a single flash, this can only be provided by large flash bulbs with standard bases for use in regular 120-volt sockets in combination with efficient reflectors. Setting up such a system is time-consuming and the large blue flash bulbs are becoming increasingly hard to obtain. Controlling the output of these bulbs is more difficult than with electronic flash.

In order to compare or rate the potential light output of a portable electronic flash unit, a guide number is provided by the manufacturer. For a particular film speed this guide number, when divided by the distance of the subject from the flash, provides the aperture for correct exposure. For example, a guide number of 110 in conjunction with a 10-foot flash-to-subject distance would indicate an aperture of $f/11$. In theory, the built-in electric eye would select the correct output when the flash head is placed 10 feet from the subject. In this case, the output would be the maximum possible and would have required an aperture of $f/11$, which would have been set on the unit's aperture scale along with the film speed. If the aperture of the lens on the aperture scale had been $f/8$ but other details remained the same, then the unit's automatic control would have reduced output to half, or by a factor of one stop.

The range of studio-type electronic flash units varies even more widely than the portable type. High-output models of the kind required to light the average interior space may weigh thirty pounds or more and become cumbersome to transport. There has been much improvement over the years, however, and the unit that I now use regularly produces over four times the amount of light and is smaller and lighter than its predecessors of a decade ago.

Power output for the large studio units is normally quoted in watt seconds or joules. These models usually have multiple sockets permitting the use of two or more flash heads. Each flash head may then be placed in the optimum position to produce the desired effect. The light output is normally measured with a special strobe meter used in the manner of a regular incident light meter. These meters will indicate an aperture setting for a given film speed. The studio type electronic flash uses regular AC current and may take several seconds to

attain maximum output level. When shooting fast, the electrical load may be considerable, particularly at full power. If a unit trips a circuit breaker, reduce the firing rate and switch to slow recycle; this will reduce the current drain.

Many models incorporate a remote electric sensor. This permits the use of several noninterconnected units simultaneously. Only one electronic flash need be directly connected to the camera; the others will trigger automatically, provided their sensors can "see" the first flash. Similar results can be achieved using radio-controlled devices in place of synch cords.

The bigger studio units are essential when the photographer must use a large format camera, 4×5 and up. The light output, from whatever size flash unit, will determine the lens aperture for any particular film sensitivity or speed rating. The greater the distance the flash has to travel, the wider the aperture of the lens needs to be to yield the correct exposure. If the output is at the maximum, only an increase in film speed will permit the use of a smaller f-stop. Therefore, the size of the area to be photographed will determine the power of the unit required to illuminate it. Various lenses have optimum shooting apertures for maximum sharpness and depth of field. To stay within the optimum aperture range may require the photographer to switch to a faster film, if one is available, or to alternately use multiple flashes to produce the necessary amount of light.

The duration of the flash is very short, even shorter for the smaller portable units, and longest for the studio units when used at full power, ranging between 1/50,000 second for the former to maybe 1/1,000 second for the latter. Since these speeds far exceed the range of shutter speeds most frequently used when photographing an interior partially lit by natural sources, the duration of shutter opening will be unaffected by the use of electronic flash.

Another advantage of the electronic flash is the fact that it generates comparatively little heat. When fired continuously at high output levels it certainly will heat up, but under the normal circumstances of an interior shoot, there is usually no reason to shoot at such a fast rate, as there might be, say, in fashion photography.

Possibly the greatest single disadvantage of electronic flash or strobe lighting is that the photographer cannot see the result on the job. Even with studio-style units equipped with modeling lights that simulate the flash, the ratio of their output to the available daylight is very different and can only indicate the roughest equivalent to the actual flash. Most professionals, therefore, resort to Polaroid tests to help them achieve the right balance between available and supplemental light. Pol-aroid tests also pinpoint unwanted reflections, hot-spots, or undesirable shadows. Special Polaroid backs are now available for the more popular 35mm single-lens reflex cameras so these tests can be performed with the actual lens selected for the final photograph. One disadvantage of these 35mm Polaroid test prints is the small size of a 35mm image. They are difficult to evaluate precisely. When no testing is feasible, I recommend bracketing over at least a one- or two-stop range in exposure.

The alternative to this approach is to use a separate nonautomatic Polaroid camera for testing or a 120 camera like the Hasselblad with a special Polaroid adapter. The resulting test (in this case $2\frac{1}{4} \times 2\frac{1}{4}$) is easier to judge than the smaller 35mm size. When a 4×5 view camera is used, it is a simple procedure to insert a back for 4×5 Polaroid prints (actual size $3\frac{1}{2} \times 4\frac{1}{2}$) in either color or black and white. Certain Polaroid film is closer in ASA rating to the film that is likely to be used so no exposure adjustments are necessary between the test shot and the final version. The test will show the light balance and will allow the photographer and editor or client to study the composition in print form and make any adjustments that are somehow less easy to spot when looking through the viewfinder.

To summarize, the available natural light in an interior will determine the shutter speed for a particular lens aperture that in turn has been determined by the intensity of the supplemental flash. A note of caution: Some older lenses or cameras have both M and X synchronization settings. When using an electronic flash it is the X synchronization that must be used. Also, focal plane shutters may only be used in conjunction with electronic flash units at shutter speeds of 1/30 of a second, or longer. Certain cameras, the Nikon FE-2, for example, are synchronized at speeds of up to 1/250 of a second. With the leaf-type shutters incorporated in some cameras and most view camera lenses, the flash will be in synch throughout their range, provided, of course, that the X-setting is used when appropriate. The M-setting is used in conjunction with flash bulbs that have a relatively long flash duration when compared with electronic flash.

Tungsten

Tungsten light is more flattering than many of the alternatives, especially to skin tones, fabrics, jewelry, food, and many other items. There is also a very high degree of control with this type of light, from pinpoint spots and framing projectors, to very widely distributed, even illumination, hard-edge, or diffused. For these reasons as well as the fact that, unlike electronic flash, it is a continuous light source and therefore much easier to

assess, tungsten is the other basic type of supplemental lighting used by photographers.

Most tungsten photographic lighting is either 3200°K or 3400°K. Simple photo floods, if unmarked, are probably 3400°K for Type A film and home movies. The more widely used Type B film is balanced for 3200°K. The lower-wattage photoflood bulbs are inexpensive and come as regular bulbs requiring aluminum reflectors as well as reflector floods or spots. Bulbs as high as 5000 watts are available for use with extra large reflectors.

Different shape and size reflectors permit the photographer to control the light, diffusing or concentrating, softening, or otherwise altering it. Particularly useful for diffusion purposes are umbrellas. They come in a wide variety of shapes, sizes, and surfaces. Light, either quartz or flash, bounced into a large white umbrella will illuminate a room in much the same way a window might, preserving a natural look and avoiding deep shadows. The larger the umbrella, the less apparent is the direction from which the light is being introduced. Umbrellas have the great advantage of being collapsible, light, and easy to transport.

Regular tungsten bulbs have a limited life and are also fragile. As the lamps get older their light output diminishes and the color temperature drops, becoming visibly yellow. For these reasons, photographers now favor tungsten-halogen or quartz lights. Due to much higher operating temperatures, a higher efficiency is attainable and the color temperature remains constant throughout the life of the bulb.

Many basic fixtures are available. Some have adjustable built-in "barn doors" to prevent unwanted spillage. The barn doors are also useful to control the amount of illumination when used in conjunction with an umbrella or other reflecting surface. Care should be taken that adequate ventilation is permitted so that the bulb does not overheat and burn out.

Quartz bulbs are also available for spotlights. The beam from a spotlight is concentrated and very sharp. Spotlights incorporate a lens and have focusing capability much like a projector. They should be used sparingly as they can easily overpower the other lighting. Wattages for these lamps may not have to exceed 100 or 150 to do the job, even when used with 1000 watts of diffused illumination.

Whatever a photographer's choice of lighting may be, care should be exercised. Do not overload the electrical circuit. If the installation is old, there may be little excess capacity, with fuses rather than circuit breakers. The photographer should check the permissible load of the available circuits and distribute the fixtures sufficiently widely to avoid overload. Carrying spare fuses is a good idea. Always make sure the location of the fusebox or circuit breaker is known and that it is accessible during shooting. Extra long extensions can be useful when distant sources have to be tapped. Sometimes the capacity of a particular circuit can be improved by turning off lights and removing loads that do not directly influence the space being recorded. All electricity-dependent photography equipment should be adequately wired and grounded whenever possible. Always have some adapters handy whenever a grounded plug has to be used in an ungrounded outlet.

One final comment on supplemental lighting. Except in unusual circumstances, I prefer not to use strobe or, for that matter, any major supplemental light source directly. I normally favor the indirect or bounced light approach in which illumination is much more diffused. Direct light yields harsh, almost silhouetted objects in combination with sharp, clearly defined shadows which usually appear unnatural. Bounced light gives much softer results with little or no harsh shadow and a more normal appearance. It may be impossible for the viewer to determine whether supplementary lighting has been introduced or not. This becomes very much a matter of personal preference, and, whenever possible, I approach the lighting of a particular project with an open mind, letting the design dictate the preferred method.

LENS SELECTION

There are a number of factors that the photographer should keep in mind when selecting a lens. Having decided on the boundaries of the photograph, there may be more than one lens capable of providing the necessary coverage. For example, the same lateral coverage that can be obtained with a wide-angle lens from one viewpoint can be achieved with a less wide-angle lens by pulling the camera back further from the subject. However, the resulting photographs will be very different. Objects recorded by a wide-angle lens, when they are substantially off the optical axis of the lens, may be quite distorted and unnatural in appearance. This condition is aggravated further off the axis these items may be and also the closer to the lens they are located.

Off axis, round objects photographed with a wide-angle lens are depicted as extreme ovals sliding out of the composition. (Tables should be tilted to offset this problem.) It is this sort of distortion that illustrates the undesirable characteristics of the wide-angle lens and brings it into ill repute. To solve this problem, select the longest focal-length lens capable of including all that is to be recorded. The particular conditions at hand will permit the optimum choice. I suggest that the photographer try as many variations as the number of lenses available permits. In this way only will the characteristics of a particular focal-length lens become familiar.

Pyramid of the Sun near Mexico City photographed with six different lenses and two points of view.

105mm *F* 2.5 lens.

55mm *F* 3.5 micro lens.

28mm *F* 3.5 PC lens, shifted.

24mm *F* 2 lens.

Another important consideration is the distortion of apparent size. Wide-angle lenses expand the volume of a space. The shorter the focal length of the lens, the more pronounced the expansion. This is the great photographic dilemma: select the lens to show as much as possible of the interior without enlarging it unacceptably. Basically, all interior photography is a compromise. The photographer sacrifices some coverage to prevent the scale of the subject from becoming overly enlarged. There will be instances when the expansion of a tight space is desirable. Not only the space itself will be influenced by the focal length of the lens selected but also the contents of it.

A wide-angle lens exaggerates the size of objects close to the camera and diminishes those that are furthest from it. There are techniques for minimizing this form of distortion. One approach is to show only portions of foreground furnishings that, if shown in their entirety, would be too dominant. The moving of background objects closer to the camera can partially compensate for their otherwise diminished importance. If a long, narrow space is to be photographed, the use of a very wide-angle lens will lengthen the corridor and make it appear almost infinitely long due to perspective exaggeration. Using a longer focal length lens will visually reduce the length of the corridor.

Whatever adjustments the photographer makes must ultimately be determined by what is seen through the viewfinder of the camera or on the groundglass. The photographer must train himself or herself to see what is in the camera and not be overly preoccupied by the reality. When viewing a room, the photographer may know that a grouping of furniture is symmetrically arranged in relation to the fireplace. From the selected camera position, this symmetry may not only be much less apparent but it may be less, or not at all, apparent. And yet, because the photographer knows that the furniture arrangement is axial about the fireplace, he or she may fail to notice that it does not appear to be so in the viewfinder.

This is another reason why Polaroid tests during shooting are so valuable. Even in black-and-white, these tests permit close examination of the proposed rendition in photographic form before it is actually recorded.

Some would-be photographers become so preoccupied with what they are looking at through the viewfinder that they are unaware of the frame and may inadvertently crop out part of their picture, or fail to notice that the camera is not level. Make sure the camera is directed exactly to frame the image that is planned. I usually compose my photographs so that they do not require cropping. Occasionally, I will take a picture that will produce an uncropped image of 4 × 5

35mm *F* 2.8 PC lens, shifted.

18mm *F* 4 lens, with camera half the distance of the other views.

Manhattan apartment at dusk.

or 35mm format (more likely with the former than the latter because of the more elongated shape). Cropping a slide is difficult it must be remounted between glass and 4 × 5 transparencies have to be taped to some other shape should that be more appropriate. Enlargements can be made in whatever shape is desired.

Narrow-angle telephoto lenses will foreshorten spaces, compressing elements so that they appear to be much closer to one another. This can be an interesting way of emphasizing repetitive features like columns or alcoves, pilasters, and so forth. The photographer can draw attention to particular relationships by reducing the distance between them. If only portions of architectural elements are shown, the results may be quite abstract. So the use of the long focal-length lens to focus on details can complement the wider, all-encompassing views used to establish the basic context. The very different look of these two types of photographs will add interest and liveliness to the overall photographic documentation.

The essence of a design may at times only be captured with extreme measures that I would not normally consider. I am referring to the use of the fisheye lens, or more correctly, the full-frame fisheye lens. The difference between the two is that the former creates a complete circular image while the latter incorporates only the central portion of such an image and the edge of the circle lies beyond the frame of the photograph. The angular coverage these lenses provide is very wide, well over 100 degrees, and wider than anything possible using lenses without linear distortion.

With the full-frame fisheye lens there will be distortion and the photographer must use the lens with extreme care or the results will be disastrous. (See the fisheye photos of the Newman house in Chapter 5, pages 65–66.) The distortion will be most extreme at the edges of the frame and least noticeable at the vertical and horizontal optical axes. The image will render straight lines parallel to the picture frame in progressively curved fashion the further away from the optical axis they occur. If the subject has no straight lines near the perimeter of the picture area, the distortion may not be objectionable. Objects close to the middle of the photograph and not too close to the lens may even appear normal with little visible distortion. Round subjects may not appear to be distorted at all.

COMPOSITION

The subject of composition in photography is highly complex and also very personal. All the subjects dealt with in this chapter have an influence on composition. In addition, there are more involved philosophical aspects that the reader should be aware of. When considering a set of photographs, it would be quite unusual to obtain a consensus of opinion on the subject of composition from any sort of diverse group. Taste varies widely and few persons will have exactly the same priorities. The celebrated interior photographer, Jaime Ardiles-Arce, assisted by Thomas Loney, is known for the drama of his compositions. Foreground objects are often very prominent in his photographs and darkness and light are manipulated in complex ways.

Much has been written about whether or not composition can be taught. For many, it does not seem to be a natural instinct. If it cannot be taught, it can certainly be developed. Careful analysis of particularly admired photographs may reveal just what elements contribute most.

My own sense of composition began to be developed in the highly conservative field of the salons of amateur photography promoted by the Photographic Society of America in the late 1950s. The "rules" for success in this field were astonishingly rigid and the formulas predictable. It has always surprised me that in the field of serious amateur photography, unpressured by economics, then, there was a great reluctance to experiment and that the pictorial material produced, even by technically very competent nonprofessionals, was usually very conservative. The photographer should be prepared to ignore the rules should the circumstances dictate.

In his book, *Photography and Architecture* (The Architectural Press, London, 1961), Eric de Mare lists the following five qualities relating to composition: contrast, repetition, balance, climax, and cohesion. Contrast, he elaborates, is between light and dark, solid and void, vertical and horizontal, rough and smooth, plain and decorated, or large and small. Repetition helps to bring unity. In architecture, it may be the repetition of windows or of a cohesive "grammar" of detailing. Balance means equilibrium, placing of the focal climax in the right spot, arranging the elements in the right relationship to one another.

The essential question is: Does the composition feel right? Climax is the dominant, binding point of a composition to which all the other parts are related. The climax will be the center of attraction and will often be subtly concealed. Finally, cohesion depends on the above factors but on something more as well—the story the creator wishes to express, the simple, binding idea the photographer has experienced and wishes to communicate. These qualities are equally appropriate to both interior and exterior photography and also to both black-and-white and color photographs.

DOMESTIC SPACES

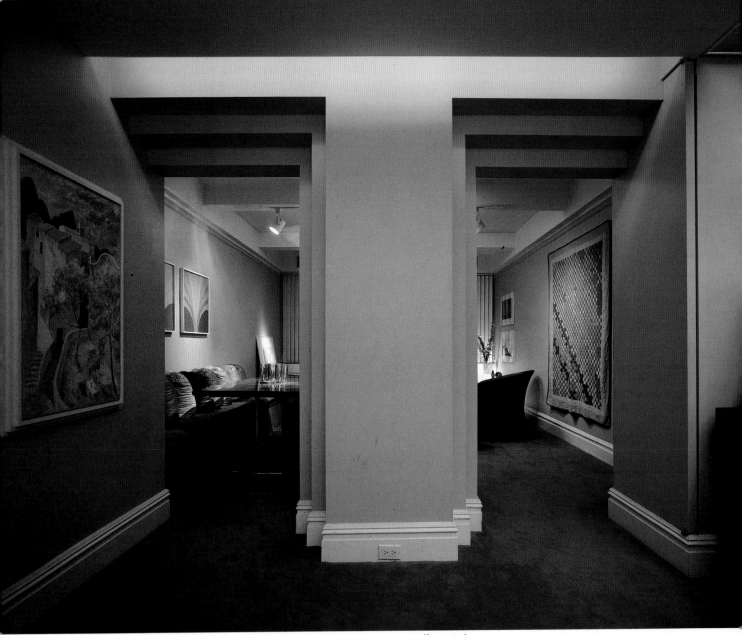

McGrath living room and entrance foyer, New York City. The architect was William Cohen.

Average-Size Living Room in Available Winter Light

I captured the subtle elegance of this recently redecorated, traditional yet contemporary living room by photographing it with available winter light. Between midday and late afternoon, it went from sunny to cloudy to overcast. There was snow on the ground outside.

The even distribution of natural light coming from the eastern and southern exposure windows on adjacent sides of the room enabled me to photograph three basic views without introducing supplemental illumination, using Kodachrome 64 film. The first view was of the sofa head-on with the large window to my left and the other window behind me. The second view was taken diagonally from a point midway between the two windows. The third view was taken toward the fireplace wall, with the large window behind me and to my right and the smaller window also to my right. The direct sunlight did not complicate the situation, since it did

not fall on any area of the room I wished to include. Had it done so, I would have lowered the blinds.

In the fourth and least successful view, where I shot directly toward the main source of illumination, the actual amount of light reduction I achieved by lowering the white blinds was negligible, since they transmit so much diffused illumination.

The exposures for this series were determined with a reflected-light handheld exposure meter of approximately 18 degrees acceptance angle and confirmed by the through-the-lens (TTL) exposure meter built into the Nikon FE-2, 35mm single-lens reflex camera. The shots ranged from 1/4 second ƒ/8 earlier in the day to 1 second, ƒ/5.6 as the light level outside fell. Each shot was bracketed approximately one stop over and one stop under in 1/2-stop increments. Lenses varied from 35mm focal length all the way to the ultra-wide 20mm.

For this first shot, right, I directed the camera to the sofa wall, used one-point perspective, and kept the film parallel to the wall to keep the amount of angular distortion to a minimum. By using a 28mm lens, I was able to include a small amount of the ceiling and the front edge of the cube table in the foreground. Laterally, I wanted to be sure to include a part of the table with the lamp on the left and the doorway on the right. The door was deliberately left open to make a more interesting shape.

I emphasized the symmetry of the foreground table and the sofa and print above it by selecting a camera position on the same axis. For better balance I placed the small table with cyclamens on it to the right of the sofa and then further improved the composition by moving the objects on the cube table around until I was satisfied. Note the jug at right, in profile.

The duck watercolor at the left of the sofa was tilted forward at its right-hand edge to move the reflection from the window away from the center and onto the mount area. Further tilting would have eliminated this reflection entirely but would have been too obvious.

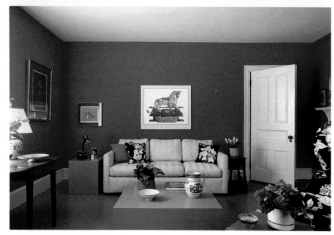

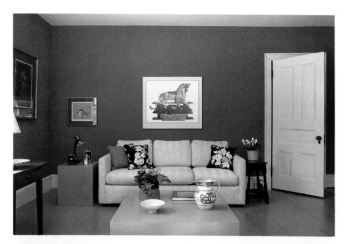

The next photograph, shown for comparison, was taken a little further back with a slightly wider-angle, 24mm lens.

Note first that the room appears bigger in this photo-

graph. Although the cube table in the foreground seems little altered, the importance of the sofa is diminished relative to the overall image and it appears smaller and further away. The graphic is similarly made

less important in this shot. More of the table and lamp and the wall on the left can be seen in this photograph. A small table with flowers, a piece of a wing chair, part of the mantelpiece, and a piece of the right-hand wall also now appear.

There is, no doubt, more information given in this view, but does that make it a better photograph? It really depends on personal preference and the ultimate purpose of the photograph.

Both of these photographs suggest important elements without showing them, illustrating the important concept of *inference*. When only one edge of a table is shown, it is assumed that it stands on the floor and has two or three more legs than are actually included in the photograph. Showing a small portion of the chair at the right edge of this shot is enough for the mind to complete it. From the way the light falls on the table on the left and illuminates the room, it is evident that there is a window beyond the frame of the photograph on that side of the room. Of course, the photographer could also introduce an artificial light at some location to suggest to the viewer a nonexisting natural light source or manipulate the environment in other ways to further control the final results.

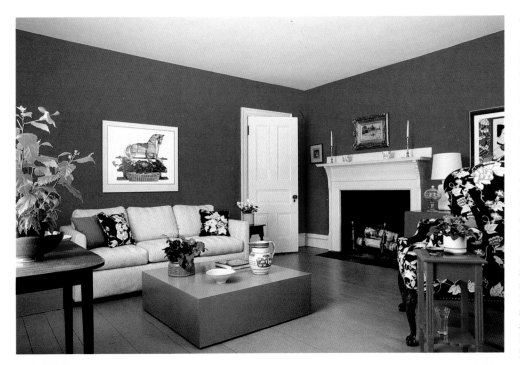

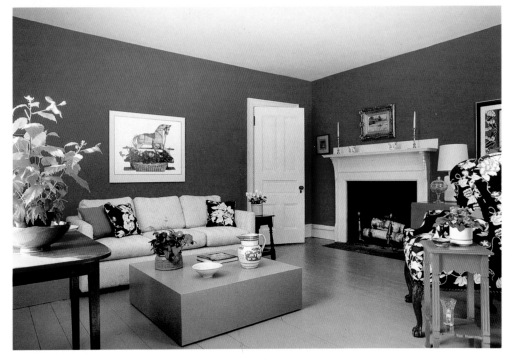

This shot, left, was taken from the corner between the two windows on a diagonal axis. The height of the camera above the floor was adjusted to include the complete base of the table at center. Because I used a 24mm lens I was able to include the whole sofa at left as well as a piece of the table in the left foreground and a part of the painting to the right of the fireplace. Again, I chose to include a portion of the side table at the right and the arm-chair. I carefully adjusted the profile of this chair to mini-mize distortion, show the two front legs, and maintain a rea-sonable position in the room. I also felt that a clear view of the fireplace was important to this shot. White birch logs were added to brighten what would have been a very dark fire-place.

Notice that here the table in the middle of the room ap-pears to be to the right of the sofa rather than on center with it. This illusion is due to this particular viewpoint; the table was, in fact, on the same axis as the sofa.

All the details for the photo-graph left are the same as those for the one above, ex-cept that the window blind was raised. Only the flowering plant at left sits in direct rays of the sun. Sunlight bouncing off the floor in the foreground does light up the red table on the right, but otherwise the overall room is little changed by this adjustment of lighting.

For the third basic viewpoint, top opposite page, I se-lected a point to the west of the south-facing window on the axis of the fireplace. I used a 24mm lens and the camera height was 35 inches above the floor. The film plane was paral-lel to the fireplace wall, keep-ing the junction of this wall and the ceiling parallel to the top of the picture.

The foreground table was moved away from the camera to pick up its near edge. The book on the table was moved to the right, changing places with the round bowl which otherwise would have been

distorted by being so close to the lens and off axis. I chose the low camera position to minimize the size of the sofa by cropping into it. The wing chair was positioned to show only half of it, avoiding the apparent widening of it caused by the combination of the wide-angle lens and its position at the edge of the frame. Care was taken to conceal the lamp cords, and the pillows were adjusted for best color effect.

I improved the composition by rotating the flowers in the foreground, and closing the door. One window blind was lowered to diffuse the southern light and the other was raised to admit more light, particularly that which bounced off the snow-covered ground.

For this second shot, taken from the same viewpoint, center left, I used a 20mm lens and raised the camera position to 37 inches. The position of the chair at right was adjusted again to include only a portion of it. The foreground table was moved toward the camera.

Notice that in spite of the axis of the table and camera being parallel, the table really does not look square since it is so far to the right. Also, the sofa looks disproportionately long in this version and the room size is overly exaggerated. This shot is too wide.

I would not have normally taken the bottom left shot, but it does illustrate the point that without the right equipment the results will be compromised. The shot does not work for many reasons: I had to shoot toward the main source of illumination; the main source of light had to be included within the frame of the photograph; the similar shape and size of the two windows balance too well and make for a boring composition; the focal point of the photograph is a shaded corner occupied by a dark wood chest of drawers; I had to compromise on exposure.

Window areas are so overexposed that even the window mullions are barely visible.

Living Room at Dusk or Night

I took this series of photographs of my own eclectic, nondesigned Manhattan apartment (before it was redone) to illustrate lighting and exposure techniques, rather than to use for publication. The space is used mostly at night, and the room's lighting is calculated to provide a comfortable, low-key atmosphere. I sought to convey the room's warmth by photographing it in late afternoon winter light with no sunlight. Some shots were done entirely without daylight and the daylight inside the room was not a factor.

All the room's lights are incandescent. There is a Japanese floor lamp, two can lights concealed behind the plants in front of the windows, and two lights in the wall unit on the right. Supplemental lighting was provided by quartz lights bounced off either white umbrellas or the 8 foot-9 inch white ceiling.

I felt that the most flattering view of the room was the axial one down the middle toward the two north-facing windows. These two windows are on the narrow dimension of the rather long room. On the opposite side of the room, a wide column separates a small dining foyer from the living room. Unfortunately, unless I settled for an off-center viewpoint, the column prevented the camera from being moved into the foyer, so I positioned it on a tripod directly behind the two Colombo chairs (seen in the foreground).

In order to show enough of the interior, I selected a 24mm wide-angle lens. This lens is rather wide for the proportions of the room, but I felt it was the best choice since my 28mm lens really did not include enough of the room and my 20mm lens included too much and also made the room appear very tunnel-like.

The four photographs illustrate that many approaches are possible and considerable variations in atmosphere and mood can be achieved by varying lighting ratios and/or exposures. Keep an objective in mind and take a series of exposures at different settings to obtain the best results.

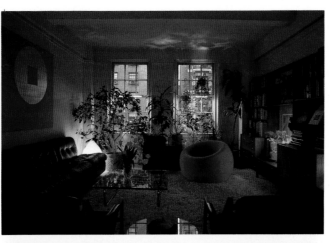

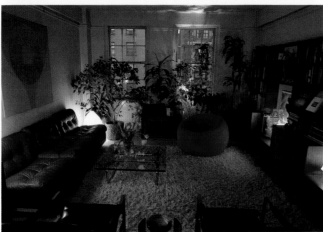

Since there was still some daylight outside when I began photographing, I used Kodachrome 64 Daylight film, for this shot, top right, knowing that the interior would be rendered very warm in tone, or yellow as a result of the incandescent lamps. I used a Nikon F2 camera with a 24mm F 2.8 Nikkor lens. The exposure reading was taken from the window area with a hand-held exposure meter, approximately 1/2 second at f/8. I deliberately exposed the film to highlight the details and to illustrate the latitude.

The view seen through the windows indicates the correct color balance. The two fluorescent plant lights, placed under the windows, were switched on for this shot but were not powerful enough to cause any detectable color shift. Many of the objects have little or no detail and are rendered as silhouettes due to the contrasty lighting.

For the shot at bottom right, I switched to a film compatible with the interior lighting. It was less bright outside when this photograph was taken so the interior appears somewhat brighter. I used a Nikon FE with the 24mm F 2.8 lens, with Professional Ektachrome 50 Tungsten Balanced film, exposed for approximately one second at f/5.6. This film gives the exterior a definite blue cast, and this cool element also gives the interior a more appealing look. Only one additional lamp was switched on to the left beyond the picture area.

I raised the camera to a higher position and moved the foreground chairs and round table toward the camera to give the room a more spacious look. I also moved the glass-top coffee table closer to the camera in order to make it appear centered on the sofa (which it was not). I concealed the white cord underneath the cabinet on the right, but failed to notice that it had reappeared. If I had used a Polaroid test with larger format I probably could have avoided this problem. I didn't use any supplemental lighting for this shot, and the results indicate too much contrast and some underexposure.

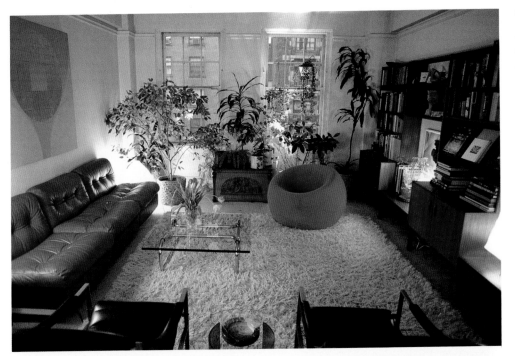

The addition of a 600-watt quartz light bounced onto the white ceiling transforms this shot, top left, into a well-exposed interior photograph. It is identical to the preceding one in every other detail. The bounced light gave a good distribution of illumination. I located the light in the center of the room to avoid window reflections.

Although there was less daylight in this photograph than in the previous shot, it appears brighter due to the longer exposure. The Nikon FE with 24mm *F* 2.8 lens was exposed for four seconds at ƒ/8 with Professional Ektachrome 50 Tungsten Balanced film. The floor lamp beyond the sofa is now perhaps too bright and, in retrospect, I should have put in a lower-wattage bulb.

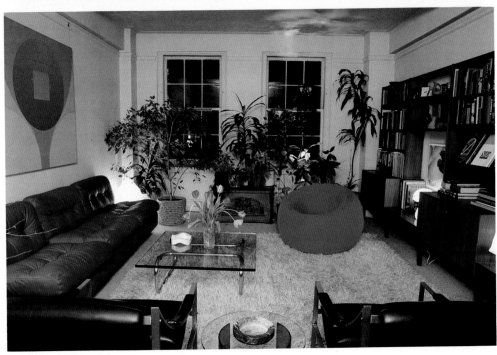

By the time I took this last photograph, bottom left, which is definitely less appealing than the previous two shots, there was no light outside and the windows had become black rectangles. The ratio of supplemental to ambient light had also changed, the latter being less dominant.

I lowered the camera position, readjusted the foreground chairs, pulled the coffee table even closer to the camera, moved the red chair, and tidied up the books and magazines for this final shot. In spite of these "improvements," the end result is not more pleasing than with the other photographs. Do not miss the moment when the interior and exterior are perfectly balanced by fussing too much with less important details.

I again used the Nikon FE with the 24mm *F* 2.8 lens with Professional Ektachrome 50 Tungsten Balanced film for this photograph. The exposure was two seconds at ƒ/8.

Contemporary Interior with Large Expanse of Glass

This living room has a feature that is typical of many contemporary houses: a glass wall which is oriented to a view that is an essential part of the design. When the architect Vuko Tashkovich designed this house in Westchester County, New York, for his own residence, he certainly considered the view as a major element. Tashkovich retained me to document the house for his own use and for potential publication.

The window wall faces south and has a *brise-soleil* for summer shade. When the doors to the dining room are open, natural light floods in from three directions. A clerestory window over an entrance vestibule, not seen here, provides additional natural light opposite the glazed wall. The white walls and ceiling have a non-reflective, matte finish and the floors are polished parquet. The fireplace wall is of granite masonry with open-back shelves flanking it. Opposite the fireplace is a projecting architectural element that springs from the horizontal window mullion and terminates in a half-round column to create an alcove.

The shooting was done on a bright day in May—a soft day, as they say in Ireland—with occasional hazy sunshine. I used the Sinar F 4×5 view camera with two Schneider Super Angulon lenses: 90mm F 5.6 and 120 mm F 8. The film was Ektachrome 64 and 100 Professional Daylight. None of the room lights were switched

The most important single view of the room is the one at right, which is shot directly at the window wall. It flatters the spring foliage and best captures the symmetry of the window mullions. By locating the camera on the central axis, all the horizontal elements remain parallel to one another, reducing distortion which would otherwise have resulted.

The positioning of the two supplementary strobe lights was critical. I bounced each into white umbrellas, one to the left, the other to the right of the camera. To avoid reflections in the sliding glass doors, I opened them. All the glazing is Thermopane—two layers of glass with a vacuum between—so there were actually four layers of glass when the doors were open and this made them appear darker. This was offset, however, by positioning the mesh screens over the open segment.

Each strobe head and umbrella was positioned as far to the left and to the right as was possible without causing reflections. They were aimed high to project their illumination into the room without overexposing the foreground area or sending shadows into the alcove. The camera level provided a normal view of the

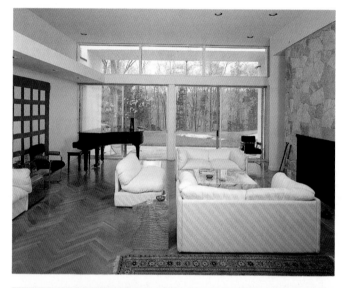

room at about the eye level of a standing person. The photograph was taken with the 90mm F 5.6 lens using Ektachrome 100 Professional Daylight film. The exposure was approximately 1/8 second at f/22.

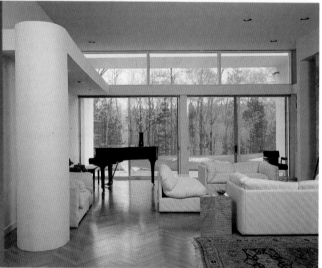

Moving the camera two to three feet to the left and using a less-wide–angle lens produced the variation in the lower photograph. The round column enclosing the near end of the alcove is now a major feature of the composition. I moved further back into the room and lowered my viewpoint. The piano—now almost a silhouette—and the relative sizes of the furnishings are less exaggerated. The left-hand strobe head was moved further in that direction. Its reflection was thus blocked by the column, which permitted me to close the left-hand sliding door. The right-hand door remained open to prevent the other umbrella from reflecting.

For better composition and balance, the lens was shifted laterally to include a little more of the room on the right. The round column is rendered somewhat oval in shape, but the longer focal-length lens minimizes this to acceptable proportions.

on for the shooting. A 5000-watt second Balcar strobe unit, used with umbrellas, provided the additional interior lighting required.

With this kind of interior, the challenge is to get just the right exposure balance between inside and outside light. Too much brightness inside gives an unnatural look, and too little light can result in a gloomy, unappealing photograph. The daytime exterior should look brighter than the interior. It is the level of ambient light inside, however, that dictates the combination of shutter speed and f-stop. The amount of illumination provided by the strobe determines the aperture of the lens according to the particular sensitivity of the film being used; the aperture may change as the strobe output is varied. If small apertures are required, more supplementary lighting will have to be used. The most common problem is the availability of sufficient strobe or electronic flash output. Most of the powerful strobe units are designed for studio use and are heavy and expensive. Smaller strobes may be flashed more than once if no moving objects are in the photograph. If the outside light level changes substantially during the photographing, the exposure may require re-testing. Polaroid testing is invaluable with strobe lighting, because it provides on-the-spot indications of the balance between ambient and supplemental lighting.

The photograph right establishes the relationship of the dining room to the living room, but still retains the relationship to the outside. Shooting the room at an angle made the location of the strobe light much less critical. There are no foreground furnishings to interrupt the flow of one space into the next. The portion of the seating group at the right clearly suggests that there is more of the room in that direction without actually including it. One strobe light was located close to the camera on the left, with a second head further away to the right, both with umbrella reflectors. A third strobe light was added this time, in the dining room. Some highlight from this unit is seen on the left-hand side of the round column.

Sunlight on the end support of the *brise-soleil* washed out that area a bit, but since the trees and other exterior greenery determined the exposure reading for the outside, I had to live with this degree of overexposure.

I shifted the lens to the right so that the convergence of the lines formed by the top and bottom of the wall and the alcove would be reduced. In addition, it forced the optical axis closer to the round pil-

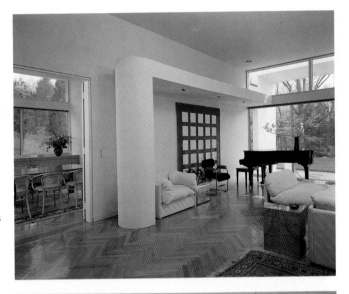

aster and thus kept its roundness intact. (It would not have been too extreme even if I had not moved the lens, since this element was some distance from the camera.)

The 90mm F 5.6 Schneider Super Angulon lens was set at 1/5 second at f/16 using Ektachrome 64 Professional Daylight film. The additional strobe light in the dining room was provided by a 1200-watt second Thomas unit triggered by the main 5000-watt Balcar with the use of an electronic eye. This obviated the need for a direct connection between the units to provide synchronization of the flashes.

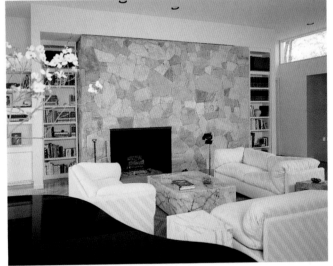

The photograph left focuses on the fireplace wall and the main seating area. Framing the photograph with the silhouette of the piano immediately relates this view to the previous one, enabling the viewer to get a better overall concept of the space. The deliberately out-of-focus flowers provide a softening element.

Two bounced strobe heads provided virtually shadowless illumination in combination with the 120mm F 8 Super Angulon lens. Ektachrome 64 Professional Daylight film was exposed at 1/8 second at between f/16 and 22.

A Large Bed in a Small Space

This is the master bedroom of architect Vuko Tashkovich's modern house in a New York suburb of Westchester County. Tashkovich designed this house for himself and his family and he commissioned me to take these photographs for his own use and for possible publication.

The room, which opens onto a garden and swimming pool, is spare and uncluttered but nonetheless inviting. The frilly borders on the pillows soften the hard edges of the built-in cabinetry and the rounded corners of the bed and the table to the left of it combine to create a harmonious image. The plant on the table disguises some hard edges and balances the bed pillows. Only the four red tulips were added to the collection of family photos and books beside the bed. Several items were removed for the shoot, including the telephone.

I took these shots with a Sinar F 4 × 5 view camera with Ektachrome 100 Professional Daylight film on an overcast but bright spring day. The exposure for all three was approximately 1/15 second at *f*/16 to 22. None of the incandescent lamps in the room were turned on and a 5000-watt second Balcar unit provided the supplemental illumination required to balance the interior with the exterior. I strove to introduce lighting so that it could have come from natural sources in a logical, inobvious way. There are times when dramatic lighting is appropriate but I did not feel this was one of them.

Although the bed is quite large, the room itself is big enough to project a spacious impression and to afford me a number of options.

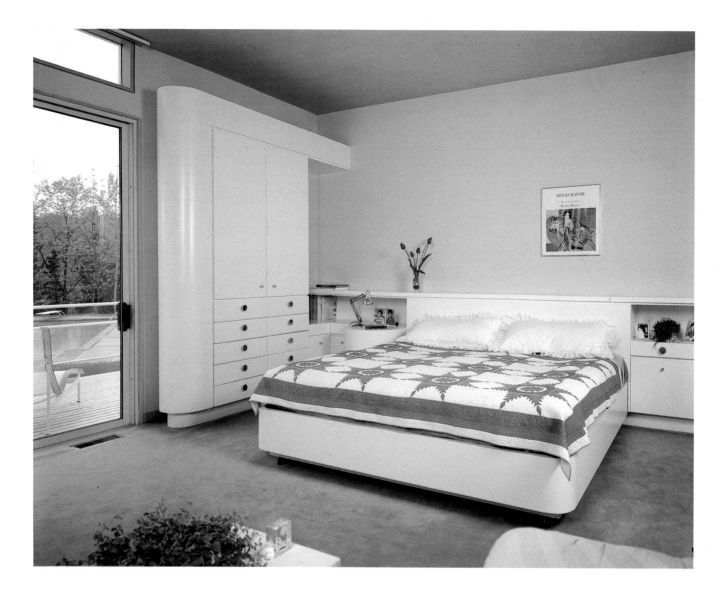

In the first shot, opposite page, I sought to convey the relationship of the bedroom to the deck, garden, and pool. The edge of a chaise lounge was included in the photograph to emphasize the nature of the deck. The viewpoint was low enough to minimize the size of the bed but high enough to retain some of the quilt design. I used the 90mm F 5.6 Super Angulon lens and raised it slightly to determine the number of objects included in the foreground and to show the upper portion of the window. Some left lens shift was used to reduce the convergence of the horizontals and to avoid distortion of the bed.

To produce the lighting I wanted, I used two heads with my 5000-watt Balcar strobe unit. The lights are each bounced off white umbrellas to give a soft, almost shadowless effect. The stronger of the two sources was positioned to my right at about 6 feet, the other closer to the camera on my left at about the same level. The highlights on the rounded end of the cabinet give the viewer a clue as to the location of the unseen lighting positions. The exposure was approximately 1/15 second at f/16.

This next photograph, top right, is an alternative to the first and was not intended to complement it. Much of what is shown is similar but there is less emphasis on the exterior and the picture is more contained. The relationship of the bedroom to the corridor/dressing area is now explored and minor changes were made in the selection of the accessories. The built-in wall unit at left is shown but is less defined at this angle and the cantilevered shelf beside the bed is now better illustrated. The higher camera position displays the quilt nicely but also distorts the shape of the bed more.

I had to select a wider angle lens than before in order to include both the top and the bottom of the cabinet at the left. This lens exaggerated the

size of the foreground objects, so I moved the chairs back and only caught part of an arm, not really enough in retrospect.

I used the same basic lighting setup for this shot as I did in the previous one. I positioned one head with an umbrella very close to the entrance to the room. The second unit is in the corridor. By controlling the illumination of the adjacent surfaces, the curved corner is now visible. Very little, if any, vertical lens movement was used but I did shift the lens laterally to the right to reduce the distortion caused by the converging horizontals.

A 75mm F 4.5 Nikkor lens was used and it was set at about 1/15 second at f/16.

This last photograph, bottom right, was taken to complement the first one, and I have included parts of the same elements to more clearly orient the viewer to the space.

I pulled back as far as possible and framed the photograph by the opening into the room. The right-hand wall coincides exactly with the right edge of the picture. The round dish on the mantle shelf was added for this photograph and helps to offset the blankness of the wall. The lens was lowered slightly to include more at the bottom part of the composition and less ceiling. For added texture I drew the vertical blinds halfway across the window and set them perpendicular to the glass, allowing daylight to enter the room, but not enough to be seen through from the camera's perspective. Part of the *brise-soleil* is visible outside, as is the deck and its railing.

Two bounced strobe heads with umbrellas were again used to provide the necessary additional lighting and balance. One light source was placed quite far to the right on the far side of the bed and the other was moved close to the camera almost above it but slightly to the left.

I used a 120mm Super Angulon F 8 lens and the exposure was approximately 1/15 second at f/16 to 22.

The Many Surfaces of the Kitchen

The photographs of this contemporary-style, complex Manhattan apartment kitchen were taken on two separate occasions for four different clients. The proposed objectives and uses for the photographs varied substantially. My clients were the architect/designer, a general interest magazine, a public relations firm representing the Italian floor tile manufacturer, and the manufacturer of the plastic laminate used for the cabinetry.

These photographs illustrate that the same design photographed with varying techniques and equipment may present entirely different impressions even when done by the same photographer. Clearly, some of these photographs satisfied all the clients' needs. However, each client did have specific requests that had to be met.

On the first day of shooting, a sunny day in early March, I concentrated on the needs of the two manufacturers and the architect. The floor tile had to show to its best advantage for the public relations firm, of course, although it also wanted general views that simply included some floor area. The manufacturer of the plastic laminate was very sensitive to the fact that the counter tops and backsplash were not made with their product, which somewhat limited the usefulness of this project for their purposes. All photographs that clearly showed

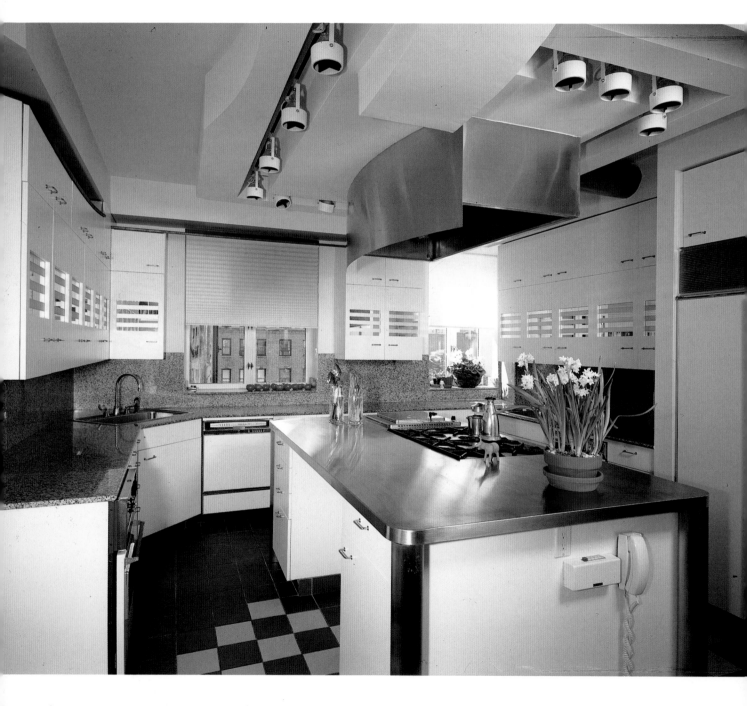

the major features of the design would please the architect. In addition, he wanted some specific detail shots, particularly of the cabinetry.

The second day of photography, an overcast day in early April, was completed at a later date for a "house" magazine or shelter publication, as they are known in the trade. This session was shot in close cooperation with an editor of the periodical, who had a clear understanding of the viewpoint desired. Not only were the angles carefully selected to reflect this image, but all the accessorizing of the kitchen was done by the editor with

little advice from me. (It wanted shots of an "in-use" situation.) The magazine's specific look is now obvious in these shots and there is a big difference between the two published features, which was another one of my objectives.

I used a Sinar F 4×5 view camera with Schneider and Nikkor wide-angle lenses and a Nikon FE-2, 35mm single-lens reflex with wide-angle lenses of 20, 24, 28, and 35mm focal lengths. On the second day I also used a Hasselblad CM, $2\frac{1}{4} \times 2\frac{1}{4}$ single-lens reflex with 80mm, 50mm, and 40mm lenses.

This basic shot, opposite page, shows the most important elements of the kitchen looking toward the windows. The granite counters with backsplash show clearly from this angle, as do the cabinets above. To the right, the photograph includes part of the built-in refrigerator and clearly shows how the island counter sits in the middle of the space. By keeping the accessories to a minimum, the viewer can focus clearly on the design features of the room. Though minimal, the tomatoes, the foreground pot of flowers, and the small terracotta animal provided the necessary color accents. The sunlight in the right-hand window adds some liveliness, but unfortunately did not quite make it to the second window. I did not want to overemphasize the size of the island counter by including some of the flooring, so I raised the lens slightly to show more of the ceiling with the stainless steel hood and recessed light track detail. The camera level was set slightly above the bottom of the cabinets. Most of the basic appliances are included: the range top, the dishwasher, a second oven, and the corner sink.

I used two heads on my electronic flash unit with reflector umbrellas to diffuse the light. One was mounted fairly high to the right. Its location was rather critical because of

the highly reflective, brushed stainless steel hood and countertop below. The mirrored strips on the doors of the cabinets and the glazing would also reflect a misplaced light source. The window blinds were lowered for aesthetic reasons, but also helped eliminate unwanted reflections.

The tungsten lighting was not switched on, because the architect wished to retain the cool white appearance of the room. I would have preferred to turn these lights on to add visual warmth. The supplemental strobe lighting, in any event, would have largely overcome any color shift resulting from the use of a tungsten light source with daylight film.

This shot was taken with my Sinar F and a 90mm Super Angulon, F 5.6 lens and Ektachrome Daylight film. The strobe unit was a 5000-watt second Balcar. The exposure was approximately 1/8 second at $f/16$ to 22.

The shot at right, done for the magazine, was taken from virtually the same viewpoint during the second photography session. This time, however, I used a Hasselblad camera with a square format. The lens selected gives almost the same lateral coverage as that of the first view but includes more vertically. In order to maintain more constant color, I used a Type B Tungsten Balanced film throughout,

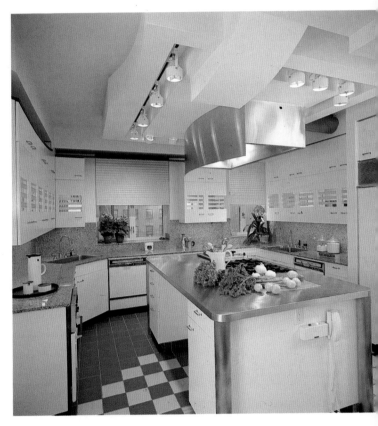

which meant converting the daylight to that standard. This was accomplished by covering the window areas with a layer of 85B gelatin filter material. (If this filter does not lie absolutely flat unwanted reflections will result, so considerable care is required in positioning it.) This time all the lighting was switched on, both the overheads and the counter lights. Supplemental illumina-

tion used was quartz, again bounced into umbrellas to diffuse it. The day was quite overcast, so the window light is rendered rather blue by comparison to the interior, in spite of the corrective filtration.

The lens used on my Hasselblad CM was a 40mm Biogen F 4. The exposure for the Professional Ektachrome 50, Type B (EPY) was 1/4 second at $f/8$ to 11.

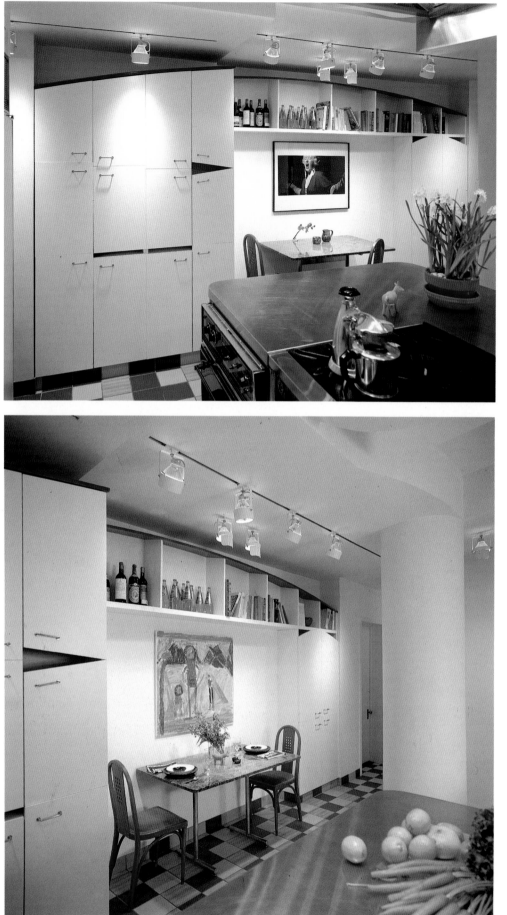

The photograph top left shows the kitchen facing the opposite direction. Shooting over the island counter, a built-in cabinet with a curving top is seen, the line of which is continued by the open bookshelves, forming a shallow arch below the ceiling. A small portion of the tile flooring shows at the left and the photograph is framed by the round column on the right and a slice of the refrigerator on the opposite side. This shot clearly shows the cabinet details, so it was particularly appropriate for the plastic laminate manufacturer.

I shifted my 90mm Super Angulon F 5.6 lens to the right to minimize some of the distortion resulting from the use of a wide-angle lens in a comparatively small space at close quarters. This reduced the convergence of the horizontals formed by the junction of the wall with the ceiling and with the floor and other planes parallel to them. The lens was also slightly lowered to show more floor and to eliminate most of the hood above. Tungsten Balanced Ektachrome film was used in the Sinar F 4×5. Exposure approximately five seconds at $f/16$.

Bottom left is a Hasselblad variation of the previous view, this time moving further from the window wall and thereby eliminating all but a corner of the steel-topped counter. This makes more floor visible and shows the complete breakfast table ensemble. Angling the camera to the right does permit the round column to be included, but now only part of the cabinet is visible. A child's painting has been substituted for the photograph. Lemons and carrots add color to the foreground and place settings enliven the table. Fill-in lighting from the right reduces the shadows below the table and beneath the shelving. It also highlights one side of the column, emphasizing its roundness and simulating the brightness which might have come from the windows. A 50mm F 4 Sonnar lens was used on the Hasselblad CM. Professional Ektachrome 50 Type B (EPY) film was exposed for one second at $f/8$.

I chose a particularly high viewpoint for this photograph, right, in order to show the greatest possible area of flooring. Being closer to the ceiling than to the floor, with the camera angled downwards, produces this aerial view with a fair amount of distortion resulting from the tilted camera with wide-angle lens. No perspective control or correction was possible with the 35mm setup. When an unusual or unexpected camera position is used, the resulting distortion may be used creatively to add impact to the composition. The viewer knows that the refrigerator is basically rectangular in shape and that it does not taper to a narrower width at its base. This distortion is accepted, in part, because the photograph is not taken from a normal position.

Bounced fill lighting with quartz units was used high up and to the right of the camera, as well as low down to the left to suggest a strong counter light. This shot was taken after dark, so there was no daylight to contend with.

The inclusion of the chair in the foreground is important, since it explains the granite surface of the table under which it is pushed. The viewer would not otherwise recognize what this was. Another way of doing this might have been to include a place setting, but the method used seemed appropriate to me.

I used a 24mm F 2.8 Nikkor lens on the Nikon FE-2 with Professional Ektachrome 50 Type B (EPY) film. Exposure was approximately one second at f/8.

The inclusion of a closeup detail within a series of overall shots may add pace to an editorial coverage. It also gives an indication of the attention to quality detailing that sets the good designer apart from the competition. This is the only part of the kitchen where the inset mirror turns a corner. The very clean lines of the solid-core Formica plastic laminate are also highlighted, as is the quality of the granite backsplash and window ledge. This photograph turned out to be the architect's favorite.

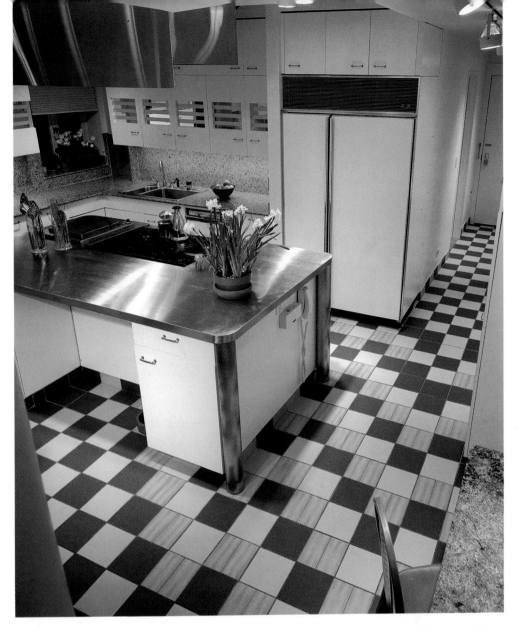

Technically, the most difficult aspect of this photograph was getting everything in focus. The depth of field of the longer focal-length lens was substantially less than that of the wide-angle lenses previously used. This dictated stopping the lens down to a much smaller aperture.

Bounced electronic flash lighting was used with one head directed toward the open shelving with the framed photograph below.

I used a 180mm Symar S F 5.6 lens on the Sinar F 4×5 view camera and Tri-X film. The aperture was f/32 and the exposure one second determined by the ambient daylight. Polaroid tests confirmed the correct balance between supplemental and existing sources.

Complex Spatial Relationships in Halls, Corridors, and Stairways

The entrance hall of a well-designed interior is where the design is first communicated and therefore its documentation on film is of considerable importance. The photographer should have a clear grasp of the subject and the design objectives before shooting.

The photographs I have chosen are of Herb and Edna Newman's New Haven, Connecticut home: a multi-layered, complex, highly individual design. It gave me a large number of alternatives and variations, and was, without a doubt, a highly photogenic space.

This classic-style entrance hall, done in a modern idiom, is the heart and the core of a radiating design. The design is a culmination of many ideas and inspirations of the designer's over a considerable period of time. To get from one room to the next, most paths lead through this space at one level or another. Basically square in plan, it is three stories high with a "flying" stair leading from the second to the third level.

The hallway is virtually flooded with light most of the day. Above the second floor there is a sloping line of glass all the way around, permitting light to enter from the open corners and from the large round openings in the upper part of each wall. A four-foot-wide circulation space runs around at the second floor between the inner and outer surfaces of the tower.

I took these photographs on a bright, sunny, early fall day. Available natural light was supplemented in certain views by a 5000-watt second Balcar strobe unit with two heads. Exterior views of the Newman house are on pages 132–133.

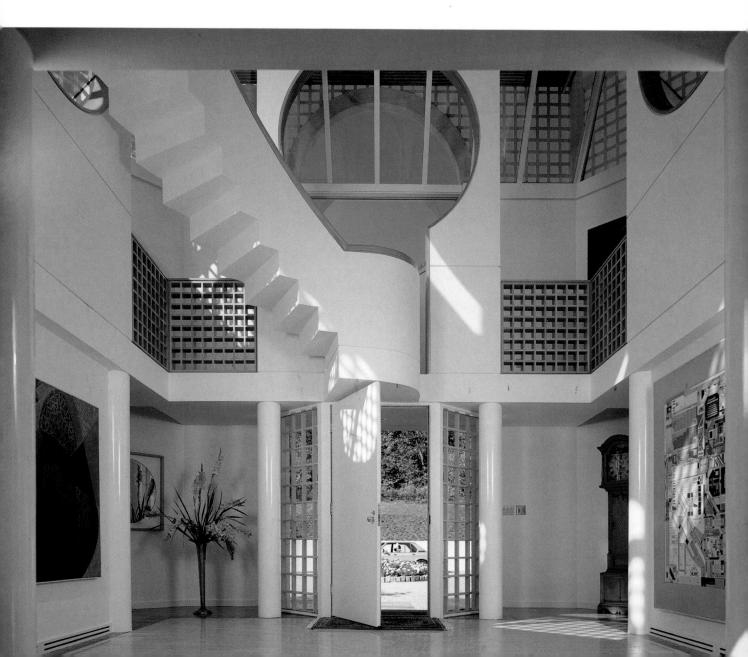

This first photograph, op-
posite page, is of the hall-
way looking toward the front
door, due north. I wanted to
frame the photograph between
two round columns on either
side of the entrance to the
living room. Moving down
some steps into the living
room, I was able to include
both columns and part of the
floor above without using a
very wide angle lens. The cam-
era was approximately three
feet above the hall floor, so I
had to use a substantial
amount of lens rise to show so
much of the upper space and
so little floor.

Being back this far gave me
greater flexibility in locating
my strobe heads with um-
brellas. With bright sunlight
falling in the room the contrast
range was too great for an
available-light-only photo-
graph.

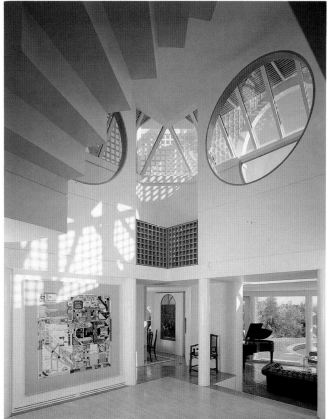

Here, above, is the camera
position and lighting setup
I used in the first shot. Note
that this shows the Nikon
35mm rather than the Sinar F
4 × 5 view camera used for the
photographs reproduced here.
(This shot was taken with the
Pentax 6 × 7 and a full-frame
fisheye lens to show the whole
step.) I left the front door ajar
to see more of the outside. I
moved my car into the back-
ground to conceal an overly
bright section of sunlit white
wall.

I used the Schneider 90mm
F 5.6 Super Angulon on the
Sinar F 4 × 5 with Ektachrome
64 Daylight film. Exposure was
approximately 1/15 of a second
at between f/16 and 22. The
blue of the sky is somewhat
exaggerated by the amount of
lens offset.

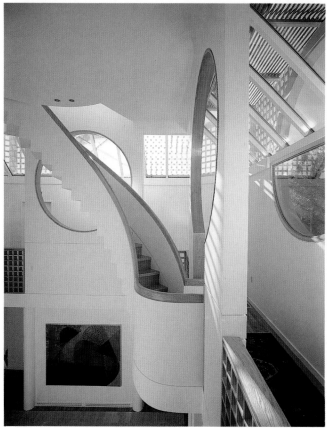

I took this photograph, top
left, looking diagonally into
the dining room. I selected a
high camera position because I
wanted the underside of the
stair to be a major element in
the photograph and because
the higher elevation rendered
the drop in level into the living
room more clearly and ex-
posed more pool and grass.
The photograph is symmetrical
about the diagonal axis. I sub-
stantially elevated the lens to
include as much of the stair as
possible but still retain a com-
fortable amount of floor. I
again used two bounced strobe
lights one on either side of the
camera. The left light was
lowered slightly to better clear
the stair. In addition, another
strobe unit was positioned in
the dining room and it was
triggered remotely with an
electric-eye. Without it, very
little detail would have been
visible there.

I used a 75mm F 4.5 Nikkor
lens on the Sinar F 4 × 5 with
Ektachrome 64 Daylight film.
The exposure was approx-
imately 1/15 of a second at f/16
to 22.

The photographic pos-
sibilities were even greater
at the second floor level. This
view explains much about the
design function of the stair, the
circulation system at the sec-
ond floor, the sloping window
detail, and the relationship of
the outer round windows to
the inner circular openings. By
including both the floor below
and ceiling above, the viewer is
provided with plenty of infor-
mation to recreate and under-
stand the spatial significance of
the design. To lighten up the
lower part of the hall I posi-
tioned one strobe with um-
brella downstairs, slightly to
the left of the camera. A sec-
ond bounced head was situ-
ated at the second-floor level.
This compensated for the
rather strong back lighting in
this photograph.

I used my Schneider 90mm
F 5.6 Super Angulon on the
Sinar F 4 × 5 view camera.
Ektachrome 64 Daylight film
was exposed for 1/15 of a
second at f/16 to 22.

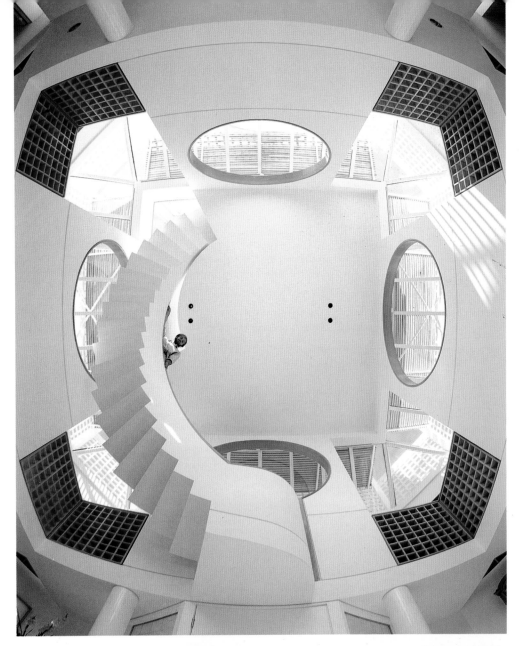

Here, left, is the 120 format, fisheye lens version of the ceiling scape. This lens has an astonishing coverage. It offers much more than the 65mm optic, which is the widest available non-fisheye lens for the 4 × 5 format that does not vignette. Being of the full-frame variety, this lens does not have a circular image, but has a rectangular format which is only the central portion of the round image this lens would produce on larger film. Many people are offended by the curvature this type of lens introduces, so it should be used only in moderation, and, when possible, as an alternative to a normal wide-angle lens version. Note, however, that the distortion is minimized near the center of the image and increased toward the perimeter. I included my assistant for scale.

Ektachrome 64 Professional 120 Daylight film was used in the Pentax 6 × 7 single-lens reflex camera in conjunction with the 35mm F 4.5 fisheye Takumar lens. The exposure was approximately 1/60 at ƒ/8 to 11 and no supplemental lighting was used.

The photograph below left shows the setup for the final upshot. The camera shown here is the Sinar F, not the Pentax 6 × 7 actually used. This shot was taken with the Pentax using the full-frame fisheye Takumar lens. My camera was as close to the floor as I could get it and still attach the reflex viewfinder. Note that I used my gadget bag as a counter weight for the 4 × 5 camera to stabilize it. The exposure was not recorded.

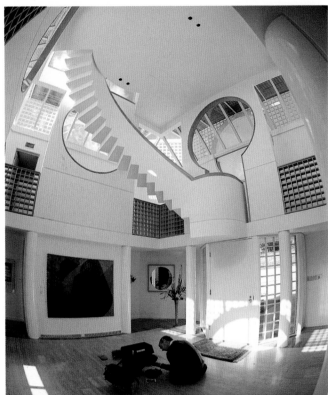

Mirrors in a Tiny Bathroom

There is only a shower stall with small basin in the very compact bathroom shown in these photographs. The upper half of one wall is completely mirrored. Glazed Italian tiles cover all the walls. I would have been able to record only a small portion of the room if the left-hand mirror had not been hinged. The only possible viewpoint was from the entry and because of the lack of downlights, supplementary illumination was necessary.

William Cohen of New York City was the architect for this remodeling project.

All the existing lighting in this bathroom is visible in the photograph. The only location for this lighting was close to the camera and low down. There was barely enough space for a small umbrella to bounce my quartz light into. There was so little room to maneuver that I was unable to use the eyepiece for the viewfinder of my 4×5 camera.

I concealed most of the umbrella's reflection in the tile with towels hung beside the basin. The low-wattage bulbs used here are rather warm in tone compared with the quartz light, which was the correct color balance for the film I used. I could have allowed for this by making a two-part exposure with correction filters for the warmer lights, but I didn't feel the extra time this would have taken was warranted.

I used a 65mm F 4 Nikkor lens with Ektachrome Tungsten film in the Sinar F 4×5.

CHAPTER 6
WORK PLACES

Kleinberg Electric offices in New York City. The architect was Seth Robins.

Diverse Lighting in a Small Lobby

The lobby of this small office in the Hong Kong Bank building in New York City has a combination of perimeter fluorescent cove lights and tungsten recessed downlights. In the banking area beyond the glass doors there are regular fluorescent ceiling fixtures and between the glass doors and the counter beyond are more recessed tungsten downlights. The difficulty here is centered on controlling the different light sources and the inevitable reflections.

The main design features of this small lobby are the highly reflective round column and the ceiling. To increase the impression of height in the space, I selected a low viewing angle and vertical format. The camera position was also dictated by the desirability of showing at least two of the elevator entries and the right-hand lobby wall. The combination of the low viewpoint and the wide-angle lens added a dynamic dimension to the jointing in the marble flooring. In spite of the proximity of the camera to the highly reflective column, the image of me is so abstract that it is not a problem.

I was engaged to photograph this lobby for the architect's portfolio and for possible publication in the design press. The illumination within the lobby is regulated by a computer, and access to the controls was impractical at the time. The only possible control of lighting occurred in the back area beyond the doors. A Polaroid test indicated that the somewhat contrasty lighting would yield a reasonable photograph, and although the background area was overly bright, I knew I could control the illumination of that area by switching off those lights. The tungsten downlights produced pools of brightness on the floor, but had very little effect on the overall light level. Certainly the cove lights provided the predominant illumination and the film had to be balanced for them. The cool white tubes dictated the use of a 60R filter with Type B film. I reduced this to 50R because of the tungsten downlights, which I knew would have a warming effect (because of the heavy filtration dictated by the fluorescents). A second Polaroid test showed a better balance with the background lights switched off for half of the exposure.

A 75mm F 4.5 Nikkor lens was used in combination with the Sinar F 4 × 5 view camera. The lens was shifted vertically to show more ceiling and to include the junction of the column with the ceiling. Exposure was determined by reflected light meter reading of 90 seconds at $f/11$ with a 50R filter and Ektachrome Professional Type B film.

This lobby was designed by architect Der Scutt.

Angle and Design Adjustments in Reception Areas

This reception area of an electronics company, located in the rural town of Puyallup, Washington, was designed by the architectural firm of Henningson, Dunham and Richardson of Omaha, Nebraska. Its ceiling is high and its curving shape somewhat irregular.

I studied the interior for some time before selecting this viewpoint. A stairway leads up to the second floor in the corner opposite the curved seating at left. I considered a view from this stair looking straight toward the seating and out toward the view beyond. However, because of the way in which this segment of the room is enclosed, a high viewpoint gave a cramped and uninviting impression.

I also considered positioning the camera behind the counter, in which case the foreground would have been entirely occupied by this curved form, the curved wall to the right would have been more foreshortened, and the background focus would have been more on the view outside.

All these factors considered, I feel that this viewpoint was most flattering to the space. As I worked, the outside light level increased, altering the balance between the interior and the exterior. This first shot, top right, was done entirely with available light.

The exposure was ƒ/16 to 11 for 30 seconds. I used the 90mm F 5.6 Super Angulon lens on a Sinar F view camera with Ektachrome Type B film for both of these photographs.

For this version, bottom right, I used two supplementary 250-watt tungsten modeling lights with strobe lighting converted to 3200°K with the use of glass shells. With the strobe light and modeling lights switched off, this exposure was 7 seconds, again at ƒ/16 to 11. The tungsten lights in the room were also switched on. Due mainly to the increasing amount of daylight, the two versions are remarkably similar, even though the

ambient light exposure changed so much. By the time this shot was taken the light level outside increased fourfold, or two full stops.

The scalloping effect of the downlights on the wall was a little less obvious when the supplemental lighting was used and the duration of the exposure was shortened. The planter on the left and the blue chair facing the camera also indicate the presence of supplementary light, as does the slight shadow on the wall to the right above the window.

These photographs, opposite page, are of the reception area of the corporate headquarters of Dunfey Hotels in New York City. The architect for this project was Peter Gisolfi Associates of Hastings-on-Hudson, New York.

I photographed this interior on two separate occasions, since at the time of the initial photography the correct chairs for the waiting area had not yet arrived.

The symmetrical design suggested a similar photographic approach. To enable me to get as far back as possible, I decided to locate my camera in the elevator lobby and shoot through the glass into the reception area. This meant having to contend with the logo affixed to the glazing. By carefully adjusting the height of the camera I positioned the lettering so that it did not dominate the photograph or conceal a major design element. I also decided to let it be slightly out of focus. The foreground chairs, borrowed from another area of the office, were angled so they appear to be in a correct position, though they were not.

I wanted the viewer to be drawn into the conference room and beyond so the doors were opened and aligned to produce the least interruption between the two spaces. A plant was positioned in front of the mirror to conceal the reflection of the camera. The conference room blinds were adjusted to admit some daylight but not enough to

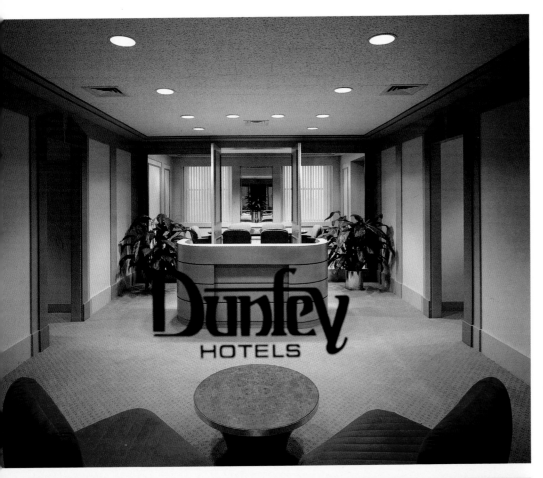

adversely affect the color in the closer areas.

The incandescent downlights provided adequate illumination for the Type B film to be used unfiltered. The windows and surround look bluish in color because of the daylight, but this is natural in appearance and what the viewer would expect in a situation in which these two light sources coexist. The positioning of the chairs blends naturally with the subtle diagonal pattern of the carpeting.

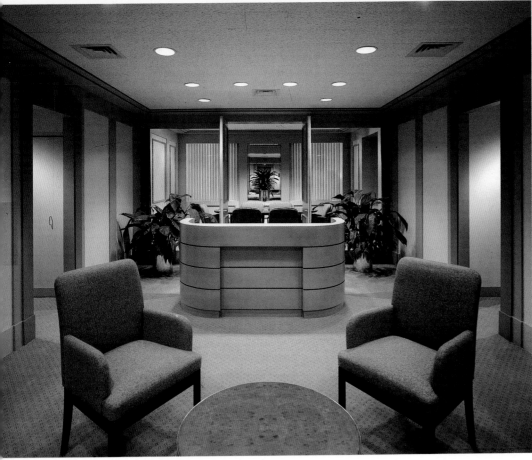

In this photograph, bottom left, the original chairs meant for the design were used. To eliminate the hotel logo, the camera was positioned as close to the glass wall as possible to still permit focusing.

The daylight was much less strong for the second shoot although the vertical blinds were similarly adjusted. The mirror image appears much brighter in this photograph since the elevator lobby lights were left switched on. (They had been turned off originally to prevent parts of the camera or tripod from being reflected in the glass through which I was photographing.) The foreground table was moved closer to the camera to exaggerate its size relative to the chairs because I felt that it looked too small for its purpose in the original photograph. Reshoots do permit fine tuning.

The 90mm *F* 5.6 Super Angulon lens was used on a 4×5 Sinar F view camera. Vertical movement of the lens was minimal, but the cropping of the bottom of the photograph is quite critical both for the tabletop and the front chair legs. Chair legs when positioned close to the camera will appear much elongated when a wide-angle lens is used. Care must be taken to avoid this, even if more ceiling is shown than might otherwise be ideal. Where the format shape is not critical, about half of the ceiling included here could be eliminated without adversely affecting the balance.

Type B film exposed at approximately 12 seconds at *f*/16 to 22. No supplemental lighting was used.

Complex Spaces of an Open Reception Area

This reception area of an architect's office is located on the fifth floor of 65 Bleecker Street in Manhattan, Louis Sullivan's only highrise in that city, completed in 1898 and recently restored by Edgar Tafel.

The space is not self-contained but flows into various other specialized work areas including a glass-enclosed conference room, a receptionist/switchboard station, a filing and secretarial area, with message center beyond, and, on the opposite side, a double-station desk for secretaries of the partners whose offices are located behind glass frontal partitions to the rear.

Large round columns punctuate the space. Above a line of these columns is a pair of parallel, waving, shallow fascias projecting below the ceiling, following the line of the curve-fronted desk below and enclosing a line of green-tinted reflector floods. Carpeting in two colors covers the entire reception area and defines the central core containing the conference room. Bright colors designate the differing functions of areas behind.

Except for some task lighting at workstations, most of the illumination is provided by individual tungsten track lights. The only daylight in the space is what filters through the partners' offices on the perimeter, and that can be controlled by the Levolor blinds.

This is a complicated design with many facets presenting the photographer with many alternatives. No one view could tell the whole story, so I took four.

Film for all shots was Ektachrome Type B, unfiltered and shutter speeds were in the region of 12 to 15 seconds at f/16. I used a 90mm F 5.6 Super Angulon lens on a 4 × 5 Sinar F view camera for the four views on these two pages.

This is the office of Sydney Gilbert and Associates, who also designed it.

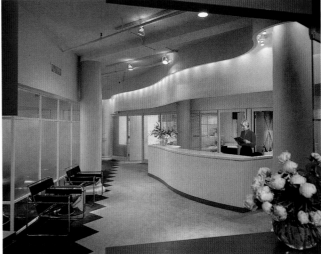

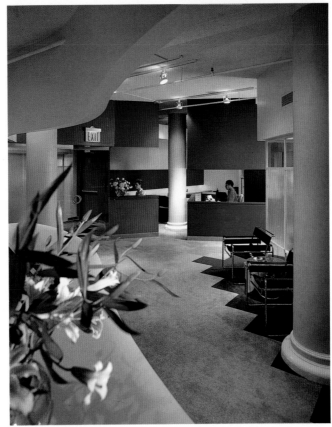

The first shot, opposite page, shows the initial view of the space as seen by the arriving visitor from the small, partially glass-enclosed, elevator lobby. I selected a 75mm wide-angle lens in order to show the complete glass wall and entrance door enclosing the elevator lobby and, in addition, the receptionist's red enclosure wall including the vertical element which links it to the fascia above. The top surface of the reception "desk" is a strong diagonal leading the eye along the corridor into the background. The curving fascia with its strong green lighting also leads the viewer in the same direction. The only illumination in the lobby comes from a fluorescent cove light on one side. Such a small area of the photograph is affected by this light that I decided not to filter for it separately and, in addition, supplemental tungsten lighting was introduced in the lobby to light the flowers and red wall on the left. Some lighting was also added behind the green fascia and in the background offices.

The second shot, top left, moves further into the reception area and uses the glass door to frame the photograph on the left side. The reflection in the door adds interest to the composition. This view looks down the other aisle with the conference room now on the right. I deliberately positioned the dark triangular element in the center of the photograph.

Supplemental tungsten lighting bounced off umbrellas was added to the right of the camera, in the conference room and behind the central elements to make them float more. The selected viewpoint was dictated by the counter height of the reception desk creating a straight horizontal line for the vase of flowers to balance on. Beyond in the background is the drafting area of the office.

The third view, top right, is taken from behind the reception desk looking toward the private offices with the curved secretarial island and fascia above framed by two columns above. The dark green carpet squares flow out of the conference room at left, making a strong zigzag floor pattern which recedes into the background. The photograph is framed by the red fascia and counter of the reception en-closure as well as a small portion of the dark blue partition at the extreme left. The figure was added for human interest, but far enough away to not be overly dominant. Some supplemental tungsten light was added: in the far office behind the flowers, in the conference room, to the right of the figure, in the foreground to brighten the flowers. A small amount of daylight is visible filtering through the Levolor blinds in the private offices.

The last photograph, left, is a vertical looking back at the entrance lobby, showing the reception desk and the blue partition behind it to the right. I wanted to accentuate the curve of the secretarial station in the left foreground and the fascia above. These two elements become strong features of the composition. A nice rim of green light falls on the edge of the desk at left, further separating it from the darker carpeting. The out-of-focus foreground flowers add color and depth to the photograph, but conceal unwanted details at the extreme left and also break up what might otherwise have been too large an expanse of desk surface in the foreground. The two figures add interest in the background. The vertical height of the space is emphasized by the vertical format and the way the view is framed by columns left and right.

Curves and Angles of an Open Office

This project is the corporate headquarters of Best Products in Richmond, Virginia. The space, designed by Hardy Holzman Pfeiffer Associates, contains multifunction facilities, private offices, semi-private and open plan areas with low, modular partitions separating workstations. The offices occupy two floors of a very long, curved building with one exterior wall of glass block which lets daylight into the adjacent areas. This glass block is very green in color but has set into it a pattern of contrasting reflective blocks. A major feature is the tiled "roadway" following the curve of the front facade, down the spine of the building, bisecting the office areas. A highly patterned carpet covers the floor. A structural grid of columns, beams, and ceiling coffers contrasts with the curvature of the building and is strongly expressed in the interior layout.

There are a number of fully enclosed, private, executive offices but for the most part there are no rooms; areas flow from one to another. Workstations with low fabric-covered partitions are lined up along a higher storage element, the lower portion of which is also fabric-covered and the upper part of green painted wood with alternating book shelves and enclosed storage. These spines of storage follow the structural grid and are approximately 9 feet high with an elaborate cornice detail running along the upper edge. The basic ceiling height is a good 12 feet and suspended below it are continuous baffled fluorescent light fixtures bouncing light off the pale-colored, exposed structure of the ceiling (or floor), giving a direct downward component. Dispersed throughout each floor is a series of contrasting wood-finished boxes which house restrooms, service facilities, and small conference rooms. The structural columns are round. Items in an art collection are distributed throughout the building and add greatly to the overall impact.

The photographer must exercise restraint when documenting an interior as complex as this. There are literally hundreds of possibilities. The photographer should therefore analyze the objectives very carefully

The first shot, right, is an aerial view looking over a series of workstations, terminating in a wood-finished "box." The camera height approximates the view of a standing person, just enough to show the partition layout clearly without losing the height of the storage spine element to the left.

I used a 90mm *F* 5.6 Super Angulon lens on the Sinar F 4 × 5 view camera. The rear standard was slightly elevated to show slightly more of the foreground desk and chair and somewhat less ceiling. The available warm white fluorescent lamps provided plenty of even lighting. Type B Ektachrome Professional film was used with filtration of 40R and 10M CC Kodak gelatin filters, which required a one-stop additional exposure increase. Exposure time was about 24 seconds at f/16 to 11 and was determined by meter and confirmed by a Polaroid test.

A variation on this theme is shown bottom right. The camera was moved forward about five feet and slightly to the right. The main result of this shift was to de-emphasize the foreground desk and show the tops of the file cabinets to the right. Aligning the camera

with the center of the middle file cabinet makes for strong converging partitions and ceiling geometry. The two shots are surprisingly different, considering the comparatively slight change in camera position relative to the space.

I concentrated on a single workstation in this next photograph, opposite page, top. This is one of the larger cubicles and includes a small round conference table. This area also has a nice complement of books to help accessorize the space. The photograph was taken in late afternoon in the wintertime, so the level of daylight was quite low. The natural light is still rendered with a reddish cast as a result of the filtration used for the predominantly fluorescent light. Had the level of light outside been higher, the whole area near the windows would have been distorted in color. The pinkish glow in the corner of the workstation behind the telephone is the result of the incandescent desk lamp in the next cubicle having been left on. A similar color shift is also evident in the first photograph, opposite page, top, in the fourth cubicle down. Some lateral lens shift

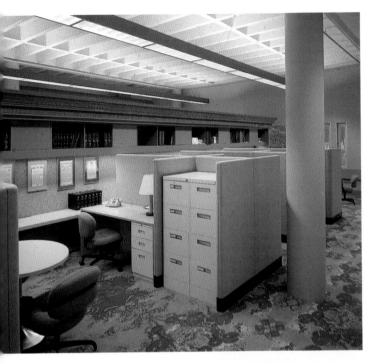

before attack. My brief for the first assignment was to document as fully as time permitted the basic office system. This meant carefully selecting views which illustrated the various design features. Some of the areas were less tidy than others and these were avoided whenever possible. When photography had to be tackled in daylight hours I avoided the locations close to the main glass block facade where daylight would have been a major complication. For the same reason, I avoided areas on the upper floor where a line of small skylights also introduced daylight, as did windows along the back wall of the building. Some of the art work had tungsten spotlights accenting them. In certain cases these were switched off so that the photography could be completed with one source of illumination only. The basic fluorescent lighting system provided more than enough light for photographic purposes without additional supplemental sources. Individual desk lights (tungsten) were provided more for appearance than necessity and were switched off.

to the right was used in this shot to reduce distortion, that is, reduce the convergence of the diagonals.

A 90mm F 5.6 Super Angulon lens was used on the Sinar F. Film and filtration were the same as before.

This view, right, is more of a detail shot, but adds to understanding of the space. As a complement to either of the first two photographs taken longitudinally, this photograph shows the lateral circulation system at right angles to the initial view. It was taken right on the axis of the opening and of the column.

Careful selection of lens and camera position were essential here. To separate the fabric-covered partitions, the camera was positioned above the top of the rounded edges but still low enough to prevent the cornice line of the more distant unit from blending in with the ceiling of the opening. This photograph assumes considerable significance in illustrating how the space works.

A 120mm F 8 Super Angulon lens was used with Ektachrome Type B film and filtration for the available fluorescent light was 40R plus 10M.

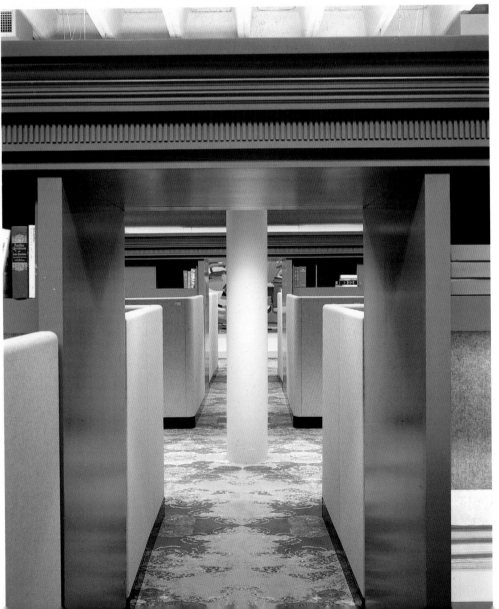

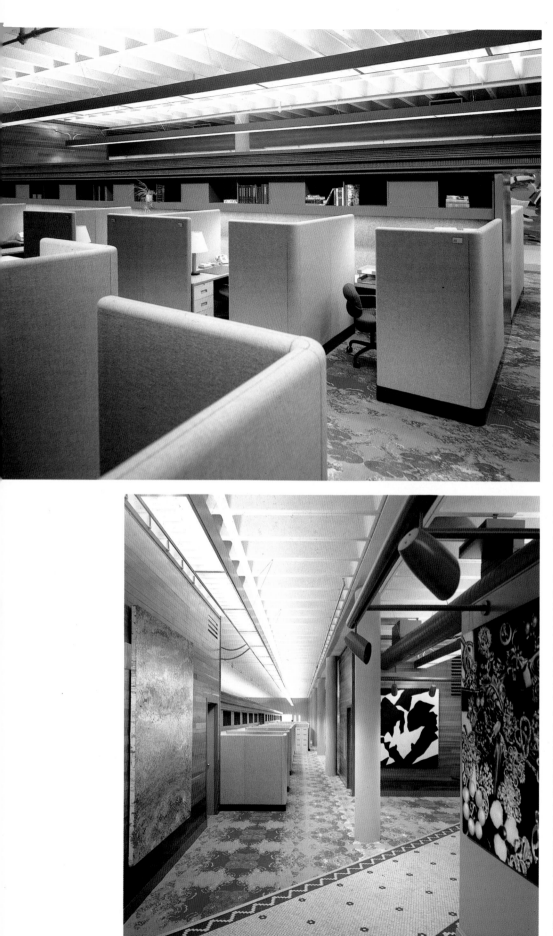

Moving through the opening in the previous picture and turning to the left we get the view, top left. This shows the smaller workstations and illustrates their degree of privacy. Incandescent desk lamps were switched off.

A 120mm *F* 8 Super Angulon lens was used with the same film and filtration as before. Exposure was approximately 20 seconds at *f*/16. I did not feel that the foreground partition being somewhat out of focus was significant.

Here, bottom left, is another longitudinal shot along the structural axis of the columns, lighting, and workstations. The object of this photograph was to show how the details of the design relate to the tiled walkway that curves through the space following the basic shape of the building. Also illustrated is the relationship of the wood boxes to the workstations and how they are used as backgrounds for the artwork. The geometric patterns of the small tiles are in sharp contrast to the carpeting. The camera viewpoint here was selected to show the line of columns receding into the background, the wood box on the right, and the disappearing walkway.

I was also concerned with the artwork both to the left and in the foreground. Keeping the optical axis aligned with my subject, I shifted the lens laterally to eliminate much of the exit sign at the extreme left, while still showing the full painting and also including more of the abstract work to the right. The incandescent picture lights were switched off to avoid two-part exposures which would have been difficult, if not impossible, under the circumstances. In the far distant background there is a bright spot of daylight coming in, but it was too far away to be of any significance. Fortunately, the positioning of the main fluorescent lights provides ample lighting for the art in this photograph. A 90mm *F* 5.6 Super Angulon lens with the same film and filtration as before was used.

Available Light Only

The curved window wall on one side and adjacent straight window wall introducing natural light from a number of different directions, create a somewhat unusual situation for an office. By carefully adjusting each segment of vertical blind, I was able to evenly distribute the natural light across the entire office as well as eliminate the view which would have made it necessary to introduce supplemental lighting with electronic flash. The outside light that day was bright but not sunny. There was a combination of both tungsten and fluorescent lighting recessed in the ceiling; all were switched off for the photography.

The camera position was selected to best show the unusual shape of the area with its radiating workstations and file cabinets. The layout shown approximates that of the original design. However, a substantial amount of furniture moving and adjustment had to be made prior to the photo session, particularly in the far corner where the actual desk position was entirely different. Chairs and plants had to be coordinated as well. The camera was set at about mid-window height so the ceiling junction and the sill below have approximately the same curvature and the workstations are clearly shown from the higher viewpoint.

I used a 120mm F 8 on the 4×5 camera, moderately wide Super Angulon lens in conjunction with daylight Ektachrome film. My exposure was 1 second at $f/22$ and I used a 10M filter for reciprocity. This is the recommended Kodak filtration for exposures in this range and prevents the transparency developing a slightly greenish cast.

This space was designed by architects Russel Gibson Von Dohlen of Farmington, Connecticut.

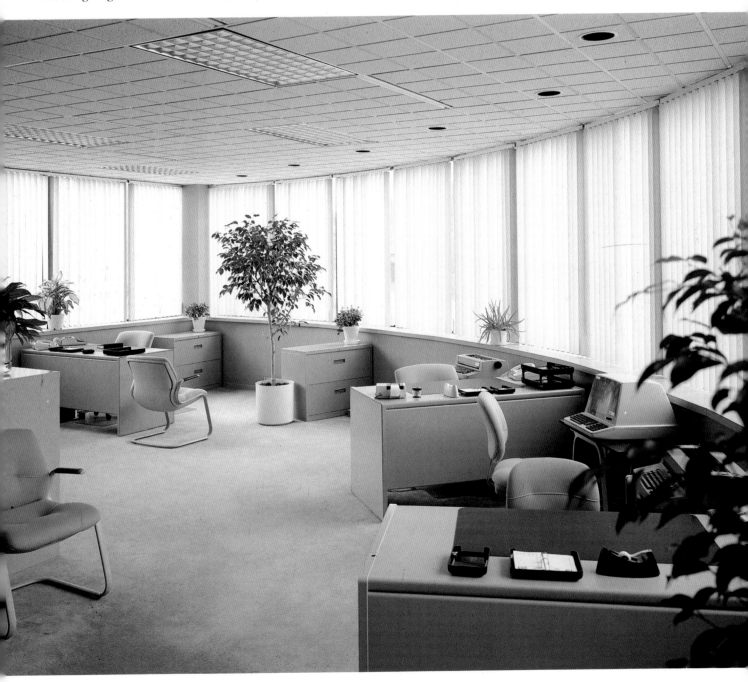

Problems of Scale

This space, formerly a super-market, is now the corporate headquarters and manufacturing facility for Canaberra Labs, an electronics company in Middletown, Connecticut. It was remodeled by architect Glenn Gragg, AIA. The complex is divided into several large open plan areas with high ceilings and powerful HID lighting bounced off the underside of the roof to supply plenty of even illumination at the floor level. Cleresto-ries in some perimeter areas admit daylight. The furniture plan is set on a diagonal axis to the main structure.

I selected a main circulation route, defined by the inlaid panels of carpeting, as the dominating axis for this first photograph, above right. I used two papier maché figures in the foreground for human interest. The bamboo trees were included to soften the composition.

The location I selected was unaffected by daylight, so I had only the HID lighting to contend with. I tried both daylight and tungsten film with a variety of filters based on information I had for standard HID lighting. My initial Polaroid tests confirmed that the ceiling area would end up being very over-exposed in order to produce adequate brightness at floor level. The exposed roof structure and ductwork are quite complex but uniform in appearance. The lighting mounted on the columns does make those areas closest very hot but, because of the generous ceiling height, the reflected light is basically well dispersed. To retain detail in the upper area of the photograph, I used a graduated, neutral-density filter.

I used a Sinar F 4×5 view camera with a Schneider Super Angulon 90mm F 5.6 lens and Ektachrome Type B film exposed for 15 seconds at f/16 with 50R plus 20Y filtration.

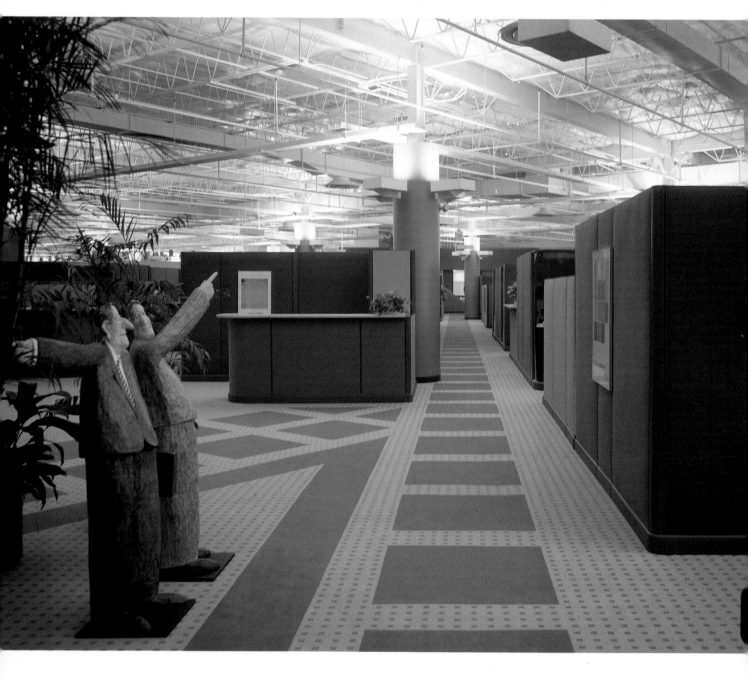

This next photograph, left, taken from a high viewpoint looking over the partitions in to the offices, complements the first one. The high camera position emphasized the lower part of the photograph and diminished the importance of the ceiling, which is now seen at a sharper angle. The lens was lowered to include more floor and less of the structure above.

Again, I chose a diagonal axis but this time at right angles to the main traffic route. By remaining true to this axis, I was able to keep the lines of the partition walls and the carpet pattern parallel to one another.

In the far background to the left, a spill of fluorescent light was rendered greenish. It happened again slightly to the right of the exit sign. I did not feel that these areas were significant enough to require correction, even if it had been practical.

I used the same camera and lens as in the previous shot, but for this one used Ektachrome 64 Daylight film exposed for 2 seconds at $f/16$ with 10R plus 10M filters.

This vertical shot, left, shows the clean window detailing and glass block that was used extensively in the remodeling of this interior and which is also quite a feature of the exterior. The axis of the photograph is now parallel to the main grid which contrasts with that of the partitions. Close examination of the carpet shows that the camera axis is a couple of inches to the left of the foreground planter. The vertical axis of the photograph is more than half an inch further to the left resulting from lateral shift of the lens. I did this to improve the composition by including more of the window wall. I also used lens rise to dramatize the generous ceiling height.

I used a Sinar F 4×5 view camera and a Schneider Super Angulon 120mm F 8 lens with Ektachrome 64 Daylight film exposed for 2 seconds at $f/16$ with 10R and 10M filtration.

Private Offices with Important Views

The views outside these different private offices, one suburban the other urban, were integral elements of the overall designs. My objective in photographing them was to focus on the interiors but at the same time make the most of their outlook.

The first photograph is of an executive's traditionally furnished contemporary office in a modern building. Located in a suburb, the office commands a pleasant view of green trees and grass. I chose the shooting time, which was late afternoon, very carefully in order to have sunlight coming into the room through the blinds in such a way as to best show the view. I used the available natural light and supplemented it as necessary to balance the illumination inside the room with the view outside.

I chose a bright, sunny day to shoot the second executive office located in New York City, so that the surrounding buildings would look their best. The camera position was also carefully adjusted to produce the best composition in combination with the optimum view. The photograph was also exposed in such a way as to balance the exterior and the interior.

For this photograph, I waited for a time when the sunlight would penetrate into the room with the blinds adjusted to obtain the best view. Had I tried to do this earlier, the blinds would have prevented the sunlight from entering from the left side of the photograph.

I supplemented the available natural light to balance the interior illumination with the view outside. The normal artificial lighting inside the room is provided by flush-mounted fluorescent fixtures. Of course, fluorescent light and daylight are not compatible. A dual exposure in this situation would not have been successful because the vertical blinds could not completely seal out the sunlight. For this reason, I used a daylight film and introduced lighting within the room by electronic flash. I used two heads, bounced off large white umbrellas. One head was located far to the right, quite high up. Keeping the source high enabled me to direct the lighting downward onto the desk and darker floor. The blinds eliminated the reflection of my strobe, which otherwise would have been visible in the window. The second flash head was located to the left of the camera.

Exposure determination is critical for a shot like this. The exposure was 1/8 second at *f*/16. The lighting inside the room from the electronic flash combined with the ambient daylight will determine the duration of the shutter speed for the particular aperture selected. (A flash meter is necessary to determine the required aperture.) The exterior exposure can be measured directly with a regular light meter. There are some meters that will provide both settings simultaneously. The trick here was to balance the sunlight falling on the carpet inside the room and the view outside. It may be necessary to overexpose the outside view somewhat to obtain the desired amount of sunlight on the surfaces within the room.

When the window light is very bright, it may not be possible to see the reflection of the strobe modeling lights, even when they occur within the frame of the photograph. Flashing the strobe unit while looking through the lens may be the solution to this problem, although the short duration of the flash makes this difficult.

The only sure way to check for unwanted reflections is with Polaroid tests. When possible, the test exposure should be made at the same setting as the final shot so that the light ratios are similar and so that depth of field and sharp focus may be checked also. For this reason, I favor the use of Polaroid Type 55, positive/negative which has an ASA rating of 50.

I may decrease exposure half a stop for the final shot when using Ektachrome 64 Daylight film. I have found that if the Polaroid test result is satisfactory, no further adjustment is required to produce an accurately exposed Ektachrome transparency. If the Polaroid negative (which I normally do not keep) is properly washed immediately after development, it may yield a good quality negative suitable for enlargement. Some high-speed Polaroid emulsions, while good for some purposes, require substantial filtration to reduce them to the equivalent

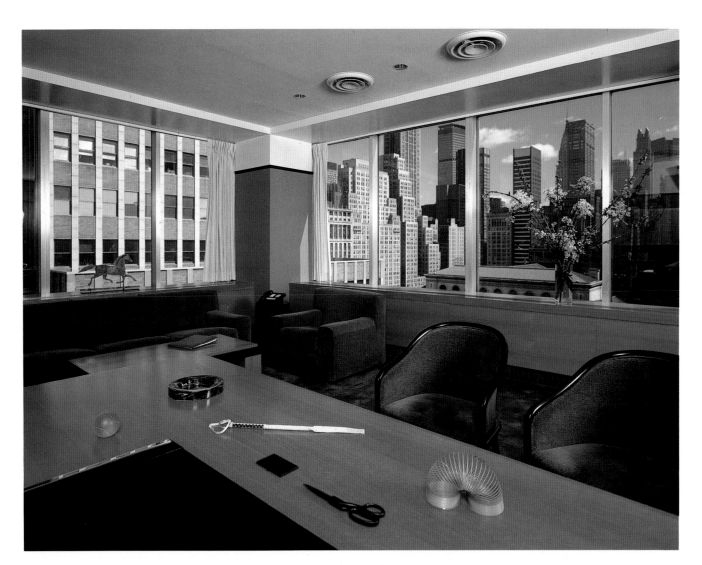

sensitivity or ASA rating for Ektachrome I use and should, therefore, be avoided.

The fact that sunlight is falling onto surfaces included in this photograph will limit the variation of possible shutter speeds that will yield satisfactory results. If there were little or no sunlight to contend with, then a wide variety of results could be obtained by varying the shutter speed without materially affecting the rendition of the interior since it is primarily illuminated by the electronic flash. Reflections of skylight or other bright areas outside on surfaces within the room will be affected by the length of the exposure, but not much else. The photographer will soon realize that a wide variation of effects is possible just by changing the shutter speed. A dull or overcast day can be made to appear much brighter or, conversely, a very

bright situation can be underexposed and made to seem much less so. Where Polaroid testing is not possible, the photographer should bracket exposures and use different combinations in order to ensure the best results.

Designed by architects Russel Gibson von Dohlen of Farmington, Connecticut.

This photograph is the private office of a corporate executive of a textile company. The office overlooks Bryant Park and the New York Public Library, an obviously prestigious location. A weekend was selected to shoot the job to permit the necessary cleanup and cause a minimal amount of disruption of the normal work schedule. Also, I wanted to photograph on a bright and sunny day. I was blessed with ideal conditions, clear, crisp light with white

clouds dotting the blue sky.

The general tones in this office are quite dark. The carpet, chairs, and sofa are dark gray. The desk, table, and enclosures below the windows are all a natural, rich wood finish. A few carefully selected items are shown on the desktop with a dark writing pad in the foreground to break up what might have otherwise been too large an expanse of wood. An arrangement of blossoms was placed on the window ledge, making sure no important feature of the view was concealed. A striding bronze horse adorns the adjacent window. The curtains were stacked as neatly as possible on either side of the corner column. My two strobe heads were positioned so that the reflections of their umbrellas fell just beyond the frame of the photograph. The room lights were kept

switched off but would have been overpowered by my electronic flash anyway.

The unexpected dividend in this photograph is the abstract quality which results from the clarity of the urban mural which looks almost too perfect to be real. Ordinarily I might have overexposed the exterior to produce a more normal effect, that is, with the outside much brighter than the interior. But by balancing the two elements of the composition I was able to achieve something more interesting. I was helped in my task by the fact that the colors of the buildings complement the interior furnishings. The right-hand chair was partially cropped to reduce its otherwise exaggerated proportions due to its proximity to the 75mm Nikkor F 4.5 wide-angle lens on a Sinar F.

This office was designed by Paul Segal and Associates.

Inclusiveness in a Small Space

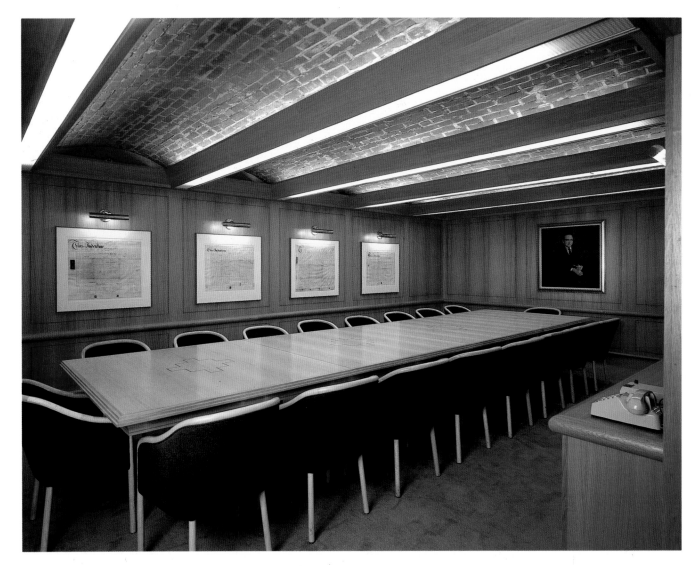

This law firm's conference room was created as a result of the restoration of an old Connecticut office building. The pre-existing barrel-vaulted brick ceiling structure in the basement became a major feature of the new space. A long, three-section table was custom designed for the wood-paneled room. The old brick ceiling, now nicely illuminated with warm white fluorescent lights, is comfortably incorporated into the contemporary setting. Each framed document is illuminated with its own tungsten picture light.

The main illumination, although quite adequate for conference purposes, did not illuminate the end walls, the portrait of the firm's founder, or the blue chair backs. Sup-

plemental lighting was, therefore, introduced. Fortunately, the white waffle beneath the fluorescent enclosure prevented glare, and the picture lights accented the documents on the main wall to the left. The portrait, however, is very dark in tone and does not have its own lighting. A small spotlight was used to brighten this painting. Focused exactly within the frame, the viewer barely perceives its presence. It was not possible to place a light in the right-hand corner of the room to the right of the portrait without unwanted reflections.

For my main source of supplemental lighting, I used a quartz halogen 1000-watt flat reflected into a white umbrella to diffuse it. This was placed to

the left of the camera. Care was taken to prevent this light from overpowering the existing room lighting. It was baffled down accordingly. The main bounced light was kept fairly low to lighten up the chair backs and to throw more light upwards into the brick vaults. Because of the mixture of two noncompatible light sources, a two-part exposure was used. For one exposure, the fluorescents were turned off and only the series of framed documents remained illuminated in addition to my supplemental lighting, the spot on the painting and the bounced quartz light to my right. All these lights, being essentially tungsten, required no filtration with the Type B film used. The second exposure was with the

fluorescent fixtures only and, for this part, a filter combination of 40R and 10M was used.

The camera height was set low enough to clearly show the ceiling structure but high enough to show the wood inlaid pattern on each section of the table. I left the tabletop bare. The chairs were pulled away from one another. (Chair positioning makes all the difference when photographing a conference room. Not only should the chairs match, but they should be adjusted to the same height and their bases turned to orient them in the same direction.)

The picture lights were also carefully aligned and adjusted to exactly the same angle to give equal brightness. The telephone was moved to the end

Shooting through Glass

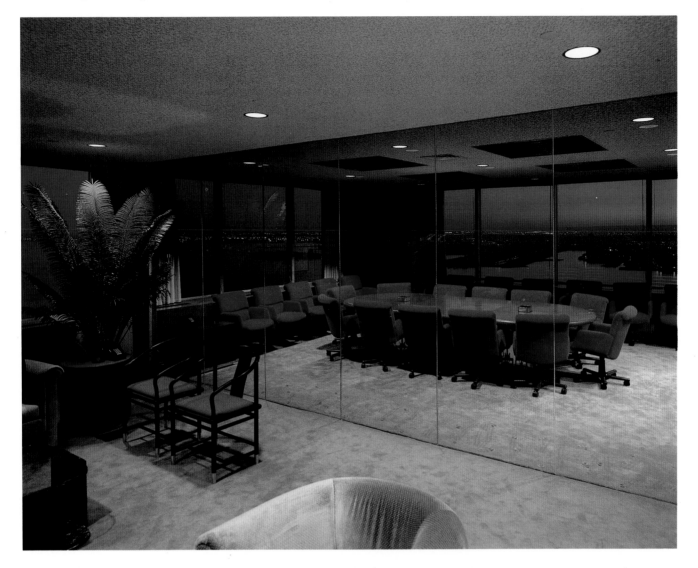

of the built-in cabinet to add a little interest. The 90mm Super Angulon F 5.6 lens was offset to the right to reduce the convergence of the edges of the table, making them more nearly parallel. This offset also renders the back wall more natural in appearance by reducing the convergence of the line at the top of the wood paneling and the chair molding below. The camera was positioned as far back as possible while still showing the full table and enough end wall to the right of the portrait to produce a properly balanced photograph. Inclusion of a piece of the door jamb in the same wood as the paneling suggests the continuation of this paneling along the wall to

the right (not seen) above the built-in cabinet.

The architect for the Cohen and Wolf law offices in Bridgeport, Connecticut was Herbert Newman and Associates of New Haven, Connecticut.

The challenge in making this next photograph, above, was to capture the magic of the dusk skyline and balance it with the interior illumination. This was complicated by the fact that the conference room is separated from the lounge area by a heavily filtered glass wall. It was through this glass wall that the conference room and the view had to be recorded. The amount of glass tinting is apparent from the change in color of the carpet

inside and outside the conference room. It is actually the same color.

The fluorescent fixtures over the table in the conference room were much too bright for the situation so I switched them off. Exposure readings and Polaroid tests indicated a substantial variation in brightness between the foreground and the area beyond the wall. Some bounced supplemental tungsten light was added inside the conference room, but not enough to make it obvious. A long exposure was then made with all the foreground in darkness. A second, shorter exposure was made on the same film with the nearer lounge area illuminated. Starting with substantially more

light outside, several exposures were completed as the light level dropped. Finally, a couple of exposures were made with no interior lights on at all, exposing for the view only. These were three-part exposures, again exposing separately for the conference area.

Ektachrome Type B film was used for all exposures, unfiltered. The outside has that very rich blue look that results from using Type B film unfiltered in a predominantly daylight situation. The hint of sunset also helps. A 90mm Super Angulon F 5.6 lens was used on the Sinar F. Exact exposures were not recorded.

This Bankers Trust office is in New York City and is the work of I.F.A.

PUBLIC SPACES

House of Worship for the Baha'i faith, New Delhi, India (right). Ceiling detail (left). The architect was Fariburz Sahba, with structural design by Flint and Neill of London.

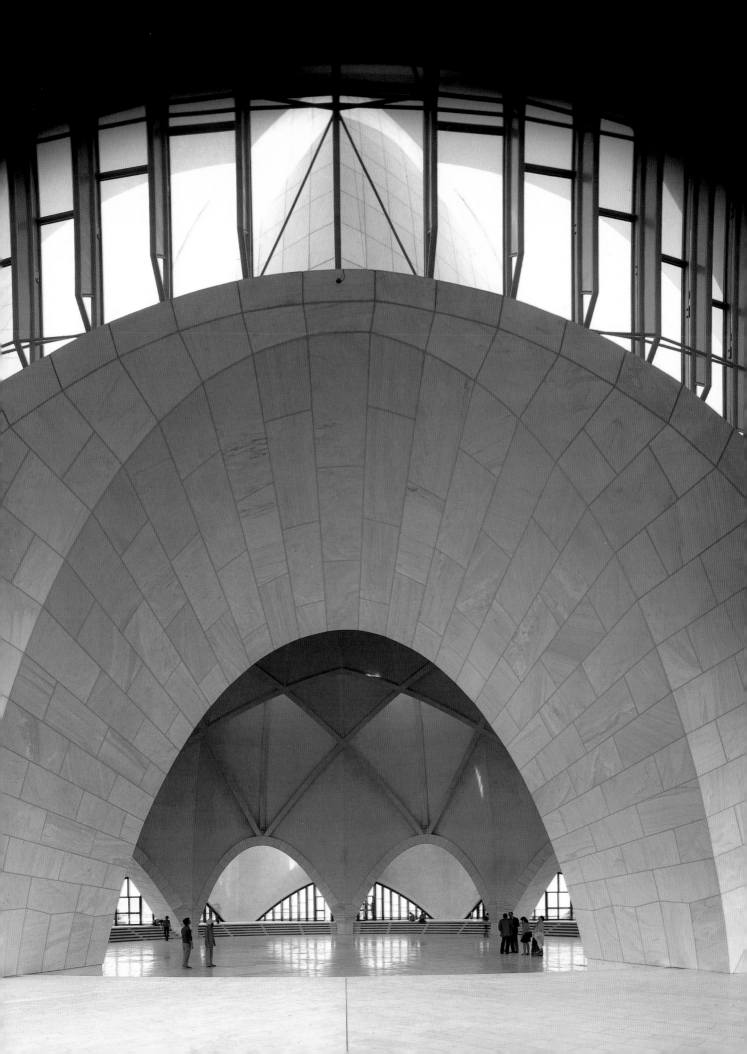

RESTAURANTS

Restaurant interiors can be particularly challenging for the photographer for a number of reasons. To achieve the desired ambience, the design of a restaurant frequently relies on low levels of lighting in combination with dark colors for the interior finishes. Some of the illumination may be provided by candlelight or low-wattage bulbs which produce yellow-toned light. Velvet and similar fabrics in dark tones tend to look almost black when photographed and the contrast with light-colored tablecloths and napkins can be extreme. Even when bright lighting is installed, it is usually used only in the daytime and is frequently dimmed to low levels to produce the right atmosphere, which is rarely suitable for photographic purposes. One of the problems with dimmable light sources is that the color temperature changes as the light level is lowered, resulting in even warmer or yellower transparencies. During daylight hours it may not be possible to control the natural light and this presents further problems.

Quite apart from the lighting problems, there are logistic difficulties to contend with. The restaurant may be open six days a week for lunch and dinner, with photography practical only on the seventh day. Worse still, the establishment may function continuously, making photography possible only in the middle of the night or in the early morning after closing time. This is a strain on everybody.

There are good reasons why photography should not be attempted when food is being served to paying customers. Taking photographs of a functioning restaurant immediately produces situations that are beyond the control of the photographer and limits the options. If the scale of the design is modest, the presence of people makes the task of capturing the major design objectives a lot more difficult, if not impossible. From a practical standpoint, the only chance of success is a combination of small format with very fast film.

Whenever the shoot is scheduled, it is essential to have the management's cooperation to ensure that the place is basically clean. Nothing is more annoying than having to waste time cleaning up, particularly when it could have been done much more efficiently by the regular staff. An advance check should be made to be sure that all light fixtures are functioning correctly and that the switches are accessible. If the bar area is to be included, ask that the bottles not be removed. Have clean tablecloths and napkins available and, if necessary, have an iron on hand. Watch for tables on which cloths are unevenly placed; these give an off-balance appearance. Whenever possible involve the restaurant staff to check the place settings and table decor. It's easy to miss an item that may be obvious only in the completed photographs. If the designer is not going to be present at the time of the shooting, a floor plan can be helpful to crosscheck the table layout since the restaurant owner may have modified the original plan for practical or other reasons and the designer's positioning may be aesthetically preferable for the photography.

Photographs of a restaurant interior can sometimes be enhanced by the inclusion of a food display. Advance arrangements are necessary for this, and the chef will almost certainly want to be involved. Purists may not feel that this is within the realm of design documentation, but there may be times when the inclusion of an elegant display is appropriate and desirable. Floral arrangements should not be neglected. A fresh flower or small bouquet on each table, for instance, can add warmth and touches of needed color.

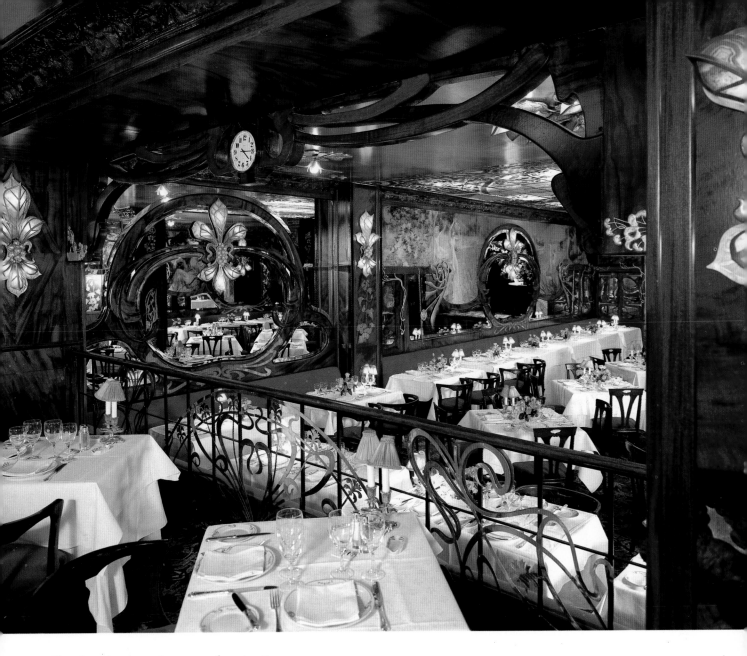

Clarity in an Atmospheric Image

The clock indicates 4:15 and that's A.M., not P.M. The photograph shows the New York version of Maxime's. Based on the original Paris night spot, the decor, ornamental light fixtures, murals, and inlaid brass metalwork were all recreated for this larger-than-life Manhattan rendezvous.

This view from the elevated section of the main dining area purposely excludes the small dance floor and stage beyond to the right because the stage looks very empty without musicians and because the contrast range is too great with only the basic lighting.

A small portion of the luminous ceiling over the dance area is seen above to the right. The light is provided by fluorescent tubes which can be switched on and off in sections, giving some control of the brightness. The ceiling is multicolored but leans toward magenta, one of the major components of the corrective filtration required with a tungsten-balanced film. For this reason, I did not make a multiple exposure (switching the different light sources on and off and changing filters) to obtain the correct color. The small table lights are low-wattage units, some of them battery operated, which produce even less light than the regular 110 volt a.c. fixtures. Positioning of the supplementary quartz lights, bounced into umbrellas, was complicated by the mirrors and shininess of some of the surfaces. Portions of the space that are seen only in reflection must also be illuminated. I kept my lights fairly low to reduce the amount of additional brightness on the tabletops and directed as much light as possible on the dark walls.

In retrospect, I could have turned the table in the foreground to make the back edge parallel to the bottom of the picture and thus eliminate the apparent slope of the tabletop. A smaller aperture in combination with longer exposure would have increased foreground sharpness, but I was more concerned with the balustrade and the area beyond.

I used Fuji 100 Tungsten-Balanced film to produce a warm-toned image, a 4×5 Sinar F view camera and a Schneider Super Angulon 120mm F 8 lens. Exposure was approximately 24 seconds at between f/16 and 22.

The designer of the interior is Janco Rasic, AIA, of New York City. The photographs were done for portfolio use and prospective publication.

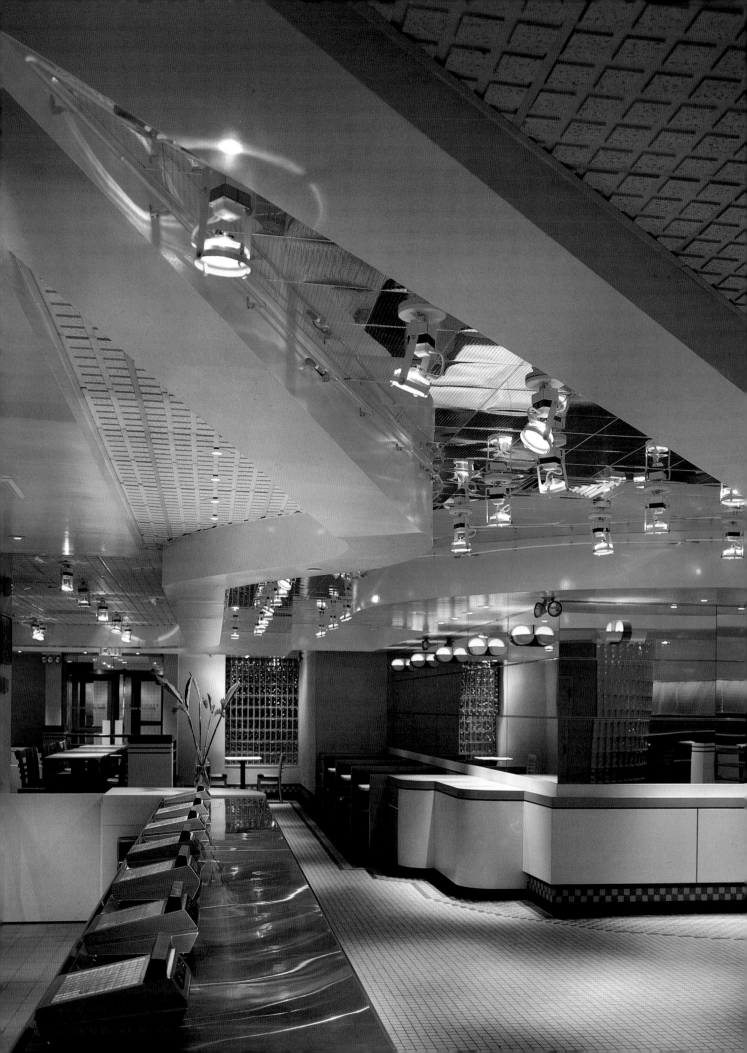

Multi-Purpose Objectives

McDonald's is changing its image. One of the latest versions is underground at Rockefeller Center in Manhattan and is a far cry from the typical fast-food establishment. In this interior, several features immediately catch the eye. Perhaps the most dominant is the ceiling design with its combinations of Simplex reflective panels and blue neon tubes snaking their way through the space. Another interesting design element is the patterned tile work on the floor and adjacent surfaces. There are also rounded forms of blue and white plastic laminate, a stainless steel service counter, glass blocks, and blue handrails. In addition to the blue neon, there is a variety of tungsten lighting; only the kitchen and rear service area are lit with fluorescent tubes.

The first view, opposite page, features the check-out counter in the foreground with its particularly noteworthy cash registers. I selected this angle to dramatize the ceiling design, which comes to a point just above the counter. I used a compact tripod to position my camera low on the counter.

The key to this photograph, however, lies in obtaining the right color and brightness balance. The blue neon tubes are very bright and tungsten film is particularly sensitive to color in this region of the spectrum. From experience, I know that any colored neon lighting system must be used sparingly to avoid overpowering all other colors. The visible dissemination of color through the composition can be misleading. Overexposure of the tubes themselves will dilute their color. My advice is to underexpose when dealing with such sources. In this example, I exposed the neon for approximately one-tenth of the total exposure. When dealing with intense colors, it is usually unnecessary to use corrections filters. (When the neon is white, I have found that filtration for warm white fluorescent tubes yields reasonable results.)

All the other lighting within the space, except for the illuminated menus that are not shown, is incandescent. The round wall fixtures with semicircular glass tops seen on the mirror to the right are extremely bright compared to the others. These were exposed for only two seconds of the ten-second exposure. I was able to confirm the correctness of this balance with the aid of black-and-white Polaroid tests. No supplemental lighting was introduced.

I set the camera up with the optical axis of the lens directly along the counter and with the film plane parallel to the entrance wall of the restaurant. I then shifted the lens to the right to eliminate the back counter area and to include most of the converging ceiling detail at the upper left. To show this I also had to use considerable lens rise. The result is a dramatic composition which is more than half ceiling. The small bit of blue-green light beyond the doors is part of Rockefeller Center. The red floor tile behind the counter is a nice counterbalance for the blue neon.

I used a Schneider Super Angulon 90mm F 5.6 lens on a 4×5 Sinar F view camera and Ektachrome Type B Tungsten film at $f/16$ with no filtration for ten seconds.

The designer is Charles Morris Mount of New York City.

A second view of McDonald's shows the same area from a different angle and with a different emphasis. The tile floor is more important now. The lighting is exactly the same as in the other shot, but there is a considerable difference in color because I used Fuji film instead of Ektachrome. Because of the inherent warmth of Fuji film, I wanted to compare them in this situation. I feel that the Fuji film's color rendition is probably more accurate. Camera and lens were the same as before but the aperture was reduced by half a stop to between $f/16$ and $f/22$ because of the increased sensitivity of the Fuji 100 Tungsten film. The shutter openings are the same as in the other view. There is a hint of fluorescent light on the counter at the left from the menu board.

Low-Key Lighting

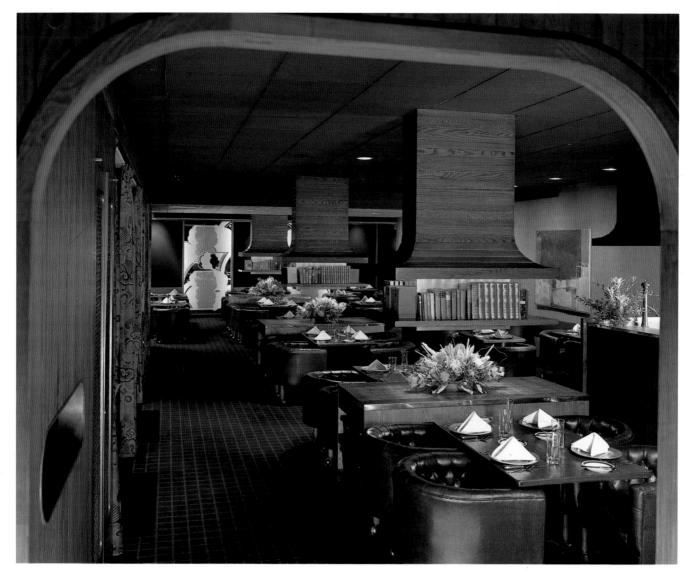

All the tones in this interior are very dark. The ceiling is almost black and reflects no light. Nor does the patterned carpeting bounce back much illumination from the down-lighting. There are wall-wash fixtures on the right which light the paintings, and in the background there are interesting decorative glass panels with vertical rows of tiny bulbs on either side. Wood-covered combination bookshelf/light units divide the space into four sections. To the left, but not visible in this photograph, are curtained seating alcoves.

The downlights in the pendant units were relamped to provide the necessary balance. Bounced supplemental lighting was introduced to show the wood surfaces, otherwise they would have been dark silhouettes. I used the frame of the entry into the main dining area to add depth and, in combination with a quite high camera position, to eliminate some of the ceiling. I used a low foreground light also. I had to take particular care to maintain the basically low-key lighting effect to preserve the atmosphere while boosting the dark areas to capture texture and finishes. This sometimes requires considerable fiddling and on occasion the use of dulling spray here and there to reduce unwanted reflection.

One of my lights was concealed behind the nearest of the bookshelves and it provides much of the illumination of the central area. Another light was bounced up into the hood over the open grill, a small corner of which is seen at the extreme right. Another bounced light is located to the extreme right of the entrance and two more in the background on the left, a total of about six in all.

The restaurant is Michael One, in downtown Manhattan, designed by Forbes Ergas Designs and was photographed for portfolio and publication.

I used a Sinar F 4×5 view camera with a Schneider Super Angulon 120mm F 8 lens, with Ektachrome Tungsten-Balanced film. The exposure was approximately 30 seconds at between f/16 and 22.

Color Shift in Warm-Toned Lighting

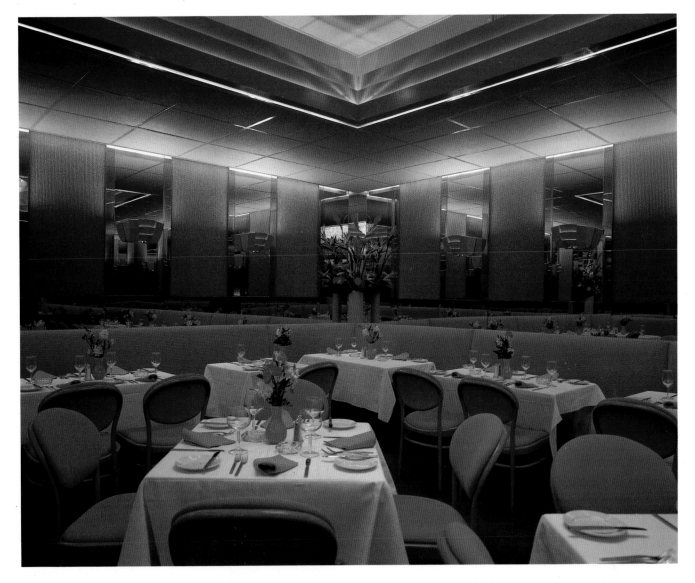

The main dining area in this restaurant is basically square with built-in seating around the perimeter. Above the seating is a narrow strip of continuous mirror, and the wall over that has alternating panels of mirror and fabric. Wall sconces mounted on each mirrored panel bounce light onto the ceiling. There is a continuous recessed strip of tubular lighting all around the junction of the wall with the ceiling. There is no natural light, and the various sources of tungsten illumination are all on dimmers. The color scheme is entirely in the warm tones.

The large surface area of mirror complicated photography and reduced the number of options. I selected a diagonal view toward one corner. By doing so, the floral arrangement conceals the reflection of the camera. This permitted me to shoot from a higher viewpoint than would have been possible had I shot straight into the wall. Unfortunately, the extent of the mirror made the introduction of supplementary lighting impossible.

With the dimmers turned to full power, the result was very harsh and without atmosphere. The interior becomes immediately more appealing as the illumination level is lowered. However, dimming the lights makes them much warmer and changes the color temperature. At full strength, the lighting much more closely approximates that for which the Type B tungsten film is balanced. The more the fixtures are dimmed, the more the resulting photograph changes in tone to the yellow-red end of the spectrum. In this room, the color scheme is already in that range and that further aggravates the problem.

The photograph reproduced here appears very warm in tone. What I ended up doing for my client in this case was having a corrected transparency made in which the tablecloths were used as a guide for accurate color. I instructed the lab to make the cloths white or slightly creamy so that the other colors would automatically be closer in color to the original design. I had used some corrective filtration during the exposure, but it was unable to compensate given the magnitude of the color shift. (When a corrected transparency is made, all the colors change and no selectivity is possible.) If the photographs are to be used in a brochure, similar correction can be made in the printing process. For most magazine reproduction, however, this is impractical and unreliable.

The Fino restaurant in Manhattan is designed by Stephen Leigh and Associates. I used Ektachrome Type B Tungsten-Balanced film with a Sinar F 4 × 5 view camera and a 90mm F 5.6 Schneider Super Angulon lens. Exposure with a 10B filter was approximately 30 seconds at f/16.

Camera Tilt and Lens Swing

The Ancora, now Las Delicias de Rosa Mexicano, on Broadway on the Upper West Side of Manhattan, was unusual in that the building was designed as a restaurant and not just an interior. One of the main features of Ancora's design was an open-hearth pizza oven with a large, round flue which thrust upward through a second-floor opening beneath a skylight.

The photograph, taken from the second-floor level, shows part of the upper dining area, the top of the oven with flue and, in the immediate foreground, an elaborate display of fish, fruits, vegetables, and cheeses. To emphasize the opening between the second and main floors, I chose a high viewpoint at the head of the stairs with the camera angled downward on the main axis of the space. This camera position enabled me to include the top of the oven, to see the dining tables adjacent to the railings, and to get a better view of the food. The camera was very close to the underside of the ceiling beams.

Looking at this photograph, it is obvious that the camera was tilted downward. The verticals are not, in fact, vertical but converge toward the bottom of the composition. This was done on purpose. I could have reduced some of this distortion by dropping the lens down more than I did. Had I moved it any further, a different sort of misrepresentation would have begun to appear. This happens when a wide-angle lens is shifted off its normal axis. The greater the shift and the shorter the focal length of the lens, the more pronounced will be a stretching of the image, with the portion of the subject furthest from the optical axis displaying the most elongation.

Here, the foreground display does exhibit some of this characteristic. For example, the yellow pepper on the extreme left is not actually as oval as this photograph suggests. The way this particular display was set up did not help to minimize distortion. But had all the foreground been made up of truly round objects, the changes in shape would have been much more obvious.

Overall sharpness is important in this kind of photograph. Both background and foreground should be in sharp focus. To ensure this, I did use lens swing. This is one of the few instances where this movement can be used to advantage in interior photography. Lens tilt, or swing, is used to control focus. Tilting the upper part of the lens board towards the foreground display brings it into sharper focus without overly affecting the background and without resorting to stopping the lens down to a very small aperture, which is the other method of obtaining greater depth of field. (Alternatively the rear standard may be tilted back. However, unlike the former procedure, there will be a change in shape and perspective of objects recorded.) This can only be done with a view camera.

To highlight the food, I used a 250-watt, focusable quartz spotlight on the left. This lamp has the same color temperature as my other supplemental lighting. To balance the light from the spot, I used a quartz light bounced into an umbrella on the right, taking care that it not reflect in the background window. This source reduces the harsh shadows that would result from the use of the spot alone. In addition, it provides general illumination to the upper level. Two additional bounced lights were used downstairs. Fortunately, there are no disturbing street or store lights visible from outside, only enough to suggest the Broadway scene beyond.

A 90mm F 5.6 Schneider Super Angulon lens was used on a Sinar F view camera. Ektachrome Type B Tungsten Balanced film, unfiltered, was exposed for approximately 20 seconds at between $f/16$ and 22.

The photography was done for portfolio use and prospective publication. The designer of Ancora is architect Charles Boxenbaum.

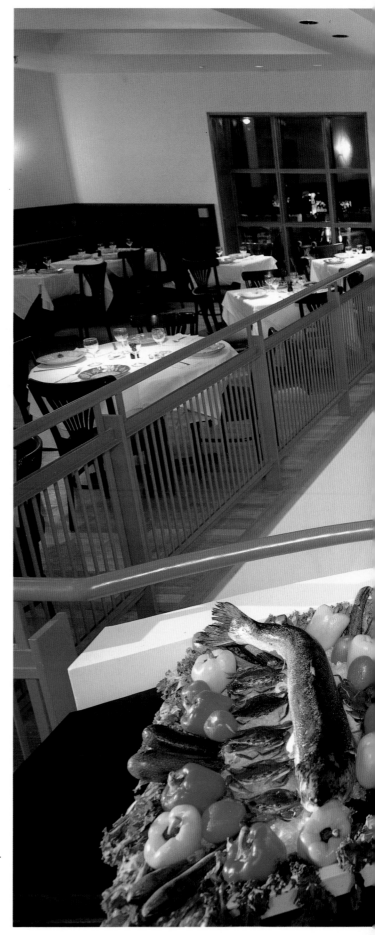

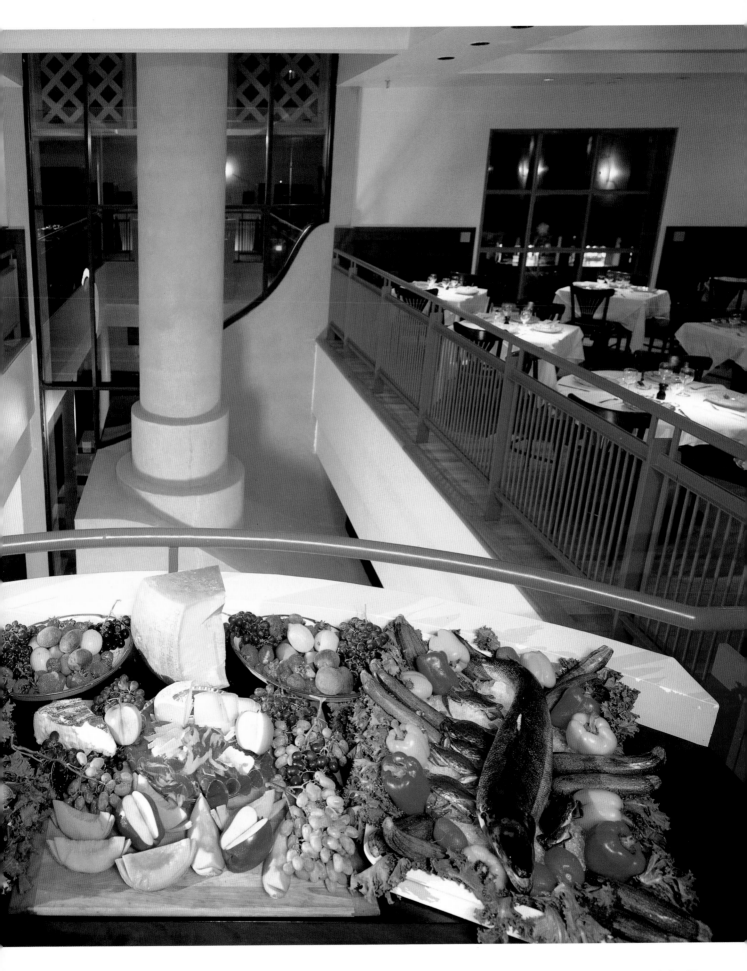

STORES AND SHOWROOMS

Store and showroom interiors are somewhat different from the other spaces in this chapter. The design objectives for most stores is twofold: to provide an inviting atmosphere for the would-be purchaser and to display the merchandise in an appropriate fashion. To a large extent, the success or failure of the store or showroom may depend on the degree to which these objectives are met. Likewise, the documentation of the sales establishment will fail or succeed not only on the quality of the photograph, but by the balance between the environment and its contents. Neither element should overpower the other.

The task of the photographer is considerable in situations where the merchandise is displayed in such a dominating manner that only the strongest design elements can compete. (Store management that is insensitive to the architecture of the space, or at odds with it, will pose problems.) However, assuming that the subject is of good quality, the documentation of it can be more straightforward than some other categories.

The use of incandescent lighting systems is widely favored, particularly in smaller establishments. The illumination it produces is pleasing and is likely to be more flattering to the items for sale and the shopper than most of the alternatives. An added advantage is the ease of control. Incandescent sources are easy to dim and come in a multitude of types from wide-dispersion to mini-spot. This is all good news for the photographer, since this category of lighting needs little or no filtration when a tungsten film is used. The addition of fluorescent tubes may somewhat complicate the procedure.

In almost all situations, incandescent and fluorescent lighting are on separate circuits and can be switched independently. Sometimes a tedious experimental process is necessary to locate unlabeled controlling circuit breakers. Rather than rely on elaborate switching in combination with two-part exposures and filtration, it may be possible and, in fact, less complicated to wrap the fluorescent tubes with the appropriate filter to convert all sources to a single balance. Exit signs, by design, are prominent and should either be minimized in some way—by a suitably colored card for example, or removal. Switching them off is usually not possible; removal of the bulbs will reduce their prominence. Showcases frequently have low-wattage, very small fluorescent tubes. The light-spread is usually minimal, and

unless the location is a particularly dominant one, the photographer may be lucky and not have to double-expose or use corrective filtration in an otherwise tungsten film situation.

When a particular area is too bright, try switching off the lights in that one spot for part of the exposure. Otherwise, supplemental illumination will be required to boost the darker parts of the composition. The former method may be simpler and just as effective. The difference in light level between a highlighted display and its surroundings can be surprising. The ratio can be as high as ten to one, which translates into giving the "background" ten times more exposure than the brightest area. A more typical ratio is in the range of two or three to one.

In large department stores lighting may vary substantially, but, in general, will probably be of one basic system. This may be a combination of different types mixed together and in such situations only advance testing is likely to produce acceptable results.

The paraphernalia of selling is likely to include cash registers, credit card machines, electronic monitors and telephones. If moving these items is necessary, be very careful. Never unplug a computer or electronic machine without first checking that no serious consequence will result.

Mirror, glass, chrome or other reflective surfaces can also produce problems. For real emergencies, take along a can of dulling spray to kill undesirable highlights. Make sure first that the spray will not harm the surface to which it is applied by testing a small area in an out-of-the-way spot.

Most store windows are better photographed at night or at dusk. The drama of the lighting will be more apparent and, most important, reflections of the outside world will be minimized. Adjacent establishments with bright lighting may pose problems. Try to have them switched off during photography. The other solution is to make a large black backdrop to intercept all unwanted interference. If much of this type of photography is to be attempted, a backdrop is a worthwhile acquisition, since it can be reused indefinitely. "Polecats" (aluminum tubes) can be used to support the backdrop. They are light and break down into shorter sections for transport, and can be rented from professional supply houses.

Clarity in Composition

Although the display cases on the left and right are not the same, the space is otherwise symmetrical. I selected an axial viewpoint and moved the free-standing items just enough to permit each element to be visually separated from its background. The positioning of various silver objects was also adjusted for similar reasons. The two primary sources of light are incandescent downlights in the ceiling and thin, vertical, tubular lighting concealed by the wood sections of the perimeter cabinets. Though the latter are fluorescent tubes, they happen to be deluxe warm white, one of the few types that is incandescent-compatible and thus does not require special filtration with Type B film. To produce somewhat more even illumination, I did use a single 1000-watt quartz light, bounced into an umbrella behind the camera.

The subject is Buccellati's silver store in Manhattan, de-signed by Gabriel Sedlis. The photograph was taken for the architect's use and for publication in an interiors periodical.

I used a 4 × 5 Sinar F and a 90mm F 5.6 Schneider Super Angulon lens with Ektachrome Type B Tungsten Balanced film exposed for 5 seconds at f/16 to 22.

Diverse Light Sources

The top photograph on this page shows the Robert Homma store. Located on the ground floor, slightly below street level, the shop has a single, "house-size" window that functions as a frame through which a shopper can see the enticing environment beyond. In spite of its narrow dimension, the strategy is successful and I felt it provided the basis for my photographic approach.

The location of foreground elements determines what is seen beyond. In addition to beautiful flowers and plants, the owner of the store selected particularly handsome pots and art objects for inclusion. All the lighting is by individual, adjustable, incandescent fixtures attached to two tracks running the full length of the shop. There are both wide and narrow beam spots. Many were adjusted to avoid hot spots on the white areas or to highlight a particular arrangement. To reduce contrast and to lighten up some shadow areas I used two bounced quartz lights off to the left of the space.

My client was Formica, manufacturer of the plastic laminate used for the table top and the shelving and counters beyond. The designer for this Manhattan flower boutique is Michael Haskins. The camera used for this photograph was a Nikon FE-2 with a 28mm *F* 4 PC lens. The lens was offset downward to show the top of the window close to the edge of the frame from a quite high viewpoint.

Ektachrome Professional 50 EPY Tungsten film was exposed for 1 second at *f*/11.

Swirl is a ladies garment wholesale showroom. A rounded end wall which separates the reception from the buyers' area is a major feature, as are the reflective ceiling panels. To emphasize the apparent ceiling height suggested by this treatment, I chose a vertical format, of which almost half is reflection. Perforations in the ceiling tiles add an interesting texture to the reflections.

The main illumination is provided by recessed incandescent down lights. The clothes storage area does have fluorescent tubes, as do some of the office spaces off camera to the right. For this reason I used a two-part exposure with tungsten-balanced film unfiltered for the incandescent portion only, but with 40R plus 10M filtration and the warm white fluorescents only switched on. The project was photographed for portfolio use for the architect and potential publication. Swirl, located in Manhattan, is the work of architects Gwathmey Siegel and Associates. I used a Sinar F 4×5 view camera with a 90mm *F* 5.6 Schneider Super Angulon. Ektachrome Tungsten Balanced film was exposed for approximately 12 seconds between *f*/16 and 22, unfiltered with the main lighting only for 20 seconds with filters.

The facade view of this book store suggests the elegant style of the interior. This particular version of the photograph was taken at a time when neither the interior nor exterior lighting dominated. I used a tungsten-balanced film with 85B daylight filtration for better color rendition for the five-second exposure. Reciprocity failure of daylight film would have required corrective filtration also but would have been less predictable. The yellowish cast of the incandescent interior lighting is somewhat exaggerated but looks acceptably accurate.

I selected an axial viewpoint using a Schneider 120mm *F* 8 Super Angulon lens on a Sinar F 4×5 view camera. The lens was substantially raised to crop the sidewalk and include more of the building. My tripod was set right at curbside.

Ektachrome Tungsten Balanced film was exposed for 5 seconds at *f*/16 with the 85B filter. Rizzoli's bookstore in Manhattan was remodeled by the architects, Hardy Holzman Pfeiffer Associates for whom the photography was done.

High-Contrast Lighting

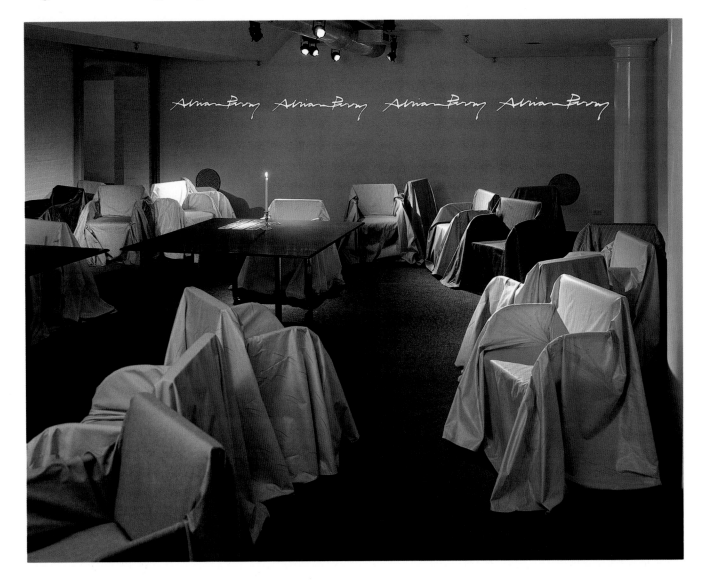

This display space was de-signed to introduce a line of new fabrics to designers. More akin to a surrealist stage set, the trick here was to preserve the dramatic atmosphere created by the high-contrast lighting. The writing on the wall is, in fact, projected. The brightness of the candle is an indication of the generally low level of illumination. I introduced a minimal amount of bounced quartz light from two locations, the main one being to the left of the camera. The supplemental lighting is most apparent in the foreground. I adjusted some of the ceiling spots to reduce contrast, re-directing beams from light to darker fabrics and ensuring that none shone directly to-wards my lens. The exhibit was designed by Lee Stout for the Knoll Design Center in New York City.

A Sinar F 4 × 5 view camera was used with a 120mm *F* 8 Super Angulon lens. Ekta-chrome Type B Tungsten-Bal-anced without filtration film was exposed for approximately 30 seconds at *f*/22.

Impossible Fluorescence

Photographing this establishment during daytime business hours was out of the question. Quite apart from the hustle and bustle, strong daylight creates a band of light at eye level that is entirely too contrasty to permit acceptable results. By shooting at night, I was able to have a degree of control that would otherwise have been impossible.

The merchandise was organized to look its best from the single viewpoint of the camera. The one-point perspective adds impact to the straightforward design, which is inserted into an existing surround. Except for the fluorescent-lit central glass case, the illumination is overhead incandescent bulbs in large white reflectors. A two-part exposure was impossible, since I did not have access to the control panels. The alternative of wrapping the cool-white fluorescent tubes with filters was not practical because it would have entailed the removal of much of the food inside the refrigerated cabinet. I was able to switch off the light inside the case, and used a small, 250-watt spotlight to illuminate the merchandise.

Situated in the South Street Seaport in Manhattan, Paxton and Whitfield is the work of designer Judith Cash Stockman. I used my Sinar F 4 × 5 view camera with a 120mm F 8 Super Angulon lens. Exposure with Ektachrome Type B Tungsten Balanced film was approximately 20 seconds at f/16.

Two Looks

I wanted to do a "portrait" of the designer of this to-the-trade display space in the context of the environment she had created. The curved window looking into the enclosed space seemed like a suitable, somewhat unusual setting. In order to light my model dramatically without over-illuminating the window wall itself, I redirected a couple of spotlights on the far side of the window and, with the addition of one of my own, produced the quite effective backlighting of the model.

Items within the enclosure were arranged for clarity and simplicity. The warm-white deluxe fluorescent tubes in the built-in cabinets, fortunately, did not require separate filtration from the basically incandescent lighting.

Naomi Leff is the designer of this Ralph Lauren promotion for Fieldcrest. The photos were for editorial publication and portfolio use.

I used a Nikon FE-2 35mm camera in combination with a 28mm PC lens. Ektachrome Professional Type B film was exposed for 1 second at between f/8 and 5.6.

The major design theme of the wholesale garment showroom shown here is the partly plaster wall with its wire lathe and metal support structure. The existing incandescent lighting had to be supplemented to reduce the contrast. I bounced a quartz light into an umbrella high up to the left of the camera to minimize reflection from the screen of the monitor. I chose a low viewpoint and used a wide-angle lens to exaggerate the perspective, with the sharply converging horizontals of wire lathe disappearing into the giant crack. Snippets of color at the left suggest activity beyond.

James D'Auria, architect, designed this showroom for Gene Ewing in New York's garment district.

I used Ektachrome Professional Type B film (EPY) in a Nikon FE-2 with a 24mm F 2.8 lens. Exposure approximately 1 second at f/8 to 5.6.

Altered Viewpoint

Shown here is part of a wholesale shoe salon. The showroom has a series of windows around the perimeter of the space which the designer wanted to show. For this reason I positioned my camera to catch the view from the left-hand window and adjusted the blind to the half-way position. Normally I would have had to use an electronic flash to illuminate the interior and include the scene outside. However, the interior lighting is an intrinsic part of the design, and overpowering it with flash would have destroyed this aspect of it.

My solution was to convert the window light to a tungsten equivalent by exactly placing a sheet of 85B filter over each pane of glass. Since the blinds are translucent, the window areas behind them were also filtered. This procedure yields

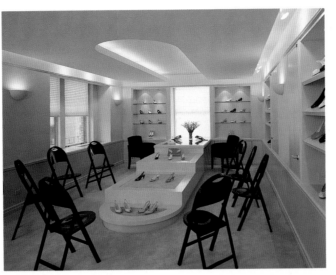

a reasonable balance between the daylight and the incandescent light inside. The formality of the room was somewhat offset by the random positioning of the black chairs. To reduce contrast, I introduced two quartz lights bounced into umbrella reflectors, one on either side of the camera.

I used a 90mm F 5.6 Super Angulon lens on a Sinar F 4×5 camera. Ektachrome Tungsten-Balanced film was exposed for 10 seconds at f/16 to 22. The Craddock-Terry Shoe Corporation showroom in New York City was designed by architect Stewart Skolnick.

Another angle of the same space is shown here to illustrate how different two photographs of the same interior can be. I chose an axial viewpoint for this version, pulling back as far as I could and using a lens of double the focal length to compress the composition. The stepped platform and the ceiling recess above are foreshortened and appear more modest in dimension. The entire room seems to be smaller.

Each photograph has its own validity. This picture is more graphic but less informative, providing the viewer with less of the impression that being in the space would provide.

Lighting and camera details are the same as before but the lens used was a 180mm F 5.6 Symar S. Exposure was approximately 15 seconds at f/22 for added depth of focus.

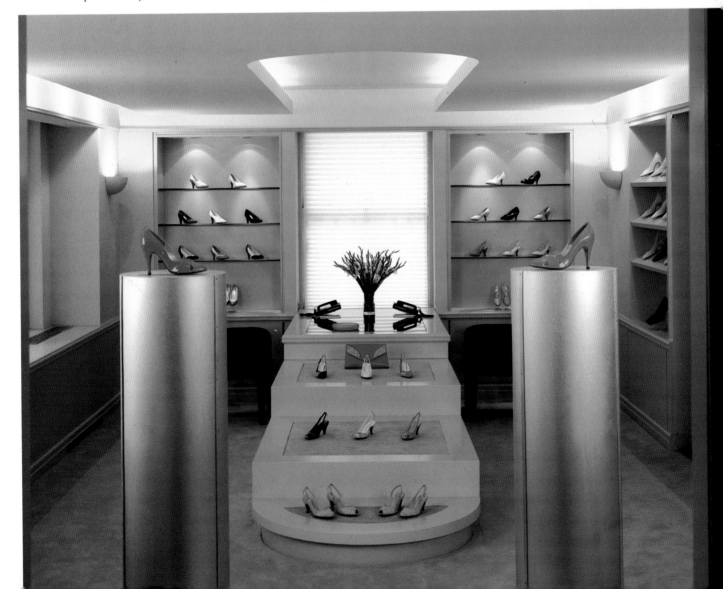

SPORTS FACILITIES AND AUDITORIUMS

Few inexperienced photographers will have to tackle the problems that are inherent in documenting very large spaces. The major problem involves recording the design and capturing the space with available light sources only and with limited control.

The majority of auditorium-type spaces are too large to light artificially. Even when it is possible to introduce supplemental illumination, it is almost always obvious in the photograph that the added lighting is not part of the basic design.

The easiest conditions occur when a single type of lighting has to be dealt with: daylight alone, for example, or only tungsten. Since films come balanced for both these sources, no filtration may be required. In the case of daylight film, some filtration may be necessary for reciprocity; the light level is likely to dictate longer exposures than those typically used for exteriors. Unless extreme accuracy is required, an interior with only incandescent lighting will probably yield acceptable results using unfiltered tungsten film. The existing lighting will probably be of lower degrees Kelvin than the film is balanced for (3200°K), and the resulting photograph will be warm in tone.

If the space has daylight and incandescent light in a fairly even combination, a photograph that has approximately the same ratio may look all right. This will depend on how evenly the two kinds of lighting are mixed. The use of tungsten film, half of the exposure unfiltered and the other with an 85B for daylight conversion, may produce a satisfactory result. Keep in mind that the filter has a factor which will lengthen that part of the exposure correspondingly.

The exact ratio between the two different types of light is not as critical as one might think but will be translated into pictures that may be somewhat warmer or cooler than the interior appears to the eye. Experiment with different ratios and see which results you prefer. Try switching off the interior lighting to evaluate the contribution of the daylight portion. Obviously, if the space seems to be sufficiently evenly lit without the variable source, then shoot it that way.

In a situation that has unusual lighting requiring heavy filtration, tests may be necessary. There are now on the market large numbers of light categories for which filter recommendations are hard to come by. These include certain kinds of mercury vapor and neon lighting, which is sometimes similar to fluorescent but sometimes not, high intensity discharge (HID), and metal halide.

Light sources may be used indirectly bounced off wall or ceiling surfaces. When these surfaces are not white, the result is a shift in color temperature which, if extreme enough, may require additional correction. Only advance testing will guarantee acceptable results. In certain circumstances, a color temperature meter may be helpful.

When faced with difficult circumstances, the photographer may have to compromise. Filter for the predominant light source and hope that those areas with other types of illumination will be rendered reasonably well, if not accurately. Eliminating offending variables and allowing certain portions to go dark is a possible alternative. When desperate, shoot a color negative and then have a corrected transparency or print made afterward. High-speed color negative material, available only in roll format, is much more forgiving when used in awkward light situations.

A note of caution when selecting the lens to use in recording a large space. Unless you wish to exaggerate the apparent size of the subject, don't use a wider-angle lens than necessary. The scale of the design may be important. The architect may wish the space were even larger than it is, so a photograph which suggests this may be preferred. Usually, however, a large enclosure will not need that sort of amplification. Careful selection of viewpoint may enable the photographer to include repeating elements that suggest the true dimensions without showing everything.

Evaluate the architectural features of the space and play up these attributes by careful composition and selection of camera position. If the design has more than one basic axis, a strong diagonal perhaps, consider photographing along it for added impact. The inclusion of foreground elements—railings, columns, or screens—will add depth and help the contrast range within manageable bounds. Avoid photographing directly towards very bright areas, or conversely, overly dark ones. Sometimes a minor change in position can radically alter the parameters of brightness within the frame of the picture.

Don't be overly concerned by moving people or objects in the photograph. Unless they are very close to the camera, they probably won't be a distraction. If it seems that they might be, select a smaller aperture and use a time exposure. When you do include human figures, try not to have them look posed. Try going through the motions of taking pictures a couple of times and then catch the people unaware.

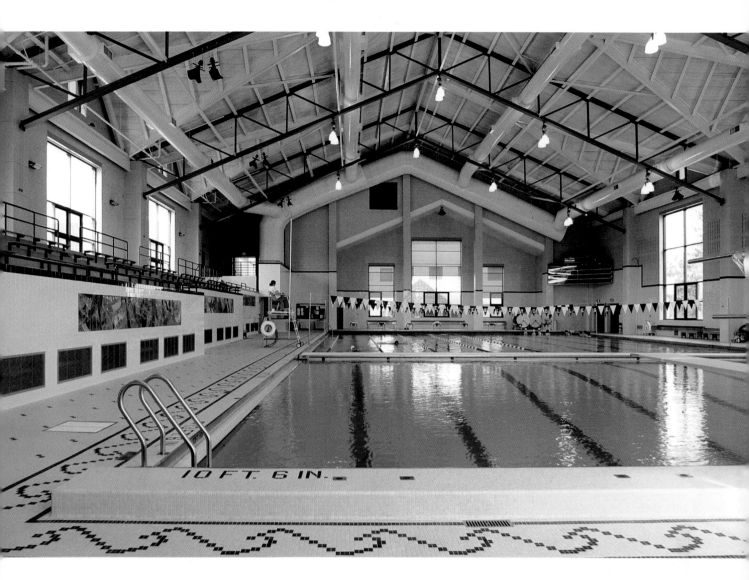

Perspective Control

The large indoor swimming
pool shown here is part of
an athletic complex at Welles-
ley College in Massachusetts. I
had photographed this interior
in late afternoon the previous
autumn. However, with direct
sunlight entering from the left,
the results were extremely con-
trasty.

On my return in June, I was
able to select a time of day that
the sun entered the room from
the southeast, to the right and
behind the camera. I selected
an axial viewpoint and a loca-
tion that would feature the
decorative floor tile work, the

pool itself, and the bleacher
seating.

The axis of the main build-
ing and that of the pool are
parallel but not the same. This
is reflected by the structure of
the back wall. Notice the half-
lowered blinds in the far win-
dows. I needed the natural
light at that end but wanted
some contrast control. The in-
terior lights were switched on
but had little effect because the
natural light level was so high.

I used a 35mm camera for
this shot in conjunction with a
very wide angle, perspective-
control lens. The lens was

shifted to the right and slightly
upwards for the best composi-
tion. The camera was fitted
with a gridded screen view-
finder and was carefully lev-
eled on a tripod. Even a small
amount of tilt would have been
immediately evident with a
lens of such short focal length.

Exposure was approximately
1/30 second at f/5.6 using
Kodachrome 64 Professional
film. The camera was an Olym-
pus OM4 with a Zuiko 24mm
F 3.5 shift lens. Architects for
this projects were Hardy
Holzman Pfeiffer Associates.

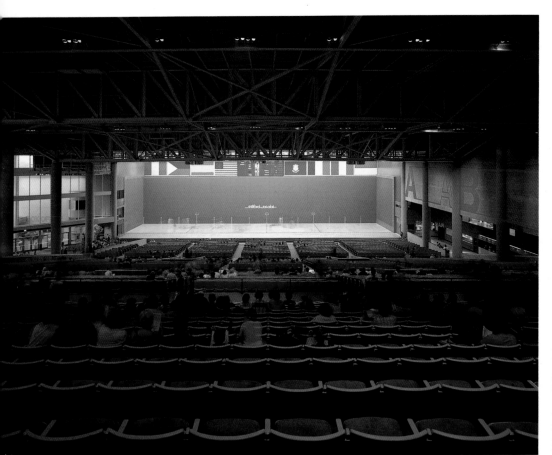

Two Views, Two Lights

The fronton, or playing area, of this Jai-Alai facility in Milford, Connecticut, is extremely bright. It is illuminated by mercury lamps, while the rest of the lighting is primarily incandescent and at a much lower brightness level. The objective of the photograph above was to relate the playing area to the seating area. The exposure and the filtration were determined by the playing area alone.

Because the fronton enclosure is very much the focal point and focus of the composition, the color and exposure of it had to be the controlling factor. This meant substantial underexposure of the seating. However, there was just enough detail to manage it, and the very reddish color resulting from the combination of tungsten film and filtration for mercury lighting does not jar the eye. The figures of the Jai-Alai players are ghostly, though visible, because of the length of the exposure.

The camera was a Sinar F 4×5 and the lens a Schneider 150mm F 5.6 Symar. Exposure was approximately 10 seconds at f/11 with a 70R and 10Y filter combination. The facility was designed by Herbert Newman and Associates of New Haven, Connecticut.

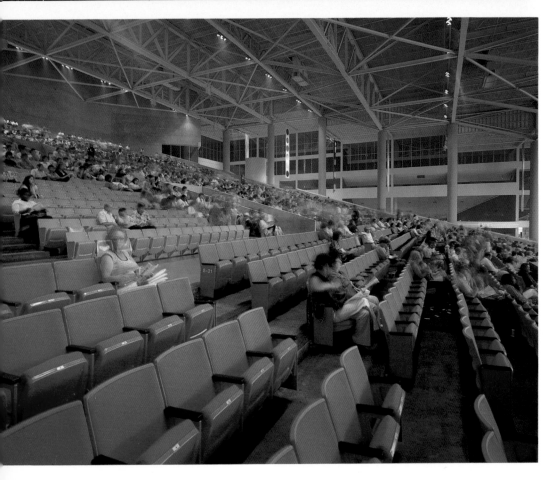

The photograph, left, shows the seating area of the Jai-Alai facility. Between each match, the house lights are raised to permit the audience to examine their programs and decide how to place their bets. The house lights are incandescent and quite bright when turned up fully, but the fronton illumination is even stronger and remains on both during and between matches. The area of the photograph to the right, closest to the fronton, has a cool cast since I used Ektachrome Type B film unfiltered.

The Sinar F was used with a 90mm F 5.6 Schneider Super Angulon lens. Ektachrome Type B Tungsten Balanced film was exposed for about 8 seconds at f/11 without filtration.

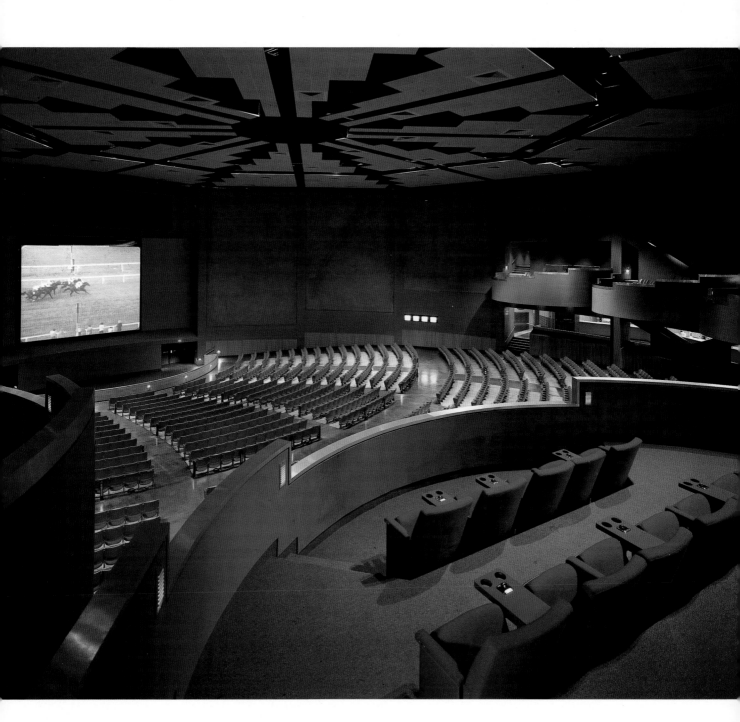

Inclusiveness

The key to the photograph above was the control of the screen image. I was able to select and freeze the image of the projected race, permitting a time exposure. Although the screen occupies a quite small portion of the composition, it is very much the focal point and the brightest part of the picture. The lighting in the main body of the "theatre" was purposely kept rather low, so many areas are quite dark. The curves of the balcony fronts, the main seating, and the ceiling all combine to give a good impression of the space. Most of the more brightly lit service areas to the rear are hidden from view. The four bright rectangles in the background are closed-circuit screens which I was unable to control.

Teletrack, in New Haven, Connecticut, was designed by Herbert Newman and Associates. I used my Sinar F 4 × 5 view camera with a 75mm F 5.6 Schneider Super Angulon lens. Ektachrome Type B film was exposed for 12 seconds at f/11 to 16.

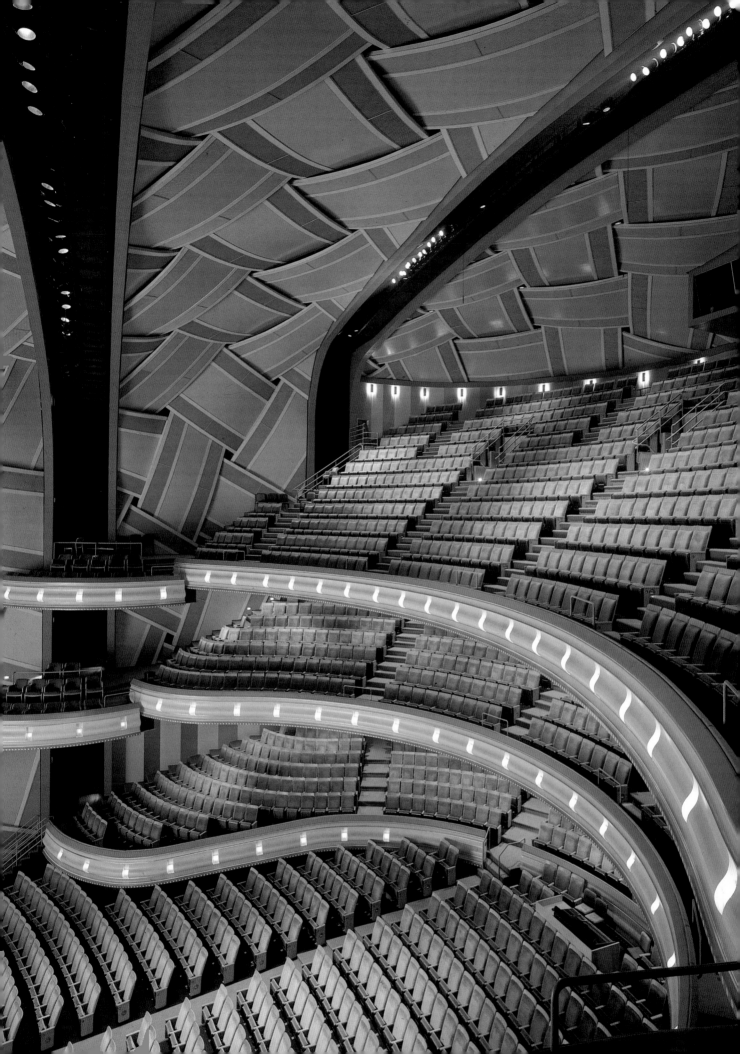

Vast Space, Many Possibilities

The auditorium of the Holt Center for the Performing Arts in Eugene, Oregon, uses various types of incandescent lighting, both switchable and dimmable. The basic house lights give a somewhat contrasty result, particularly when the balcony fascia lights are adjusted to maximum intensity. The wall sconces at the rear of the upper balcony are also quite bright. I had both these systems adjusted to rather low levels and was able to organize the raising of the main curtain. The surfaces in the stage area behind were white or neutral in color and with the aid of some of the stage lights, I was able to substantially boost the general level of illumination in the auditorium.

The main features of this multi-purpose hall are the unusual green and gold, basket-weave patterned ceiling and the sinewy, curving balconies over the mezzanine. After some exploration I found a location where all the balconies and the lower seating were simultaneously visible. The ceiling is divided into three segments by two banks of recessed stage lights. These recesses spring out of the upper corners of the composition to give added impact.

The camera used was a Sinar F 4 × 5 view camera with a Nikon 75mm *F* 4.5 lens. The film used was Ektachrome Type B. Exposure was approximately 20 seconds at *f*/16 to 22. No filters were used. The architects were Hardy Holzman Pfeiffer Associates.

The picture right is a candid photograph of the same auditorium taken during a performance. This time I could exercise no control; the shot is strictly the result of existing available light.

The general level of illumination was only a fraction of the amount for the other view. I used a fast tungsten-balanced roll film, Ektachrome 160 EPT in my Hasselblad. With a 120mm (2¼ × 2¼) for-mat camera, I was able to use faster film than would have been available for the 4 × 5 view camera, and in addition the wider aperture and shorter focal-length lens permitted the selection of a shorter exposure time. In addition, the film was pushed in development approximately one and one-half stops, so it was effectively rated ASA 400. One-second exposure was dictated by the lower level of light in spite of the wide aperture of the lens, *f*/4.

In situations such as this, it is tricky to focus and operate the camera. Be careful when changing settings, since it may be quite difficult to see them in the dark. Reading the meter, either through the lens or handheld, may be equally hard. For insurance, it may be wise to have the processing lab run a frame test on a couple of frames to determine if the exposures are in the right range. (This assumes that the entire roll of film is of the same or similar subject and was shot at more or less the same ASA rating.) A frame or two may be sacrificed for testing, but if adjustments need to be made, it will have been worth it.

By avoiding the stage area in my photograph, I was able to keep the contrast range within reasonable bounds. Had I tried to include it, I would have been forced to substantially reduce the exposure and little, if any, detail would have been evident in the auditorium.

Keep in mind that a noisy camera can make you very unpopular during a concert. Wrapping something around the camera may help to absorb some of the sound of the shutter. If you are using a Hasselblad CM, as I was, trip the mirror before the actual exposure and wait for a loud passage of music to disguise the sound. The mirror and safety cover make more noise than the shutter.

The Hasselblad 500CM was fitted with a 40mm *F* 4 Biogon lens on a tripod.

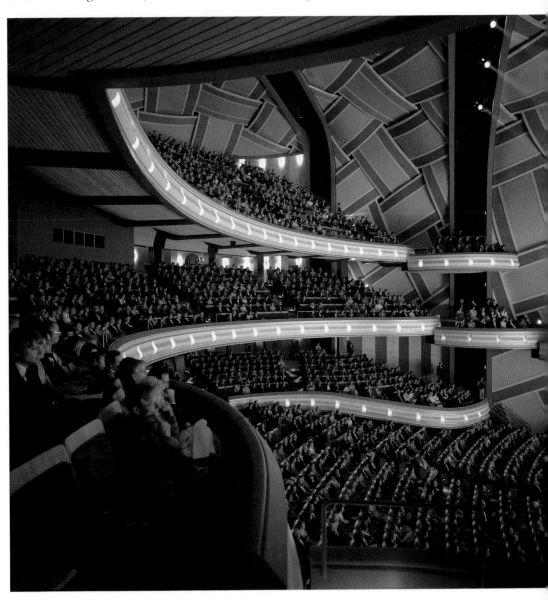

CHURCHES

Churches are frequently symmetrical in plan. Axial photographs will emphasize this. If you plan to do several views, resist the temptation to do too many symmetrical compositions. In other words, plan the coverage to give a variety of pace which will make it more interesting to the viewer. Mix verticals and horizontals and, when in doubt, do both of the same view. This may be quite easy to accomplish since the lighting is not likely to change much, if at all, between the two versions.

The majority of church interiors have some natural light; some may be comparatively bright. When daylight provides the primary illumination, the weather conditions will have considerable influence. Where openings are well distributed and little direct light enters, the lighting may be quite even. If, however, most of the daylight penetrates from a single source there will probably be quite uneven illumination. These factors may well dictate the photographic approach. It is not always possible for the photographer to take what might otherwise be the ideal view due to excessive contrast or some other uncontrollable factor. A compromise may be necessary when waiting for more favorable conditions is not practical.

Tungsten fixtures are generally the most widely used type of lighting in churches, particularly in the older ones. In a contemporary church, you may find mercury vapor fixtures. These should be avoided whenever possible since they are not compatible with any other light sources or film without substantial corrective filtration.

When supplemental lighting is necessary, tungsten lamps are easier to transport and locate than strobes. Additional tungsten light is not difficult to judge, which strobe light is, thus making Polaroid testing less essential. Only if small format is acceptable in combination with fast film is it practical to light with flash. My advice in such situations is to bracket the exposures widely, trying a variety of settings. Remember though, that direct flash can yield very harsh results.

My experience is that most supplemental lighting to be used directly, not bounced, to have much effect, particularly with a large-scale interior. With careful positioning of the lights, it is usually possible to avoid distracting shadows. Also, if the daylight coming through any windows is not too strong, it may be possible to overpower its effects, thus permitting the use of a more stable tungsten-balanced film. The daylight areas will be rendered more blue with this film, but the colors of the interior surfaces may not be adversely affected.

How do you determine whether or not supplementary lighting is required? Keep in mind that it is *not* the overall level of illumination that will determine whether additional lighting would be beneficial or even desirable, but the evenness of the light distribution. Beautiful photographs can be produced in dimly lit interiors. Only in high contrast situations must the photographer take action. In such cases, allowing dark areas of an interior to be recorded with little or no detail may be acceptable.

Don't expect those beautiful stained glass windows to be recorded the way you see them. Only in the most unusual circumstances will their detail and beauty be within the range of the film, *if* it is also to record the interior. When photographing stained glass, take direct exposure readings of the windows. Since this readout will dictate the camera settings, additional lighting must be introduced to capture interior detail surrounding the window which is included within the composition. The amount of supplementary lighting required will vary as the light transmitted through the glass changes.

A church with an interior lit entirely through stained glass windows, as some of the great cathedrals are, may exhibit some color shift when photographed. If blue glass predominates, then the results will be cool in tone; if yellows are in the majority, the photograph may assume a more "sunny" or yellow hue. As often as not, no single color predominates, and the photographer need not be unduly concerned with attempting corrective filtration. If very accurate color is essential, some advance testing may be necessary or, if one is available, the use of a color temperature meter to determine the filtration will be required.

Whenever possible, check out the position of electrical outlets in advance if you expect to introduce lighting. You may find that power sources are few and far between and require long extensions. Also, avoid plugging in more than one lamp in each circuit whenever possible and find out where the circuit breakers or fuse boxes are. Their capacity will determine how many lights can safely be connected to a single circuit. I have used as many as five or six 1000-watt quartz lights directly to illuminate a large church interior.

When selecting the lens to use, keep in mind the fact that the space may already be quite large and the use of an extremely wide-angle lens will further exaggerate this. Try, therefore, not to use a shorter focal-length lens than necessary. Shooting a high space from floor level may only be practical when using a perspective control lens or a view camera.

Stained Glass Windows

This stained glass window is located in one of the side aisles of the récently restored West End Collegiate Church in New York City. Late afternoon light was best for the window, which is attributed to Louis Comfort Tiffany. I wanted to include the inner arch to show the context of the window. I positioned one strobe head and umbrella close to the camera and slightly to the left. The second head, also bounced, was located in the aisle behind the column to the right. The head nearest the camera was set at half the output of the other to reduce the impact of the arch and the foreground seating. Leaving the tungsten light switched on makes the upper area of the aisle a little more interesting, and it has minimal effect on the color.

The photograph was taken for the architects of the restoration, William A. Hall Partnership, for portfolio use and potential publication. I used a Sinar F 4 × 5 view camera with a 120mm F 8 Schneider Super Angulon lens and Ektachrome 64 Daylight film. Exposure was approximately one second at f/16. A 5000-watt Balcar unit provided the necessary strobe light.

Quite bright sunshine provided the main source of lighting in the lower photograph. The August sun was high in the sky, falling on the pews in the center of the photograph. I decided that the interior lights should be left on, even though they are rendered rather yellowish by the daylight film. To counteract some of this I used strobe fill light, compatible with daylight. Two heads were used bounced into white umbrellas with power provided by a 5000-watt Balcar. A 90mm F 5.6 Super Angulon lens was used on the Sinar F view camera. The Ektachrome 64 Daylight film was exposed for approximately 1 second at between f/11 and 16.

Angles and Views

This renovated chapel in New Haven was photographed by choice on a mainly overcast day. A modern lighting system using incandescent fixtures was installed when the remodeling was done, producing a brightly lit interior even without daylight. I figured that I could overpower the daylight with supplementary quartz lights if I used them directly rather than bounced. Only the chains supporting the chandeliers cast shadows, but by carefully locating my lights they become almost invisible. The sanctuary has more illumination than the rest of the chapel. I selected this viewpoint to show the large organ and the round window above. Most of the lighting is dimmable but only the wall sconces and chandeliers were lowered in intensity for contrast control and to preserve color accuracy.

I used a 250-watt spotlight to boost the brightness of the choir stalls below the organ and the pulpit. The dark wood in this area made it necessary to add this illumination.

A particularly obtrusive aluminum handrail which appeared to the left of the pulpit after the new work had been completed was covered with black tape to make it less noticeable. A similar one on the right was removed, but with some difficulty.

The project is the Battell Chapel at Yale University and the remodeling and restoration work was done by the firm of Herbert Newman and Associates of New Haven. The photography was for publication and portfolio use.

I used Fuji 64 Tungsten film, since it is faster and produces a somewhat warmer, or yellower, rendition than Ektachrome would have. A Schneider Super Angulon 120m *F* 8 lens was used with a Sinar F 4 × 5 view camera. Exposure approximately 5 seconds at *f*/16.

The view shown above left is quite different. Using a vertical format, I framed both the organ loft and the sanctuary on the right between one of the large, arched balcony openings of the side aisle. The shape of the arch is rather distorted by the wide-angle lens, the penalty I had to pay for including as much in this single view as I did.

The lighting is much the same as for the above picture except for the foreground. In this instance, since the camera

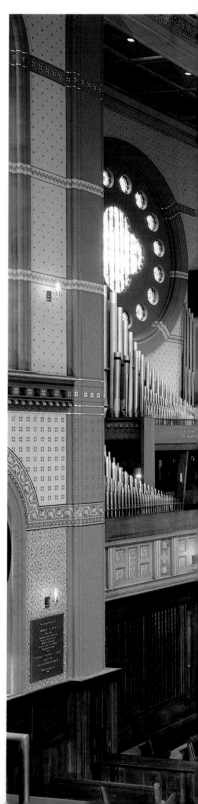

was much closer to the arch and columns, the lights could also be moved in without being included within the frame. I used two bounced quartz lights with umbrellas which enabled me to control the output more precisely and balance the background with the foreground.

Film and camera were as in the previous view, but here I used a Nikkor 75mm *F* 4.5 lens.

The axial view of the chapel looks down the nave to the rear. The light level outside had dropped, so the two central windows are much better balanced with the interior light level. I used all the lights I had, two to the left and two on the right, with a fifth on the balcony of the side aisle. I could have used a sixth in the space below to the left. All the lights were used direct and were either 1000-watt or 650-watt quartz flats that produced a very wide spread of even illumination. My lighting produced shadows of the chandeliers on the back wall, but they're unavoidable. The light level of the sconces was raised somewhat to make them brighter.

Here I used a 90mm *F* 5.6 Schneider Super Angulon on the Sinar F. Exposure approximately 10 seconds between *f*/11 and 16 with Fuji 64 Tungsten film.

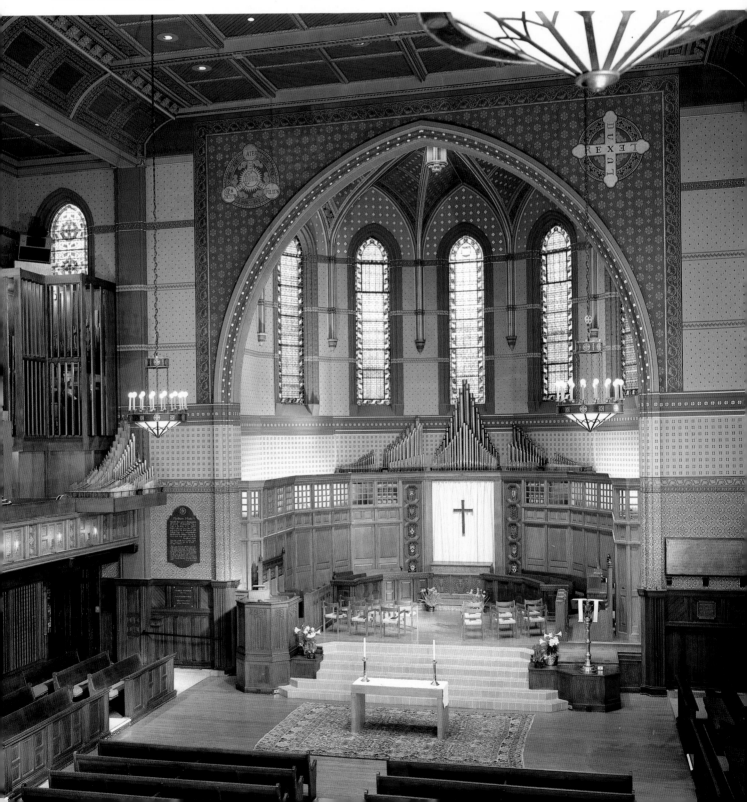

Horizontals and Verticals

All three photos shown here are of Our Lady of Lourdes Catholic Church on Long Island. Limited interior daylight was overpowered by quartz lights, as in the Battell Chapel examples. Unfortunately, some of the interior lighting was mercury vapor and could not be used. Quite a lot of heavy-looking furniture was removed from the sanctuary and adjacent areas for the photography.

Careful positioning of the lights kept objectionable shadows to a minimum. A quite low camera position was selected to help explain the suspended circle above the altar, but was high enough to get some separation between the rows of pews. The daylight produces an overly cool back wall with the tungsten film, but it is a welcome contrast to the otherwise almost monochromatic tones of the wood and brick. I used a 90mm F 5.6 Super Angulon lens, raised substantially to include as much of the ceiling structure as possible and, in particular, to capture the meeting point of the main trusses. I used Ektachrome Type B film in the Sinar F camera. Exposure was approximately 2 seconds between f/11 and 16. Bentel and Bentel are the architects for the church.

All the lighting remains the same for this vertical version, left, done from the rear balcony. Not only the switch in format but the elevation of the camera produced a totally different composition. Some daylight coming from behind the camera produces a cool cast on the foreground railing.

The full-page view, opposite, is a closeup detail of the sanctuary and altar. The major difference here is that the lights have now been moved closer in, so I was able to bounce them into umbrellas to produce a softer light without sharp shadows. The curvature of the rear wall is now much more apparent, as well as its relationship to the brick wall.

The lens and film were the same for all these photographs.

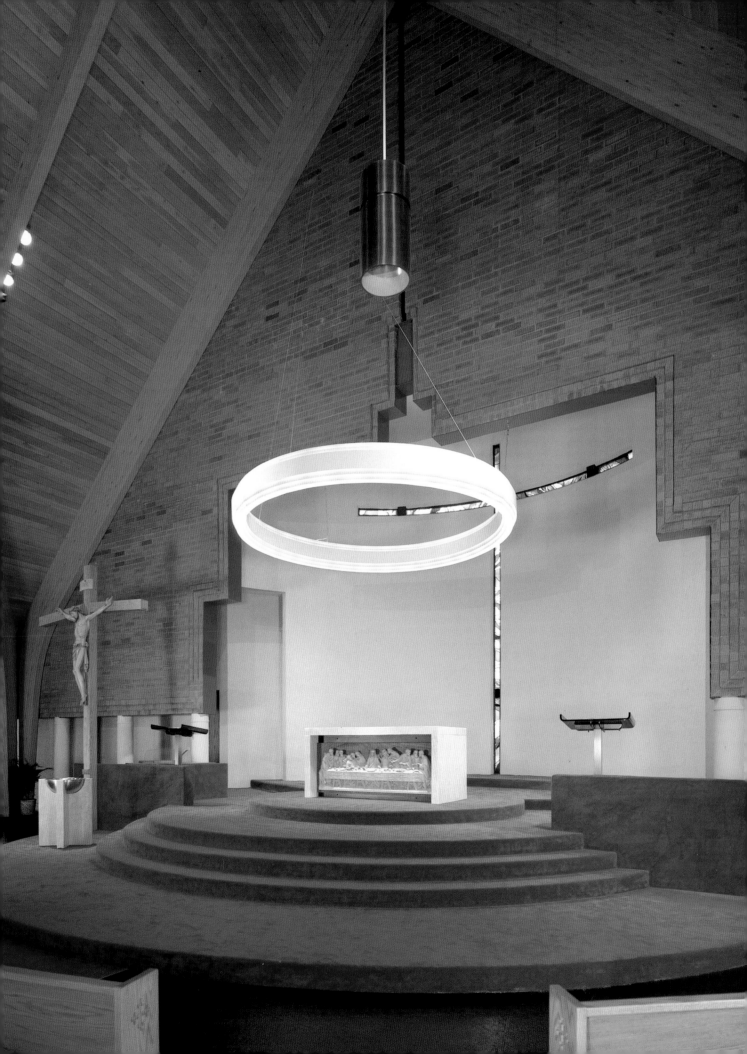

MUSEUMS

Museums have virtually no common denominators. Some are public, some private, others corporate; some are very large, others very small, and their styles are equally diverse.

Many museums are closed one day a week. When this is so, the institution to be photographed may prefer, or, in fact, may insist, that any photography requiring a tripod be done on that day. Find out what the rules and regulations are before attempting the assignment. Also determine if the museum restricts the use of the completed material. Make sure that the necessary authorizations are obtained in advance. Museum personnel can be difficult when they feel they have been left out of, or worse, circumvented, in the permissions or planning stages of a project in which they are involved.

Having made all the necessary arrangements, the photographer may find that other conditions, like the weather, may be unfavorable. If good weather is essential to the assignment, notify the museum in advance that you are counting on favorable conditions to complete the documentation. They won't have people hanging around waiting for you if the weather is uncooperative. These suggestions are mostly obvious but are frequently overlooked.

The Importance of Viewpoint

In 1978, the eagerly awaited addition to the National Gallery of Art in Washington D.C. opened. I was asked by *Vogue* magazine to photograph I. M. Pei's latest masterpiece for a spread or two in their publication. My photographs were taken during a brief period prior to the gallery's opening.

From the technical standpoint, this was an easy assignment. The entire ceiling is one vast skylight, so the interior is as bright as day. A series of interlocking trusses span the basically triangular column-free space and support the glazing. The triangular-shaped enclosure comes to a quite sharp point at the eastern end of the building. My favorite views of the design are those that look in the direction of its easternmost terminus. There are many different levels so the photographer has a wide choice of vantage points.

The vantage point for this overall view is a stair leading to one of the upper galleries off the main space. The main axis of the complex roof-support system divides the triangle virtually in half in an east-west direction. The symmetry and the convergence of the design is emphasized by shooting

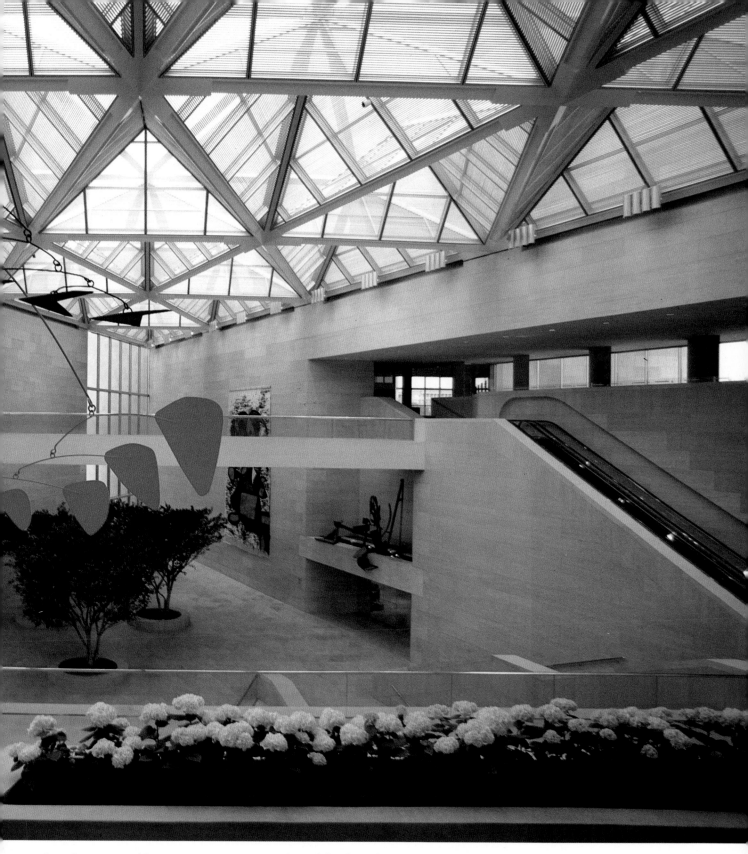

along this axis. In addition, there are several design elements on or at right angles to this axis. By selecting this common one, I emphasized several contrasting axes of the interior: parallels that intersect the strong converging diagonals. This lends an order to the composition and simplifies the structural geometry.

I watched the slowly rotating Calder mobile to determine its most flattering orientation, both for the work itself and the background. Skies were overcast when I took the shot and some of the interior perimeter lighting was on, adding a warmish tint to some areas of the otherwise daylit interior.

Part of the alcove in which the stair is situated is seen at the left. I moved down the stair far enough to minimize this wall but still maintain the desired optical axis. The 24mm Nikkor wide-angle lens does not have perspective control capability, so I had to shift my camera position to achieve the necessary balance, being careful to keep the Nikon FE-2 absolutely level. I used Kodachrome 64 film exposed at about 1/8 second at *f*/8.

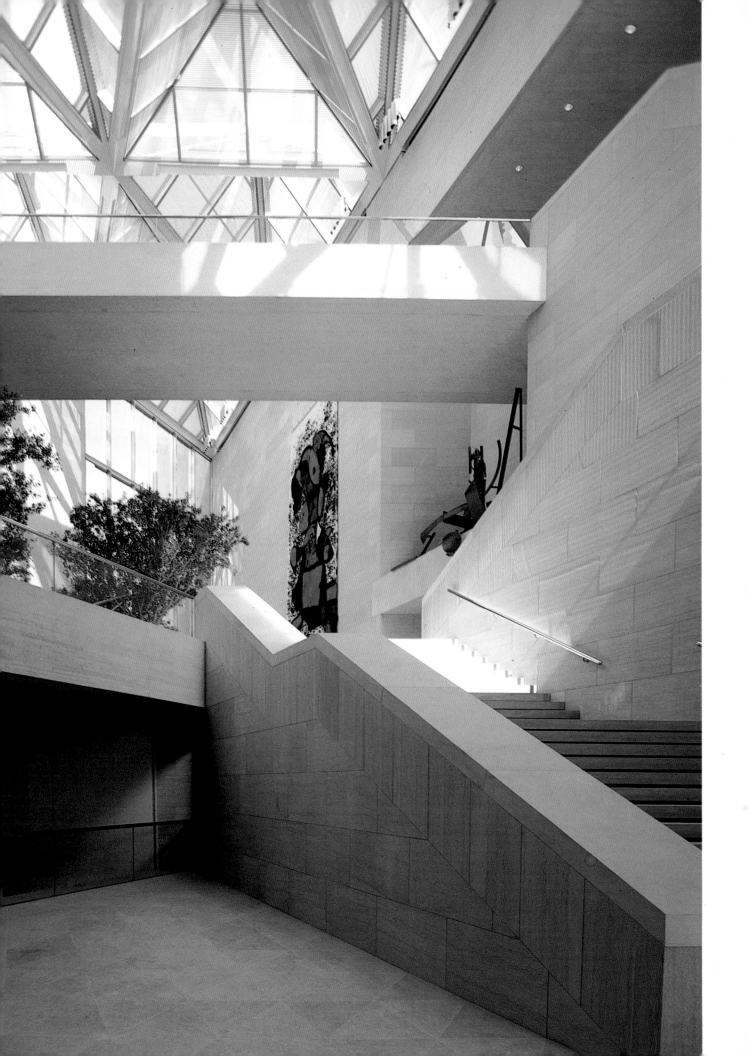

Dramatic Approaches

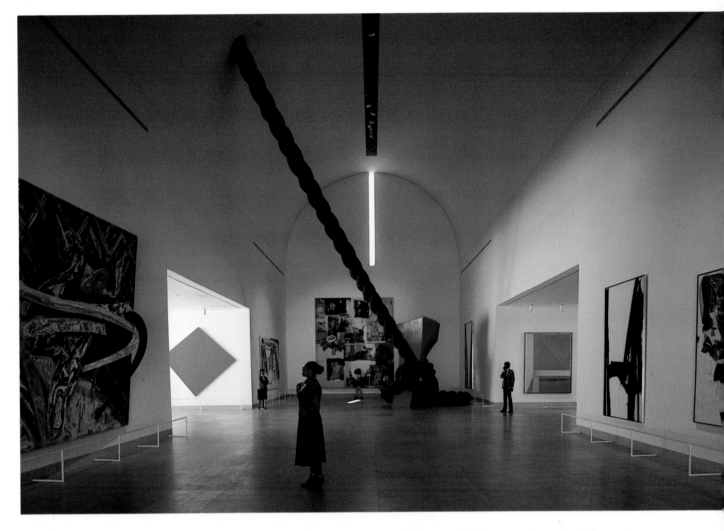

The new wing of the National Gallery may be entered from street level or by coming underground from the connecting link to the main building. Entering from below heightens the drama even more, as the photograph on the facing page illustrates. Here strong forms and shapes collide with one another. The sun broke through the clouds briefly, washing the wall at right with light and enhancing its texture. The key to this photograph is the use of the 28mm *F* 4 PC Nikkor lens. I used the maximum offset of the lens to show the structure fully and eliminate much of the foreground avoiding distortion by tilting the camera. Only this lens and the Zuiko shift are capable of producing this or similar results with a 35mm camera, the PC Nikkor FE-2 and the Olympus 24mm shift. The latter being even wider than Nikon FE-2. Exposure was around 1/30 second at *f*/8.

This museum interior, above, illustrates a high-contrast situation. Although there may appear to be some fill light from behind the camera, it comes from natural sources. The main illumination comes from the opening to the left; it bounces around the mostly white space, producing surprising brightness. The light behind me and from the narrow vertical slot also helps. In addition, there are incandescent spotlights on the art works. The symmetry of the design is well captured by the axial viewpoint. The strong diagonal thrust of the Lichtenstein sculpture is what makes the picture. The scale of the art, however, could not have been captured without the inclusion of human figures. The figures were not posed; I waited for the right moment.

This is the Amon Carter Museum in Dallas, Texas, designed by Edward Larrabee Barnes.

I took the photograph for my personal files using a Nikon FE-2 with a PC Nikkor 28mm *F* 4 lens with quite a substantial offset to include the top of the sculpture. Exposure was an 1/8 second at *f*/5.6 to 8.

Spotlighting

This interior, right, is entirely lit with incandescent spotlights. I introduced no supplementary lighting, though the subject is rather contrasty. The spots are directed at the paintings and other art objects, but there is a considerable amount of spill onto the adjacent pale yellow walls and floor. The light-colored surfaces bounce enough general light to provide sufficient general illumination for photography without losing shadow detail. Certain local areas of overexposure can be tolerated in a situation such as this, provided the major works are correctly exposed. My advice is to do some bracketing of exposures to get it just right. The objective of the photography was to illustrate the installation of the exhibit in the renovated Yale Art Gallery in New Haven by Louis Kahn. The remodeling was done by Herbert Newman and Associates.

I used a Nikon FE with a 24mm F 2.8 lens and Kodak Ektachrome Professional Type B (EPY), 50 ASA. Exposure was approximately 1/4 second at ƒ/5.6 to 8.

This second photograph, right, in another room of the same exhibit has a much darker background color. The blue surfaces bounce very little light back into the room, so the impression is of a much darker space. The existing lighting is actually the same in both rooms. In order to bring out more of this blue setting, I had to introduce some supplementary bounced tungsten lighting both to the left and right of the camera. This is the only example in this section in which I introduced additional illumination. The camera, lens, and film were similar to the first view. The silver teapot on the right is somewhat overexposed, but being fairly small in size it does not adversely affect the photograph. With extra time at my disposal, I could have redirected a couple of spotlights to control this.

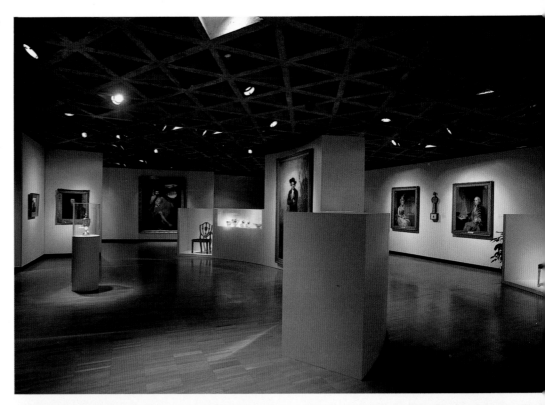

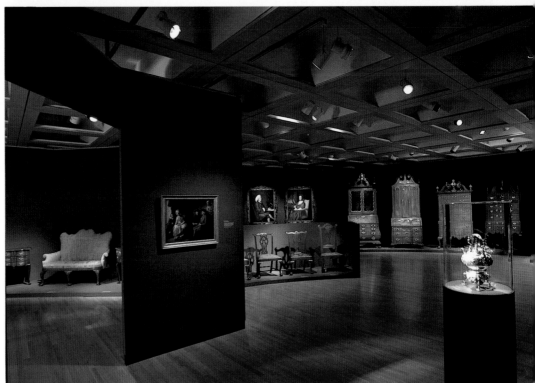

People for Scale

The branch of the Whitney Museum at the Philip Morris Building is a large, single room at the ground-floor level of the new corporate headquarters of that company in New York City. The space is three-quarters of a block long, and there are large windows all along one side and at each end. At the south end there is a glass wall separating the museum area from the lobby of the corporation. The amount of daylight in the space varies substantially at different times of the day and as the weather changes. In addition to the natural light, there is a combination of incandescent and mercury vapor lights in the ceiling which come on automatically when the light falls below a certain level. I chose a bright, sunny day for the photography with a lot of light bouncing into the interior from adjacent buildings. To avoid very brightly lit buildings outside I decided to shoot from the north end of the interior towards the corporate lobby, one level up. Looking down on the museum floor from a small balcony two levels above enabled me to show more detail of the layout and exhibits. The only disadvantage of this viewpoint was that the Calder mobile to the right merges with the sculpture in the background. I purposely selected angles that would avoid including uncompleted or unoccupied areas.

As I watched people move through the exhibit, it became evident that with a lot of visitors the interior became very busy looking. Figures are necessary for scale, but too many overpower the exhibits and produce a cluttered appearance. I had to be patient, waiting for just the right number and distribution of visitors to provide the desired balance.

The photography was done jointly for Philip Morris and the architects Ulrich Franzen and Associates. The pictures were for corporate record purposes as well as portfolio use by the designer and for professional publication. I did both large- and small-format documentation. The example shown here is a 35mm version.

I used a Nikkor 28mm F 3.5 PC lens on my Nikon FE-2 with Kodachrome 64 film. The exposure was approximately 1/8 second at f/5.6. A 90mm lens on my 4 × 5 view camera gave very similar vertical coverage but somewhat more width.

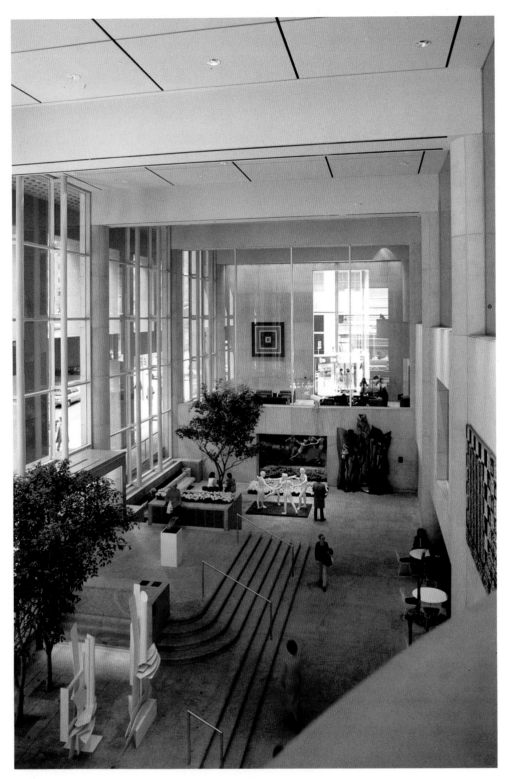

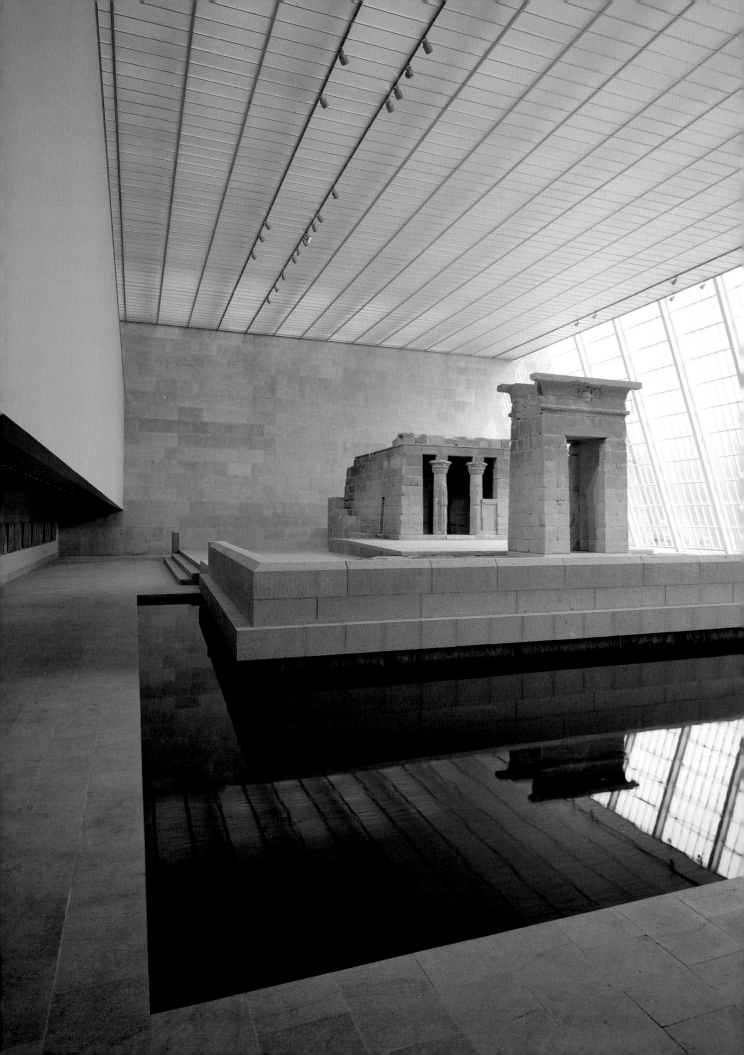

One Shot

This picture shows part of the ongoing modernization of The Metropolitan Museum of Art by Kevin Roche of Roche, Dinkeloo architects. On the occasion of the opening of the new home of the Temple of Dendur, *Vogue* asked me to produce a single definitive image for their readers. It was an unusual challenge to create, not a series, but a single photograph.

Focusing too closely on the temple itself, without showing much of its new setting, might have pleased some archivists but would not have satisfied the assignment objectives.

The temple consists of two elements: a free-standing entrance portal surmounted by a carved pediment and a lower rectangular structure with two columns set into the front facade, which stands some distance behind. Only when viewed obliquely does this relationship become clear.

I decided to position my camera close to the interior corner of the reflecting pool, thus silhouetting part of the temple against the sloping glass wall on the north side. On a Monday, when the Met is closed, I was able to set up without interfering with museum visitors. Some window cleaners appeared to add needed human scale. I used an especially high tripod to elevate my camera to a point where the base of the temple is visible behind the low wall at the near edge of the platform, about nine to ten feet above the floor. The floating wall opposite the windows is quite high and featureless, so I only included enough of it to balance the composition. To show the complete platform and its reflection, as well as the near edge of the pool, I used a Schneider Super Angulon 75mm *F* 5.6 lens.

I used Ektachrome 64 Daylight film in the Sinar F 4×5 view camera. Exposure was approximately 1/2 second at *f*/11 to 16.

PHOTOGRAPHING BUILDINGS OUTSIDE

Architectural photography falls into two distinctive categories, interior and exterior. Though both can be termed "architectural," the approach to each is totally different.

In general, nonprofessional photographers have more success with recording architectural exteriors than they do with interiors. The manipulation of light, in combination with the restraints of limited space, make the documentation of interior areas especially demanding. But with exteriors, even a comparatively inexperienced photographer can recognize favorable conditions for recording a building. The photography may even be accomplished with relatively unsophisticated equipment. A good working knowledge of the capabilities of the different focal-length lenses makes the task that much easier.

The key factor in all photography is light. With interiors, the photographer has a degree of control, and may even have complete control. But when it comes to the documentation of the outside of a building, he or she is at the mercy of Mother Nature. The sun cannot be made to stop shining, nor can it be switched on when it is reluctant. When it rains or is foggy or unclear, nothing can be done about it. The photographer must either wait it out or deal with the prevailing conditions.

Piazza d'Italia Fountain,
New Orleans, Louisiana.
Designed by Charles Moore.

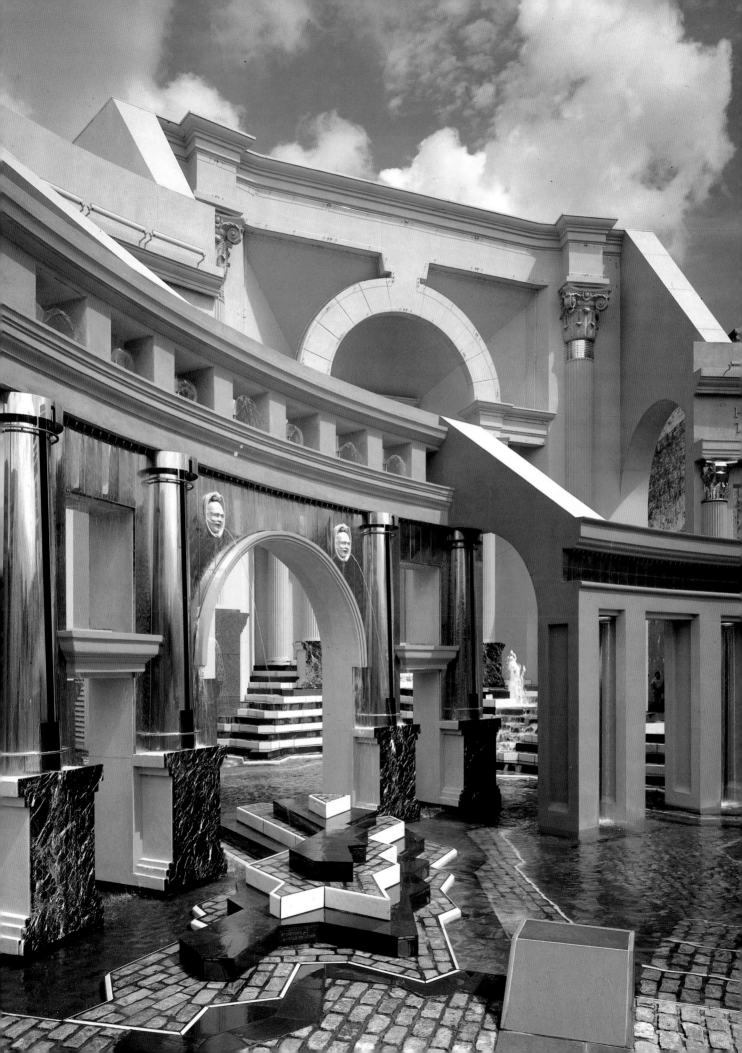

Traditional-Style Houses

Old houses of distinction frequently have an aura about them that conveys not only permanence but a sense of correctness in their surroundings. Though perhaps originally built in isolation, many older houses have become treasured elements of townscapes or cityscapes; some have even set the tone for later developments. They are anchors to another era—if not in time, at least in style—and they enable us to imagine from whence we came. These qualities are subtleties the photographer tries to capture when photographing traditional houses.

The immediate physical context is of prime importance, and the photographer should always be fully aware of it. With traditional-style houses, the garden is often a basic and important aspect of the architectural context. Large trees frequently provide complementary elements to the architecture, as do mature vines and shrubbery.

Before photographing a traditional house, the photographer should take time to become familiar with the major features of its particular style. The work of the nineteenth-century architect Frank Furness, for example, is typified by steeply angled roofs with sharply pointed dormer windows, overscale porch brackets, and elaborate brick chimneys. (See the example on page 125.) In recording such a building, a photographer needs to utilize conditions that are most likely to highlight those hallmark elements.

Whenever possible, avoid contemporary items which introduce aesthetically discordant elements: air conditioners, TV aerials, parking signs, trash receptacles, and garden hoses, to name a few. Adjust blinds or curtains so that the windows look their best. Avoid showing seasonal decorations, such as holiday wreaths, pumpkins, and so forth, which may limit the potential use of the resulting photograph.

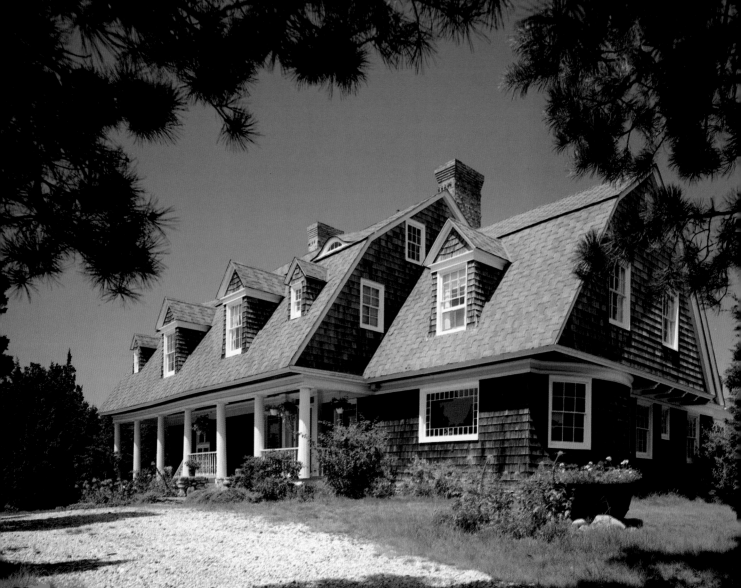

The 1892 house on the opposite page was designed by the architect Stanford White of McKim, Mead and White for his friend, the painter William Merritt Chase. Located in Southampton, Long Island, the house's front porch once had a clear view of the Atlantic Ocean. The most flattering and descriptive view shows the south-facing front of the house in combination with the east gable end. This clearly illustrates the relationship of the dining room wing to the main part of the house where the gambrel roof projects over the full-length porch.

By using a very low camera position, I was able to pull back beneath the overhanging pines without obscuring important features of the house.

The camera-to-subject distance was still comparatively close, requiring the use of a 90mm lens on the Sinar F 4 × 5 camera to include a comfortable margin around the house. The use of such a wide-angle lens at this distance exaggerated the near end of the house. This was partially offset by laterally shifting the lens to the left by between one and two centimeters. The lens was also raised to include more sky and foliage and less driveway.

A 10R filter was used with Ektachrome 64 film to counter the very blue sky. Exposure was approximately 1/30 second at f/16.

Trees and dense undergrowth made distant views impossible and restricted even the closer ones. A very wide-angle front elevation was feasible but made the house appear to be all roof with a few white columns below. In the top photograph, an angled view from the southwest is less successful than the first image, but it is valid, nonetheless. The spacing of the dormers is less flattering and the level changes of the porch diminish the apparent height of the house as it recedes to the right. The vertical format gives an airier feeling to the setting than a horizontal one would have.

I used a 10R filter, again to offset Ektachrome 64's tendency to produce blue shadows and to match the color

rendition of the first view. Exposure was approximately 1/30 second at f/16 to 22.

The foreground greenery and balustrade give depth and dimension to the line of columns on the long front porch in the photograph below. The hanging plant relieves some of the darkness of the porch ceiling, and the two-person rocker adds a nice lived-in look. All photographs of the Chase house were taken with a Sinar F 4 × 5 view camera with a 90mm F 5.6 Super Angulon lens. Approximate setting for this photograph was 1/8 second at f/22. Without corrective filtration—a 10R filter—the shadow areas would have had a decidedly bluish cast. This house appeared in the June 1986 issue and is reproduced by courtesy of *Architectural Digest*.

This is a traditional-style, but not old, masonry house on the island of St. Thomas in the Virgin Islands. On the site of an earlier structure, the house has been cleverly designed by architect John Garfield to look like a colonial dwelling of an era long past. Finishing touches to the ground cover were being made at the time of the shoot, so I had to be careful to avoid bare patches. The diagonal tree limb fills the upper part of the composition and complements the roofline, while the curved apron leads the eye naturally into the composition. I used a very low camera position, which enabled me to include more foliage without concealing parts of the house. The low stone wall and the driveway were hosed down to reduce their brightness in the strong Caribbean sunlight.

I used a Sinar F 4 × 5 camera and a 90mm F 5.6 Super Angulon lens. Exposure was approximately 1/60 second at f/16 with 100 ASA Polaroid Professional Chrome Daylight film. No filtration was used.

The back of the house opens onto a stone terrace with a pool and a magnificent view of the harbor at Charlotte Ammalie and the ocean beyond. Late afternoon light gives the house a warm glow but is rather contrasty. I selected a low angle to make the foreground planting appear more developed. Unfortunately, the near palm tree was not as full as I would have liked, and the stiff breeze didn't help at all.

Exposure was 1/30 second at f/16 with Fuji 50 film.

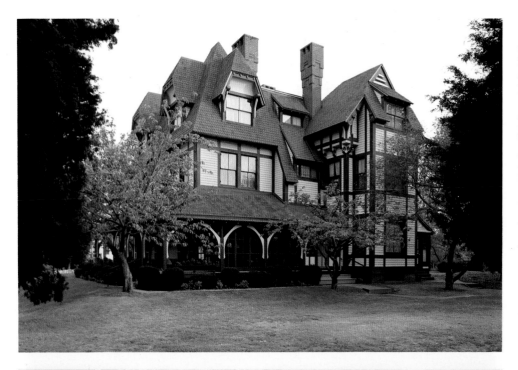

Emlen Physick, a nonpracticing doctor and country gentleman, retained the architect Frank Furness to design this summer retreat in Cape May, New Jersey. It was completed in 1879. Now substantially restored, this house is a showplace in a town famed for Victorian charm. Two dense evergreens dictated my vantage point, but the Neogothic features for which Furness is famous were not compromised because of it. The main facade faces west and receives limited direct sun in the fall. Somewhat hazy conditions on the day of the shoot produced a soft, low-contrast light that was not unflattering. Only the flatness of the sky detracts from this photograph; I could have used a graduated filter to add a tinge of blue to the sky.

I used the Nikon FE-2 with a 28mm F 3.5 PC lens, offset, with Kodachrome 64 film exposed 1/60 second at f/8.

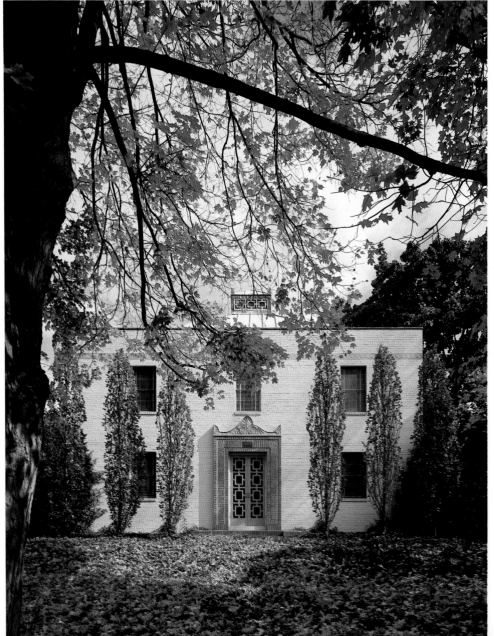

This handsome house designed by the architect Waldron Faulkner is in the Cathedral Heights section of Washington, D.C. On the fall day when this photograph was made, I waited for the sun to brush the front elevation with light to give texture to the brickwork and highlight the detail of the entryway with its combination of stone, brick, and tile. By positioning the camera as far away from the house as I could but staying on axis, I was able to include part of the copper roof and the lantern surmounting it adding emphasis to the symmetry of Faulkner's design. The blanket of leaves adds nice texture to the foreground. I used a 120mm F 8 Super Angulon lens on the Sinar F 4×5 camera. Exposure was 1/15 second at f/22, with Ektachrome 64 and a 1A filter.

Contemporary Houses

Houses in the modern idiom tend to rely more heavily on form and geometry for their impact than do most traditional-style houses. Many contemporary designs require a distinctive approach that is guided by the architectural concept and a photographic style that complements it. This means avoiding documentation in a predetermined or formulaic fashion. The most successful photographs of contemporary houses are a harmonious blend of design philosophy and interpretive sensibility mixed with a dash of good luck.

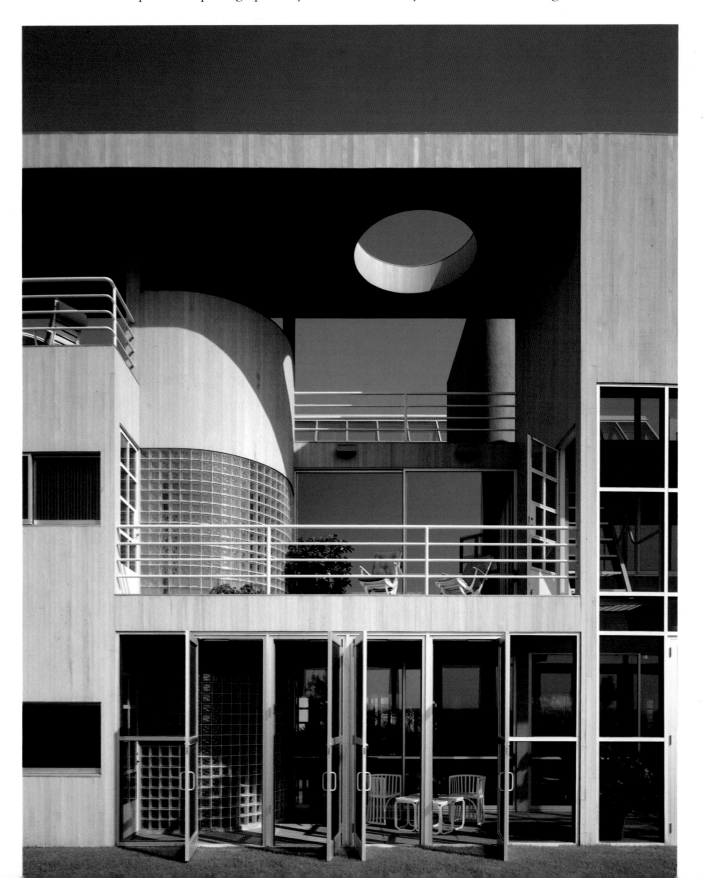

Readers may be familiar with the photograph on the left-hand page. It is on the cover of the book, *Charles Gwathmey and Robert Siegel, Buildings and Projects 1964–1984* (edited by Peter Arnell and Ted Bickford, Harper & Row, 1984). Certainly one of the most complex projects ever to come out of this talented office, the de Menil house in East Hampton, Long Island, is regarded by Charles Gwathmey as "not only the summation of all previous work, but also the opening up of new avenues for future investigation."

The complexity of the design makes the house both a photographer's dream and a challenge to photograph. With so large-scale, and multi-faceted a subject, it is difficult to avoid overpowering the viewer with too much visual information in any one photograph. The de Menil house is typical of situations in which the photographer must exercise restraint and self-control.

It is no accident that the most successful images of this mansion are probably those that focus on a particular element. The most dramatic overall documentation is of the less complex entrance facade. On the ocean side, the house presents less opportunity for overall viewing, unless one ventures onto the dunes.

This single photograph illustrates many features of the design: layers, transparency, attention to detail, geometry, and some complex interior-exterior relationships. The axial one-point perspective presents the information in straightforward style. Positioning of plants and furniture at all three levels suggests uses for these areas, and the open doors invite the viewer inside.

I used a 120mm *F* 8 Super Angulon on the Sinar F 4 × 5 view camera. The approximate exposure with a 1A filter on Ektachrome 64 was 1/30 second at *f*/22.

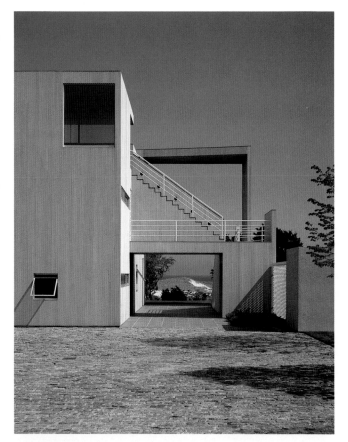

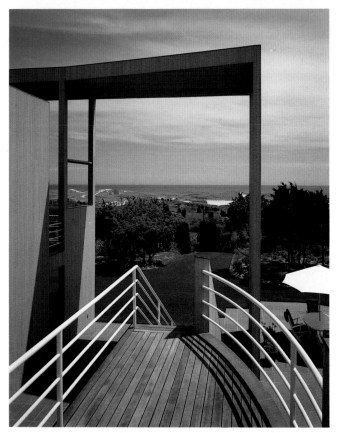

The top photograph on this page shows the west end of the house, which is a portal and frames the visitor's first view of the Atlantic Ocean. On the axis of the long, cobbled driveway, this element is also the link to the swimming pool enclosure to the right. By selecting a longer focal-length lens, I was able to preserve the relationship of the house to the dunes and the ocean. The architecture is reduced to a series of inter-related planes. Strong sidelighting articulates the texture of the vertical cedar siding. The diagonal shadow of the latticed panel counterbalances the lines of the stair and balustrade. The two lower windows were purposely opened, and the upper blinds were adjusted to permit sky to show through.

I used a 180mm *F* 5.6 Symar S lens on my Sinar F view camera. Ektachrome 64 was exposed at 1/60 second at *f*/11 to 16 with a 1A filter.

Another angle on the portal, also framing the ocean view, gives the viewer a sense of the commanding vista obtainable at the second-floor level. I positioned the camera as far back and as high as possible in order to include as much of the foreground deck and railing as I could. The curve is very important to the otherwise rigid geometry. The disappearing stair leads the eye down to the lawn and through the trees to the shore and beyond. The high viewpoint positions the horizon line above the midsection of the portal and is also visible through the wall opening to the left.

A 120mm *F* 8 Super Angulon lens was used on the Sinar F. Approximate exposure was 1/30 second at *f*/16 to 22 with a 1A filter and Ektachrome 64 film. The lens was lowered to obtain more foreground and less sky and was offset to the left to limit horizontal distortion that would have resulted if I had pointed the camera further in that direction. The normal optical axis would have been slightly to the left of the supporting wall at the right.

Sometimes distortion can be used in a creative way and may be justified on the basis of the extra information included. For this photograph, I purposely directed the camera at the central axis of the pool terrace and carefully aligned the composition to maintain parallel horizontals. From my position on the roof deck, I tilted the camera downward to include the base of the stair in the foreground, using my widest 65mm F 4 Nikkor lens. I also retained a comfortable amount of sky. Note the careful balance of wall shapes, all of them in shadow.

I used the Sinar F camera. Ektachrome 64 was exposed 1/30 second at f/16 with a 1A filter.

The most distinctive aspect of this unusual house in Easthampton, Long Island, is its dually triangular form—both plan and elevation. The entrance facade is a high vertical triangle, and I chose a vertical format to emphasize the height. The red tile walkway to the glass front door serves as the main axis for the photograph. The large, round-headed window above the entrance and the skylight beyond, together with the open stair below, permit views through the house. The forms are backlit by the sun, which was shining directly toward my Sinar F view camera.

I used a 75mm F 4.5 Nikkor lens. Ektachrome 64 was exposed at 1/15 second at f/16 with a 1A filter.

The architect of the house was Richard Dattner, and the photography was done for *The New York Times Magazine*.

In the photograph below, I framed the south facade of the house with an arched trellis through which a path leads into the woods. The use of an ultra-wide-angle lens enabled me to show the entire house, swimming pool, and tiled foreground steps, as well as the trellis. The expanse of wood-shingled roof is the major component of this elevation. Shadows of adjacent foliage help to balance the sharp edges of the foreground planes. I positioned the poolside furniture and planters to enhance the composition.

Strong sidelighting dictated an exposure of 1/30 second at f/16 with Ektachrome 64 film and a 1A filter. The distortion of the round platform at the left was caused by its proximity both to the camera and to the edge of the composition. I felt it was not an unreasonable price to pay for the other assets of the photograph.

With their family grown, and inspired by a visit to England, Herb and Edna Newman decided to build themselves a weekend hideaway. Their first task was to find a suitably spectacular site for the house of their dreams. They didn't expect to find anything close to home in Woodbridge, a suburb of New Haven, Connecticut. They found a spectacular hilltop site with a view over New Haven to Long Island Sound and beyond. This house became their year-round home. It was designed by Newman's own firm, Herbert S. Newman Associates, with interiors by husband and wife.

The house is nearly symmetrical about its north-south axis and has a large central tower of brick—three stories high—with a cone-shaped roof and belvedere. Two-story wings flank the tower, and a single-level living room bounded by a sun screen and two open porches curves outward to the south. The house is brick and wood, painted white.

Everything was complete, including the landscaping, by the fall of 1984. A day in October was selected for the first day's photography, which was to be primarily of interiors. (See pages 64–66.) We wanted fall foliage, so the second day of the shoot was postponed for two weeks to permit the leaves to develop more color. On the first day, however, there were beautiful fluffy clouds which I couldn't resist taking advantage of. This view shows why. The sky is more lively and the clouds add to the reflection in the glazing.

I used a 90mm F 5.6 Super Angulon lens on my Sinar F view camera. The bright sunlight yielded an exposure of 1/60 second at f/16 to 22 with a 1A filter. The grass and trees are rendered darker than I would have preferred. The underexposure resulting from bright sun and white surfaces, as well as the lens shift, makes the sky unusually dark toward the top of the composition.

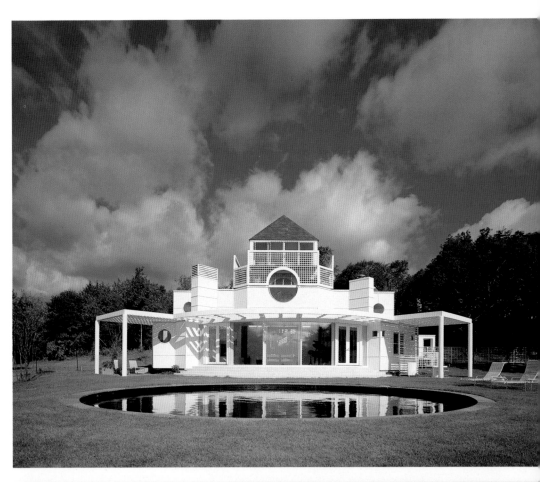

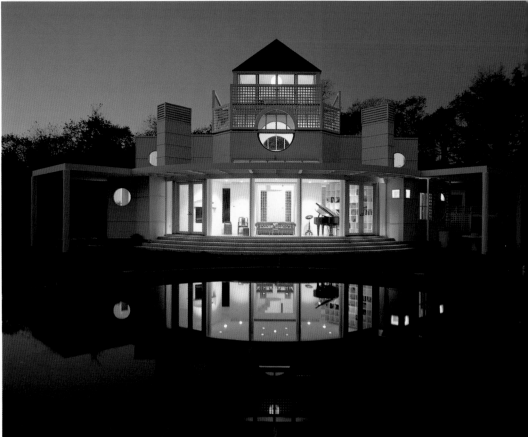

The southern elevation, right, was photographed on the later date, when there was more autumn color. I waited for the sun to move far enough to the west to produce some texture on the brick work of the tower and the foreground steps. The low camera position permitted me to capture the curvature of the *brise-soleil*, while still including reflections in the pool. The difference in color rendition here is due to the use of Kodachrome 64 film, which has a warmer tone than Ektachrome.

I used a 28mm *F* 3.5 PC Nikkor lens on my Nikon FE-2 camera. Exposure was 1/125 second at *f*/11. A few clouds would have helped. The camera was mounted on a tripod to ensure that it remained perfectly level. The lens was elevated to reduce the amount of foreground. The house was featured as an *Architectural Record* House of 1985 and was published in *The New York Times Magazine*.

The Newman house is a particularly good candidate for dusk shots: large expanses of south-facing glass, a white exterior facade, a backdrop of trees and sky, and an ideally located swimming pool that reflect it all.

I moved closer to the pool than for the similar daylight version and kept the camera low to obtain as much of the reflection as possible. All the lights were turned on. (Initially, it was difficult to judge the comparative light levels in different areas of the interior and it was necessary to dim and boost certain spaces to maintain an acceptable balance.)

I used a 90mm *F* 5.6 Super Angulon lens on the Sinar F. Exposure was approximately 20 seconds at *f*/16 with Ektachrome Type B Tungsten Balanced film, unfiltered. The exterior is rendered very blue by using an artificial-light film in a daylight situation. The color of the inside is quite accurate, since the interior illumination is compatible with the film. (See the section on dusk photography in Chapter 9 for more on working at twilight.)

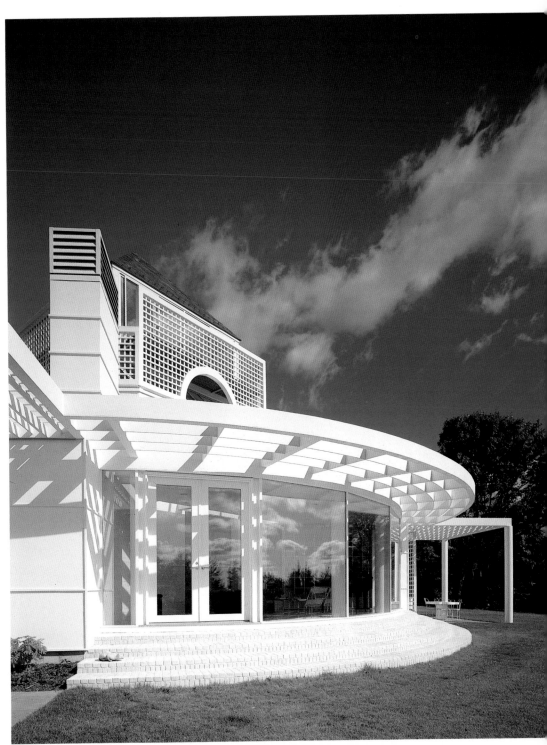

Landscaping

Landscaping can range from the careful siting of a structure to take advantage of natural elements to a formal, entirely man-made setting. More often, it involves a combination of the two approaches. Landscaping can transform an otherwise mediocre design; conversely, a poor surround will prevent what might otherwise have been a masterpiece from obtaining recognition.

I can offer few rules for photographic documentation except to suggest careful analysis of the most photogenic aspects of the subject. Unusual or elevated vantage points may be required for best results. Certain types of gardens may be more successfully photographed with moody or overcast lighting. Relating different elements within the design may be important and is particularly valid when the viewer must rely solely on photographs for an impression of the design.

In this Massachusetts residence, opposite page, the main house, the guest house, and the setting for them are the work of the Japanese architect, the late Teruo Hara. All the carefully planned terracing, the steps, the waterfall, and the marvelous granite bridge to nowhere are the product of his fertile imagination. Painstakingly shaped and pruned, even the native trees of Martha's Vineyard assume an Oriental form. Every rock and stone has meaning and purpose. The astonishingly authentic traditional-style Oriental villa, nevertheless, fits comfortably in an American setting. The house and garden were handcrafted by Hara and a small group of Korean workers.

This view is from the equally authentic teahouse. The late afternoon light produced a soft and peaceful atmosphere. I used a 180mm F 5.6 Super Angulon lens on my Symar S. Ektachrome 64 film was exposed at 1/15 second at ƒ/22.

The view of the entrance to the Tashkovich house (seen before on pages 56–59) was taken from the roof. Even though only small parts of the house are shown, the viewer has a suggestion of its generous dimensions and clean, modern lines. There is also more than a hint of formality in the slate paving, punctuated by the masonry retaining wall and manicured lawn beyond. The position of the flowering cherry draws attention away from a dull gravel forecourt.

The composition of the photograph is enhanced by the diagonal thrust of the walkway, which leads the eye upward to the disappearing driveway. I used a 120mm F 8 Super Angulon lens on my Sinar F camera. Ektachrome 100 film was exposed at 1/15 second at ƒ/16 to 22. Photography was for Vuko Tashkovich, the designer of both the house and landscaping, and was done for his personal use and for potential publication.

I have always thought that this
setting for a building de-
voted to atmospheric research
is particularly appropriate. Ezra
Stoller's photograph of I. M.
Pei's design for The National
Center for Atmospheric Re-
search in Denver, Colorado
perfectly captures the way the
complex fits into the natural
landscape. The fact that the
subject occupies such a small
area of the composition only
heightens the drama. Stoller
took this photograph in 1967

© 1967 Ezra Stoller. Esto Photographics Inc.

Eero Saarinen left a legacy of
spectacular buildings when
he died in 1961. One of them is
the IBM Building in Yorktown
Heights, New York. This sleek,
long, low, curving building sits
on a hilltop in Westchester
County. The sweep of grassy
expanse rising up to the dark
glass facade is breathtaking.
Only an occasional tree inter-
rupts the panorama of the un-
spoiled surrounding country-
side. I don't know if the site
was originally as open as my
photograph suggests, but the
minimalist treatment was, and
is, appropriate. I took this
35mm shot in the fall of 1962,
early in my photographic ca-
reer, but it still appeals.
 I used Kodachrome II, as it
was then called, in my Nikon F.
The Kodachrome of 1962 was
higher in contrast than today's
product, a factor that did not
help this photograph. Ex-
posure was probably 1/50 sec-
ond at f/8 with a 24mm F 2.8
lens. The photography was
done for one of IBM's public
relations departments.

136

At the back, or concave, elevation of the building is a moat with walkways bridging it. These provide access to the parking areas at the rear. The moat contains not water, but a sea of white gravel with grass islands floating in it. Flowering trees add to the Oriental quality and provide a particularly pleasing prospect from the offices on this side of the complex. The red crab apple trees add a colorful touch. The highly textured masonry walls contrast with the sleekness of the windows.

Even after twenty-five years, the Kodachrome exhibits no evidence of fading. I used a 24mm *F* 2.8 Nikkor lens on a Nikon F. Kodachrome II was exposed at approximately 1/60 second at *f*/8. The landscaping for the Saarinen-designed IBM facility was by Sasaki Associates.

Large Urban Buildings

Photographing large urban structures in city surroundings is, typically, a problem of limited access. Often it is impractical to utilize the best vantage points. The photographer constantly has to compromise.

Specific equipment may be required, which can only be determined by advance scouting. When preliminary or construction photographs are available they can sometimes provide useful information. A walk around the job by both architect and photographer—together—can be invaluable. The designer may express some desires and preferences *in situ* that the photographer might otherwise be unaware of, and the photographer may point out obstacles or conditions that could significantly affect the success of the picture-taking.

Advance preparation will frequently help. For example, flags that might not otherwise be hoisted can be arranged for; window-washing rigs can be moved, if not removed; parking can be restricted; fountains can be turned on or off; unsightly garbage receptacles or vendor stands can be concealed; offending signs can be relocated. With enough advance warning, power lines or other temporary services sometimes can be eliminated. Do make sure that all the appropriate people have been alerted to the photography. Nothing is more annoying than being unable to accomplish the objective because of some unanticipated condition.

One Logan Square occupies an entire city block in downtown Philadelphia. Adjacent to a small public park, the complex has two separate components: a low, granite-clad, eight-story hotel unit and a highrise office tower. Between the two is a landscaped courtyard which opens onto the plaza of the taller building. A major objective of my assignment was to record and develop the association between the two.

The long facade of the hotel, seen in the photograph on the facing page, faces north on to the square and park. Only in the summer months does it get a substantial amount of direct sun. I traveled to Philadelphia the night before the shoot to take advantage of the early morning light the next day.

I like this view, which was taken from the park before eight o'clock in the morning, the hour at which the fountain goes on.

The Sinar F with a 120mm F 8 Super Angulon lens was exposed 1/15 second at f/22 on Ektachrome 64 with a 1A filter.

There was still some minor construction underway at the sidewalk in front of the building, and a number of granite slabs were stacked against one end. I wanted to do a straight-on elevation shot. I pulled back as far as possible, while still excluding obstructions. By keeping the camera low, I was able to block the pile of granite with the flowers to the right. Similarly, the traffic island in the middle concealed other unwanted items.

I used a 90mm F 5.6 Super Angulon lens on the Sinar F. Exposure was 1/15 second at f/16 to 22 on Ektachrome 64 film with a 1A filter. The lens was shifted leftwards and raised.

The central court gets direct sunlight only for a brief period of the day, even in midsummer. This view, from the office plaza, was taken with a 180mm F 5.6 Symar S on the Sinar F. Exposure for Ektachrome 64 with 10R filter was 1/30 second at f/16.

One Logan Square is the work of designer Arthur May of Kohn, Pedersen and Fox.

In the early 1980s, Hercules, a diverse multinational company, built a new headquarters in downtown Wilmington, Delaware. It is another design by Kohn, Pedersen Fox's, Arthur May. Their prominent site overlooks a small public park running along the bank of the Delaware River. The surround is a mix of contemporary office structures of varying quality and some old, small houses.

The subtle geometry of the building's architecture changes the viewer's perception of the structure's overall shape, according to one's distance from it—as a comparison of these four photographs shows. The building is set behind a red brick forecourt. The base is of granite with modest-size windows to better relate to its environment. A mirrored glass block rises from the base. The contrasting treatment effectively reduces the very substantial mass of the complex.

The ample plaza considerably simplified the photography. An adjacent parking garage provided me with a very convenient and flexible vantage point from which I made the photograph seen at the right. I used a 90mm *F* 5.6 Super Angulon lens on my Sinar F camera. Exposure for Ektachrome 64 film was 1/30 second at *f*/16 to 22, with a 1A filter. I shifted the lens to the right to correct some of the horizontal convergence and raised it to reduce the foreground. The detailing is enhanced by the clear afternoon sidelighting.

The lower photo shows a pedestrian's view of the plaza and main entrance from across the adjacent street. The true size of the large, precariously balanced clock can now be fully appreciated. The difference in the apparent scale of the building compared to that seen in the previous photograph is arresting. The inclusion of people helps.

For this more compressed view, I used the 180mm *F* 5.6 Symar S on the Sinar F. Ektachrome 64 film with a 1A filter was exposed for approximately 1/30 second at *f*/16 to 22. Substantial lens rise was used to include the upper, near cor-

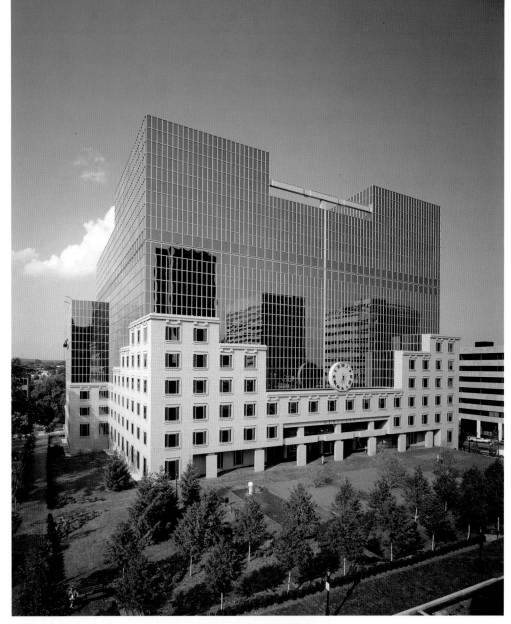

ner of the granite base as well as a portion of the top of the tower without losing the base of the steps.

Once the park had been completed, I was able to take this ground-level shot, which also gives the viewer some idea of the setting. The proportions are less distorted than in some of the other photographs. Unfortunately, with the cloudless July sky, there is little to suggest the reflective nature of the mirror glass.

Because of its orientation, this facade receives direct sunlight only until about 9:30 or 10:00 A.M. The left side was already in shadow when I took this picture, but the angled planes contrast nicely, particularly the slight corner bev-

els. I had a window-washing rig removed from the right, but even after removal, part of it was visible on the lower roof. (It had not been in an earlier view from a different camera position.) I used a 120mm F 8 Super Angulon lens on my Sinar F. Ektachrome 64 film was exposed for 1/30 second at ƒ/16 to 22 with a 1A filter.

Backed up as far as possible in a park, I took a precisely axial elevation. Although most of the clouds were low in the sky, they do reflect in the two main panels of glazing. This view emphasizes the angle of the side elements. The strong, clear light enabled me to capture the subtle details of both stone and glass surfaces. The height of the atrium can be appreciated because its skylight is seen through the topmost openings. To prevent the grass slopes from concealing the base, I elevated the camera tripod to its fullest extension.

Why does the shape of the building look so different in this view when compared to the photograph above? My proximity to the subject has changed the perspective. The axial camera position and careful leveling ensured that all the planes of the building that are normal to the film plane exhibit no linear distortion; the verticals remain so and the horizontals are all parallel because I used no lateral lens shift. However, the angled surfaces become increasingly exaggerated as they recede from the horizontal axis or ground plane. Were the building higher, the effect would have been even more pronounced.

The darkness of the upper sky is due to light falloff resulting from the considerable offset with such a wide-angle lens. A center-weighted, neutral density filter will eliminate this but requires at least a two-stop exposure increase and is expensive. The filter must be matched to one particular focal length only.

I used a 75mm F 4.5 Nikkor lens on my Sinar F. Ektachrome 64 film with a 1A filter was exposed at 1/30 second at ƒ/16.

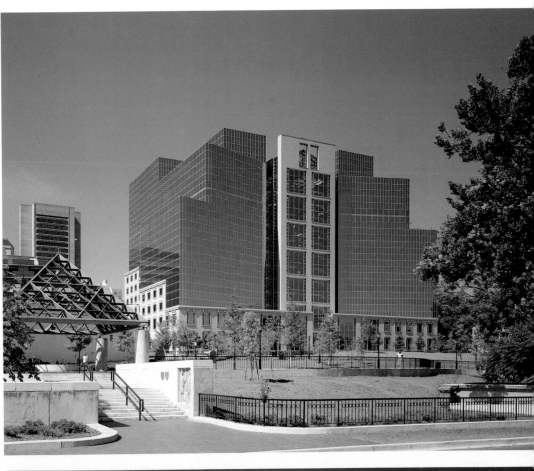

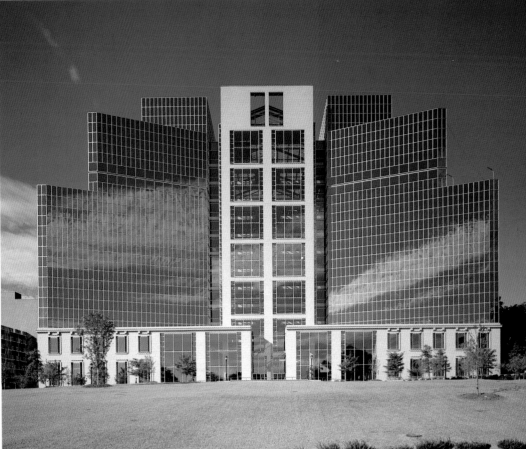

Long, Low Buildings

The most widely used standard in the field of professional photography is the 8 × 10 inch print. (The equivalent business standard is 8½ × 11 inch size, which is only fractionally different in proportion.) The proportions of a 35mm slide are substantially longer, or less square, than the 8 × 10 format. Many photographic subjects don't easily fit into either of these shapes.

It may prove to be quite a challenge to produce a satisfactory composition from an extremely horizontal building, unless the photograph can be cropped to suit the subject. Long, low structures, particularly when

photographed from some distance, sometimes appear to lack impact. One solution is to wait for interesting or unusual skies to relieve what will otherwise be a featureless area of the composition. Take advantage of trees and other greenery to frame the subject whenever possible.

Another solution is to select a rather extreme viewpoint, perhaps very low and quite close, to introduce some drama. Try shooting along the facade, with part of the structure close to the camera, to fill the frame more fully.

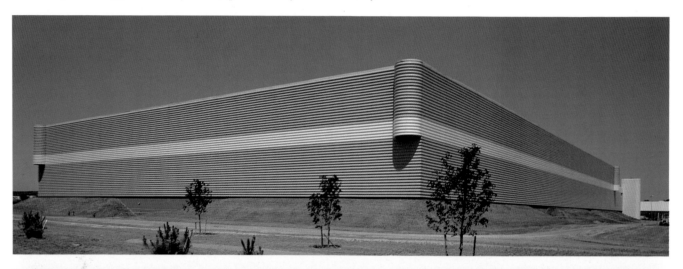

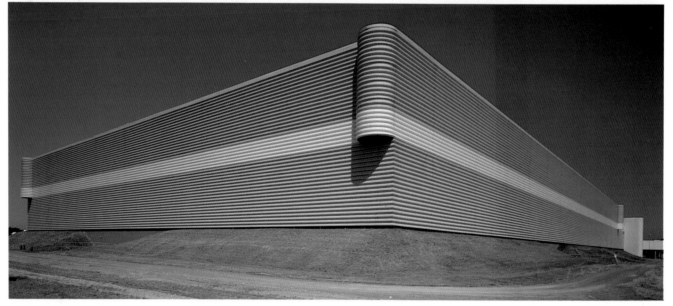

I have cropped the entire upper half of this photograph to make a long panel which suits the subject. For this project, I did want to have at least one image showing the complete design, but the sky was cloudless, and there was nothing around to improve the composition. The east and south surfaces have sufficient contrast, thanks to the sun's more southerly position. Apart from the young trees, there is little to suggest the building's true scale. It is forty-five feet high from the top of the berm. I was unable to have the yellow mower moved.

The windowless structure is a giant automated warehouse. The architects were Richard Dattner and Associates in collaboration with Davis Brody.

I used a 90mm F 5.6 Super Angulon lens on my Sinar F. Exposure was approximately 1/30 second at ƒ/22 with a 10R filter.

To create a somewhat less bland image, I made this variation. Moving much closer, perhaps half the distance to the near corner, I needed a much wider lens. The combination of

these two changes results in a greatly increased contrast between the relative size of the near and far corners. Again, I cropped off the upper part of the 4 × 5 transparency to produce a more balanced composition.

I used a 75mm F 4.5 Nikkor lens on my Sinar F. Ektachrome 64 film was exposed at 1/30 second at ƒ/22 with a 1A filter.

This detail view picks up two corners at the rear of the building. I was able to concentrate on the juxtaposition of the two round vertical elements and the large tube to the left, which provides an enclosed pedestrian link between the warehouse and the rest of the facility. The vertical format contrasts nicely with the extreme horizontals. With the inclusion of a figure on the stair landing and the red door, the true size of the complex now becomes apparent. I waited for just the right light; the shape of the shadow is very important to the composition.

I used a 180mm F 5.6 Symar S lens on my Sinar F. Exposure was 1/30 second at between ƒ/16 and 22 with a 10R filter.

The industrial complex shown here is an extremely horizontal subject. Even at a distance I needed an ultra-wide lens to encompass it. This presents a problem with 35mm equipment, since the widest lenses lack shift capability. This usually means too much foreground and sky. In scouting around, I found this meadow of wildflowers on a little hill overlooking the site. With the aid of an eight-foot stepladder, I took this shot very early in the morning. I needed the extra height to get an unobstructed view of the facility and to make the most of the floral foreground. The fluffy white clouds enhance the photograph greatly. The facility houses oilfield-related servicing equipment for Schlumberger in Aberdeen, Scotland. The architect was Jean Pierre Bonneau of Paris.

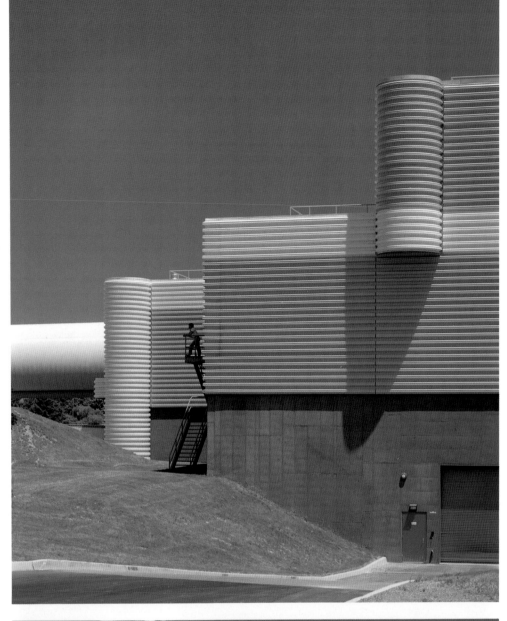

This preparatory day school has two long wings at right angles to one another. The classrooms are contained in a series of two-story, triangular shaped projections clad in white-painted industrial siding Above the linear glazing, a continuous awning projects, adding further horizontal emphasis. The ventilation system is expressed by large ducts which punctuate the roof.

Careful observation enabled me to select a time at which the sunlight produced a wide variety of contrasting tones. Photography was scheduled during term time because human figures are very necessary to this composition. The clouds also add greatly. The photography was done for the architects Hardy Holzman Pfeiffer Associates and *Progressive Architecture*. The Pingry School in New Jersey appeared in the August 1984 issue. Their award-winning coverage used this photo, cropped horizontally across two pages.

I used a 65mm *F* 4 Nikkor lens on my Sinar F. Ektachrome 64 film was exposed at 1/50 second at *f*/16 with a 1A filter.

To contrast and complement the other shot, below, I did a long-focal-length lens view which compresses the elements I wished to record. These distinctive profiles of the corners, superimposed as they recede, create a strong vertical composition and also show some of the wooded surround. By careful camera positioning and lens selection, I was able to control the location and size of each of the three corners. (The longer the lens, the closer in image size the three sections become; the apparent distance between them diminishes. The camera, of course, has to be moved further from the subject.)

I used a 240mm *F* 9 Schneider Claron lens on the Sinar F. Exposure was 1/30 second at *f*/22 with Ektachrome 64 and 1A filter.

This photograph shows the French headquarters of Schlumberger Montrouge Ltd. at Montrouge, Paris. The structures look out onto an elaborately landscaped courtyard, complete with pools, fountains, and a central mound bisected by a generous walk that is surmounted by a Teflon tent, beneath which—underground—are a conference center, a gym, and a small café. My camera with ultra-wide lens had to be perfectly level to avoid distortion of the buildings. Walkways and plantings in the foreground, plus an interesting sky, enabled me to produce a reasonable composition.

I used a 20mm *F* 4 Nikkor lens on my Nikon FE-2, set at 1/125 second at *f*/11 with Kodachrome 64. The architect was Renzo Piano with landscaping by Alexandre Chemetoff. Photography was done for Schlumberger's 1986 annual report.

Even with the little cloud, the network of cables adds the necessary interest for this vertical composition. The delicate dimensions of the supporting structural system are an integral and major part of the design. The facility is a research center for oil drilling, testing, and pumping services.

I used the 28mm *F* 3.5 Nikkor PC lens on my Nikon FE-2. Exposure for Kodachrome 64 was 1/125 second at *f*/11. For more views of this installation, see the section on aerial photography in Chapter 9.

It may be argued that the bicycles in the top photograph distract from the architecture. (I made plenty of views without them, of course.) But since this assignment was for an annual report, rather than for the design press, I took greater liberties than usual. Approaching rain clouds add greatly to the drama. British architect Michael Hopkins designed the Schlumberger Cambridge Research building in the United Kingdom.

Kodachrome 64 film was exposed 1/125 second at *f*/11. I used the Nikon FE-2 with a 28mm *F* 3.5 Nikkor PC lens, with some lens rise for additional sky.

Clusters of Large Buildings

When photographing groupings of buildings, relationships between them is paramount. Yet there must be emphasis on the individual designs.

When a complex is a series of buildings, all designed by the same architect and all carefully related to one another, the photography should be relatively straight-forward. What is usually more difficult is capturing the subtlety of neighboring structures that are not clearly cognate. And along with all the other concerns, a good photograph needs to be composed with artistic merit. In photographing groupings of large buildings, this takes some luck and occasionally great perseverance.

64 film was exposed at 1/30 second at $f/11$ to 16 with a 1A filter.

The Palace is seen in the foreground of the photograph to the left. A second project by the firm is seen nearing completion, beyond left. Although completely different, these two share a complementary, fresh vocabulary of style. Between the two towers is a third building, not by the same designers, which I purposely blocked by the palm trees. A crane on the second structure is almost concealed. I wanted particularly to show the way The Palace steps down to the waterfront with low condominium units closest to the shore.

I used a 90mm F 5.6 Super Angulon lens on the Sinar F. Exposure for Ektachrome 64 was 1/30 second at $f/16$ to 22 with a 1A filter. Photography was for *House and Garden*.

On Manhattan's Upper East Side, Plaza 1199 is a large residential project designed by Hodne Stageberg of Minneapolis, Minnesota. A large-scale, highly articulated project, it presents many photographic possibilities.

The most unfortunate thing about this photograph is that when the light for the buildings was best, I had a rather large shadow from an adjacent tower to contend with. I took the photograph anyway. It was September. In the summer, the sun's higher angle might have eliminated the problem but might also have been less flattering in other respects.

I photographed Plaza 1199 for *Progressive Architecture*, using a PC 28mm F Nikkor lens on a Nikon F2. Exposure with Kodachrome 64 was 1/125 second at $f/8$ to 11.

The resort community of Coral Gables, Florida, has seen enormous growth and development in recent years. Some of the most exciting work, including The Palace, is that of Arquetectonica, which includes The Palace.

At first glance, the photo on the facing page may appear to be two separate buildings. It is not. Relating in scale to its neighbors to the east, the red, stepped-block unit butts at right angles to the slim tower and penetrates it, reappearing on the opposite face. Its crisp detailing contrasts with that of the nearby structures.

With some difficulty, I found an unfinished balcony on an adjacent construction site that provided the axial viewpoint I was looking for. Cloud cover enabled me to shoot without unmanageable contrast. I was quite close to my subject and had to use my widest lens. This is most noticeable in the amount of light falloff at the bottom of the picture and in the plaza paving. It would have been better to have had people around the pool, but this was shot in November.

I used a 65mm F 4 Nikkor lens on the Sinar F. Ektachrome

Tall Buildings

The documentation of multistory structures in confined spaces is probably the most difficult task the architectural photographer faces. Nowhere does this seem more true than in Manhattan, my hometown, where the density of the midtown and downtown is more acute and the ratio of street width to building height more extreme than anywhere I know.

From a practical standpoint, it means that straight-on elevations are rarely possible and overall views showing an entire tower are challenging even when practical. The consequences are that the photography of skyscrapers is frequently reduced to a selection of the least damaging compromises.

When the only vantage point is not only too close to the subject but also at an awkward angle to it, the situation is tailor-made for distortion. Ground level is often the worst of all vantage points. A wide-angle lens/camera combination, pointed sharply upward, will yield tremendous convergence of vertical planes—as well as of horizontal elements—and is usually very unflattering. I usually try to avoid this. When photographing a small tower from the ground, I try to obtain an axial view which enables me to keep the horizontal components parallel. Even though the camera may be far off vertical, some lens rise (when equipment permits) reduces the degree of convergence of the verticals. I rarely attempt to include the ground level of the structure in such shots. Occasionally, one can use distortion creatively to produce an interesting composition, but only rarely is this likely to flatter the design.

If the photographer is fortunate enough to find an above-ground location that is at a good angle to the subject, then the problem may be reduced to simply having a sufficiently wide-angle lens to encompass it. Advance scouting helps here, perhaps with a small-format camera. Don't rule out renting or borrowing special optics for the final shoot; the quality of the lenses may be critical. When substantial lens offset is used, both light falloff and vignetting can occur. Expensive center-weighted, neutral-density filters may eliminate the former, but only switching to an even shorter focal length can cure the latter. The drawback is that the shorter the focal length, the less the lens movement capability will be. (Refer to the wide-angle lens characteristics in Chapter 3.)

The project shown here is Citicorp Center in New York City designed by Hugh Stubbins and Associates, for whom I did the photography. The original assignment was also for *Architectural Record*.

The photograph above clearly illustrates one of the major problems in photographing a high, reflective tower in a narrow Manhattan corridor. Projecting above its neighbors, the top of the structure is in direct sunlight, while the bottom is in shadow. Not only that, but there is little bounced light from the surroundings at this time of year, late September.

When the demolition of a building opened up a previously unobtainable vista, I took advantage of it for this view. For tall buildings, I try, in general to select a location that is about a third the height of the subject. This enables me to produce a composition with reasonable perspective without diminishing the building's stature, which can occur with too high a vantage point.

I used a 90mm *F* 5.6 Super Angulon lens on my Sinar F. Ektachrome 64 was exposed at 1/15 second at *f*/22 with a 10R filter.

On late September afternoons, only a very limited amount of light reaches the plaza level. My Polaroid test confirmed the fact that the contrast range was beyond the film's latitude. Short of a return visit, the only solution was to use a graduated, neutral-density filter over the brightest portions of the composition. Finding the optimum position is a tricky procedure; here the adjacent areas on the upper portion of the picture are darkened in tone because of the filter. I used a dark gray graduate, number 7783 by Ambico. Although this is supposed to be neutral in color, I have found that different films render it otherwise. The Ektachrome 64 used in combination with this filter produces a warm tone in the upper half. A light gray filter, number 7773 is close to neutral with the same film.

I used a 90mm *F* 5.6 Super Angulon lens on my Sinar F. Exposure was 1/4 second at *f*/16 to 22 (2½ stops allowance for the filter).

The photograph above left became the cover of the June 1978 issue of *Architectural Record*. Format for covers of this magazine are almost square or slightly vertical.

I had taken most of the upward-looking views from ground level from the opposite side of the street, but in walking around closer to the base of the tower, I discovered this angle. The dramatic way in which the building rises above its giant free-standing columns

is a major feature of the design. In February, the north facade receives little or no direct sun, only bounced light and fill light from the sky. The aluminum panels have a sheen which picks up highlights. Sunlight on the walkway above is reflected by the underside of the tower. I used a 90mm F 5.6 Super Angulon on my Sinar P. Exposure with Ektachrome 64 was approximately 1/15 second at f/16 with a 1A filter.

On the facing page, lower left, is a rare example of a successful downward-looking view. By late April, the higher altitude of the sun reached down into the plaza underneath the tower, where access to the various arcades, lobby, a chapel, and subway entrance is provided. By advance scouting, I found the ideal camera location on one of the setbacks of Citibank's building to the west. Just as I was about to shoot the photograph, the fountains were switched off. A telephone call to the right person brought them back into action. The only unplanned addition was the temporary platform at the base of the central column.

I used a 24mm F 2.8 Nikkor lens on a Nikon FE-2. Exposure was 1/125 second at f/8 with Kodachrome 64.

Although nearly two long blocks away, the vantage point for the above photo was ideal, since I was able to make an elevation view of the entire tower. No other high buildings compromised the photograph. Not only is this view of the project a flattering one, but the cityscape complements it. By using my widest lens, the foreground streets and buildings all converge and focus on the subject.

I used a 65mm F 5.6 Super Angulon lens on a Sinar P. Exposure for Ektachrome 64 with a 1A filter was approximately 1/30 second at f/16.

CHAPTER 9

HANDLING SPECIAL SITUATIONS

No guide to the documentation of architecture, inside or out, could possibly cover all the varied situations that can arise to test the mettle of photographers. Most of the examples in this chapter, therefore, are in the nature of tips on how I solve certain problems that are particular to the experience of architectural photography.

These vary from how to get high enough, low enough, or sufficiently far back from a subject to how to handle tricky filtration problems. Photographing models is particularly demanding, and part of this chapter addresses that subject. I have suggested compromises for situations where particular equipment was either unavailable or where its use would have helped but, for one reason or another, was not at hand.

Remember, there may be several ways to achieve your objective. Some may be obvious, others less so. Many procedures followed by professional photographers are utilized for speed, convenience, or consistency of results. Comparable results are sometimes obtainable using less elaborate equipment—but more time.

In the photograph below, I had to elevate my camera as high as possible. Here, I was shooting the 35mm hand-held version of the view so I could get even higher on the ladder than was possible with my 4×5, tripod-mounted camera. Be warned, it's easy to become giddy in a situation such as this one. The architect of the project looks on.

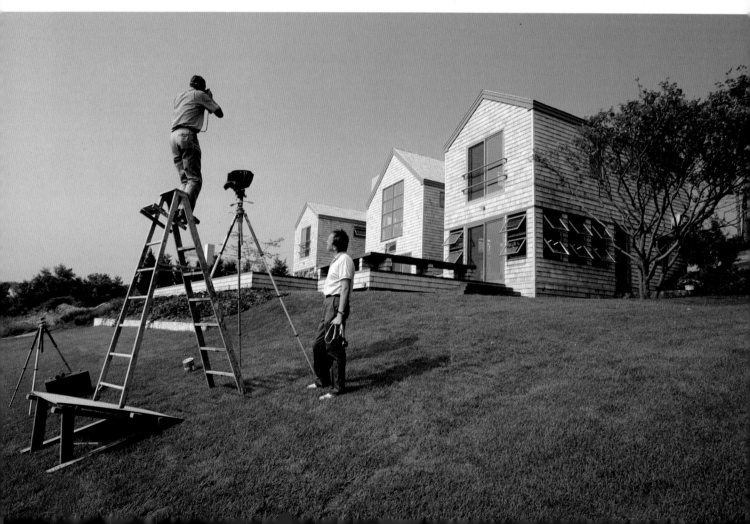

Dusk Photography

Half-day, half-night photographs require preparation and precise timing. When done properly, they are probably the most dramatic photographs of all. Here are some suggestions for creating eye-catching pictures.

Try to select a camera position that silhouettes the subject against the sky, or at least separates it from the background. Keep in mind that trees and foliage will be rendered very dark unless illuminated artificially. Select the most transparent elevation so that as much as possible of the interior may be seen. If advance scouting permits, evaluate different levels of lighting in the visible interior areas. (Some may require boosting or lowering.)

The western sky stays light much longer than the eastern, but being backlit will tend to silhouette the subject rather than illuminate it. Light-toned exterior surfaces will also retain detail better as daylight wanes. Depending on the scale of the building, don't rule out introducing external lighting. Try daylight film early on, and then switch to tungsten film as it gets darker. Type B film with a portion of the exposure filtered for daylight usually produces the best results, I find.

Located in New Delhi, this spectacular building is the new House of Worship for the Baha'i faith. Inspired by the lotus blossom, the delicate petals are actually thin concrete shells with a veneer of white Greek marble cut in Italy. Designed using the latest computer technology, the structure was, nevertheless, handcrafted in a way possible only in that part of the world. The workmanship of the reinforced concrete is the best I have ever seen. Dedicated in December 1986, three weeks after this photograph was taken, the building took nearly seven years to construct, following more than two years of design work.

It was difficult to resist axial views of this edifice. I didn't, although I decided not to risk taking dusk shots from the thirty-foot-high scaffold that had been erected for me. I didn't think I could obtain sharp pictures from it and there was not time for reshoots. The sun sets almost directly behind the main entrance. Interior lighting is quartz, and the exterior is floodlit with mercury lamps. (The latter are responsible for the greenish cast which contrasts with the warm tones of the sky and the inside illumination.)

I used a 180mm F 5.6 Symar S on my Sinar F. Exposure for Ektachrome Type B film was 30 seconds at ƒ/16 to 22 with an 85B filter for 15 seconds.

The architect was Fariburz Sahba, with structural design by Flint and Neill of London.

Daytime views of this Long Island house are shown in the previous chapter. I had to add supplemental incandescent lighting to several of the interior spaces and in particular to the open terrace at the top left.

Even before darkness approached, I could see that the existing exterior lighting was very contrasty. The sun set at the left, so there was not much fill light from the sky. I decided to use a couple of 650-watt quartz lights, direct, to illuminate the exterior—one on either side of the camera. Their location was critical because of reflections and shadows. I used a 75mm F 4.5 Nikkor lens on my Sinar F. Ektachrome Type B film was exposed for 24 seconds at f/16 with an 85B daylight conversion filter for 8 seconds. The architect was Richard Dattner and Associates.

The swaying palm trees, the scurrying clouds, and the rippled water lend an air of tropical exoticism to the grounds of this St. Thomas, Virgin Islands house, seen also in Chapter 8.

When this photograph was taken, there was still a substantial amount of light in the sky, though it lacked dramatic color. All interior and exterior lamps were switched on, including the pool's illumination. My initial experiments with Polaroid's new transparency film indicated that the film has a warm cast, particularly in the tungsten versions. By using a daylight conversion filter with a 3200°K film, I obtained this photograph. The sky color was exaggerated with the use of a light pink graduated filter by Ambico, number 7776. The entire picture has a very warm tone and the tungsten light sources are rendered very yellow because of the daylight balance of the film-and-filter combination. I used a 90mm F 5.6 Super Angulon lens on my Sinar F. Polaroid Professional Chrome Tungsten film was exposed at f/16 for 18 seconds with an 85B daylight conversion filter and a graduated pink filter for the sky. John Garfield was the architect for this house.

Many urban, domestic spaces are designed primarily for evening use, since occupants are not usually around in daylight hours. The interior lighting, therefore, is of prime importance, as is the outlook. In central city locations, apartments may have spectacular views, particularly at night.

Another kind of view-oriented space is found in corporate offices—perhaps the CEO's office. Designed to impress, they take advantage of the urban panorama and are often the only office interiors where inclusion of the exterior is valid. By shooting at dusk, or later in the evening, the time-consuming and cumbersome use of strobe lighting for a single shot can be avoided.

Again, timing is important. Everything should be set up in advance. Sunset, depending on the latitude, can occur quite swiftly. Wait until you think that the natural light will not materially alter the interior, after the exterior is less bright than the interior. As the outside light level drops, it may be necessary to supplement the inside illumination. Type B film, used for the interior, will render the outside very blue, especially in contrast to the warmer tones of the interior. Some photographers prefer dawn to dusk for this kind of photography. I am not one of them.

Looking northwest toward Central Park, this Manhattan *pied-a-terre* is many floors up in the Olympic Tower. The window detail permits an uninterrupted view of the city.

The combination of mirrors and glass made the introduction of supplementary lighting impossible, except for a little on the extreme right. As it is, the cove strips reflect in the windows. By keeping the foreground as dark as possible, I was able to prevent the camera's being reflected in the mirrored corner at the left.

I used a 90mm *F* 5.6 Super Angulon lens on my Sinar F. Ektachrome Type B film was exposed for 20 seconds at *f*/16 to 22. Designed for Arthur Erikson, the Canadian architect, by his associate, Francisco Kripacz.

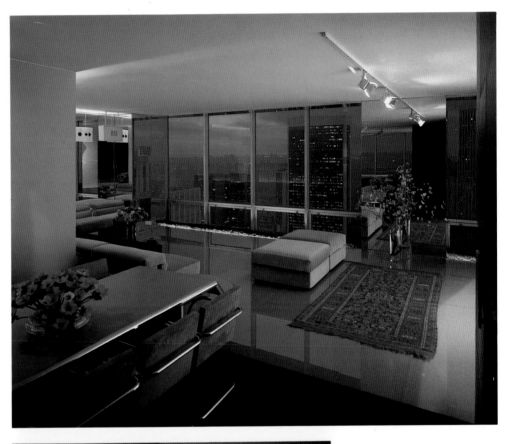

When snow covers the ground, it sometimes appears even brighter than the sky, as it did here. This is part of the student union building at Colby College in Waterville, Maine. I took advantage of some interesting interior openings that occur in an upper lounge to make this picture. I supplemented the lighting in both the seating area and the foreground with bounced quartz lamps. The roof of another wing of the building and part of the mainly traditional-style campus is seen through the window to the right. For this photograph, I used a 120mm *F* 8 Super Angulon lens on my Sinar F. Fuji 64 Tungsten film was exposed for 15 seconds at *f*/22.

The center was designed by Jeff Riley of Centerbook, in Essex, Connecticut.

Variable Weather

Successful images can be created without sunny skies. However, the photographer has to exercise some imagination to recognize the picture that may be seized from difficult climatic conditions. Storm clouds, mist, fog, snow, rain, rainbow—all present opportunities. The fact that such situations sometimes appear quickly and unexpectedly means that the photographer needs luck and skill to be able to take advantage of them. My advice is to experiment. Film is one of the less expensive costs of photography, and wasted frames are a very small price to pay for what might be a beautiful picture.

A note about camera protection. When photographing in poor weather, the use of a skylight or 1A filter will help keep moisture from the lens. Try plastic bags over the camera too. Sunshades for wide-angle lenses, tend to be shallow and therefore offer only minimal protection from rain or snow, particularly if it is windy. Keep the camera covered until ready to shoot. When the air is full of moisture, condensation will quickly form on cold equipment when taken inside. Use lens caps and warm the camera up slowly to avoid this.

Extremes of temperature are not good for equipment. When using a 35mm camera in low temperatures, place it under your coat so that it doesn't get too cold between shots. Conversely, protect cameras from direct sun. Black cameras, especially, heat up fast.

The photograph on the facing page was done in late afternoon under heavily overcast skies with light rain. Because interiors were my primary objective, an unfavorable weather forecast did not deter me. I had hoped for clearing skies but realized after the outside lighting had been switched on, that a "wet" shot in the failing light could be quite dramatic. The "Kodak yellow" color of the awnings is designed to be eye-catching from the highway. The combination of the neon-banded, stepped facade adds to the general visibility in a quite successful way for this genre. I could do nothing about the wire but figured it could be retouched.

I used a 75mm F 4.5 Nikkor lens on my Sinar F. Exposure with Ektachrome 64 Daylight film was 10 seconds between f/11 and 16. This Fuddruckers Restaurant is in Westport, Connecticut. The architect/designers are James Morris.

I arrived for the first time at this site in Nagasaki, Japan, less than half an hour before taking this photograph. The varied cloud formations suggested good conditions for a sunset shot which, in early September, was located in just the right spot to reflect in the building's facade. With efficient assistance the equipment was unpacked and I was ready to go barely fifteen minutes after arrival.

Initial Polaroid tests indicated that the sky's brightness would render the building extremely dark and lacking in detail. With the aid of a neutral-density, graduated filter, I was able to sufficiently darken the spectacular sky and thus use a long enough exposure to retain adequate detail of the main entrance on the south side. Fortunately, everything worked. There was not a repeat performance the next afternoon as the skies were clear and cloudless. I used a 120mm F 8 Super Angulon lens on my Sinar F. Ektachrome 64 film was exposed at 1/8 second at f/22 with an Ambico dark gray graduated filter, number 7783.

The Fairchild semiconductor plant was photographed for an annual report. Nikken Sekkei was responsible for the design.

The entrance facade of my own house, above, faces northeast. High ground to the east intercepts the early morning sun and the wooded setting doesn't make it any easier to photograph. With the deeply recessed front entrance, the ideal conditions for photographing this elevation are not obvious. The morning mist had not lifted when I took this picture, but a few rays of September sunshine did manage to penetrate the fog. I switched on interior lights to add some warmth to the house. Even in the very diffused light, I was able to capture the strong geometry of the design. I used a Nikkor 28mm F 4 PC lens on a Nikon FE. Kodachrome 64 was exposed at 1/60 second at f/5.6 to 8.

Myron Goldfinger was the architect.

Abstraction

Certain designs lend themselves to an unusual approach, a visual point of view that might be less appropriate with more conventional subjects. Such photographs are not normally included in the documentation of a project but are, nevertheless, valuable for editorial purposes.

Abstract photographs should be capable of intriguing the viewer in purely visual terms. The accuracy of interpretation is not the most important quality here, and, obviously, a picture in this category should be considered an extra dividend rather than the major objective. Only if the subject itself is abstract might abstraction be considered a straightforward interpretation that will convey the design philosophy.

The idea of a room photograph that shows only the ceiling and the upper walls of one corner sounds a bit bizarre, and it is. This small window is, in fact, an opening from a stair landing that permits a bird's eye view of the living room below in this remodeled Manhattan duplex. The insertion of a new wall meant an interruption of the nice ceiling moldings. A clean cut was made through the plaster and the cross section was picked out in a contrasting color. I supplemented the room light with a bounced quartz lamp. I used a 180mm F 5.6 Symar S lens on my Sinar F. Ektachrome Type B was exposed for 20 seconds f/22.

The architect for the remodeling was Stephen Levine.

One rarely views a room from above, particularly from dead center. When creating this symmetrical room in a designer showcase, the architect discovered an unfloored attic space above. With considerable foresight, a removable panel was fitted into the middle of the ceiling. Inserting my camera into the confines of this opening proved quite difficult. Once set up, I had to be able to get at the lens in order to set it and cock it between exposures. The camera location was critical, as was the precise positioning of the chess set on the tabletop and the chairs. The composition looks kaleidoscopic. I was able to work with the existing lighting. I used a 65mm F 4 Nikkor lens on my Sinar F.

Architect Stewart Skolnick designed this room in Irvington House, Southampton, Long Island.

This photograph is purposely ambiguous. I very carefully located my camera so that the alignment of the verticals coincides with the risers of the steps and, in addition, one of the treads becomes a continuation of the wall above the stairway. This creates a puzzle, since the viewer has difficulty distinguishing just what is in which plane. The lighting provides only hints to help determine what is being seen. Only the door handle and perhaps the two dark steps at the bottom of the photograph provide a link with reality. I suppose I broke one of my own rules in taking this picture, because I stated that abstract subject matter does not require further abstraction when recorded. I used a 24mm F 2.8 Nikkor lens on my Nikon FE. Ektachrome 64 film was exposed at 1/15 of a second at ƒ/8.

The architect of House Six was Peter Eisenman. The assignment was for *House and Garden*, and this photograph is reproduced courtesy of Condé Nast.

While playing around with the image of a ceiling detail, I discovered that I could get a reflection of it in a mirror. The composition still seemed to be overly long. To add the necessary interest, I moved the mantle clock to the edge of the mantelpiece and added the candleabras on either side. I raised and lowered the camera to achieve just the right balance. I introduced only minimal bounced lighting.

This Manhattan condominium, the home of a celebrated popular composer, was photographed for *Connaissance Des Arts*.

Aerials

Aerial photography is technically specific and the approach quite different from photographing at ground level. The camera is best handheld and needs to be of a manageable size. (Early aerial cameras were large-format, but cumbersome and more difficult to use.)

High-quality, medium-speed films in combination with a camera equipped with a normal lens or perhaps a short-focus telephoto lens are best. An automatic camera that selects the aperture can be very helpful because it saves having to worry about correct exposure. Be completely familiar with your equipment before attempting aerials.

I use a fast shutter speed: 1/500 or 1/1000 of a second to ensure sharpness. But because I use these settings so infrequently, I have them checked before I begin an aerial assignment. Even high-quality equipment can get surprisingly out of adjustment, cause overexposure, and ruin a take. Have more than one camera along to avoid having to reload in flight when possible. An assistant, of course, is most useful for reloading and keeping track of different films—black-and-white, color transparency, and color negative.

In addition to my Nikon FE-2, I use both a Hasselblad 500CM with an eye-level viewfinder and a Pentax 6 × 7, which is much like a large 35mm camera but produces a generous 2¼ and 2¾ image, which can be enlarged to 4 × 5 without cropping.

I run a Polaroid test when using the Hasselblad to confirm correct exposure. One test is usually sufficient to do this. With Kodachrome 64, I can shoot at about 1/500 of a second at $f/5.6$ or 1/1000 of a second at $f/4$. I wouldn't use anything slower.

What conditions are best for aerial work? Bright sun and clear atmosphere are really essential for best results. Some interesting shots can be achieved with early morning or late evening light, but for documentary purposes this probably won't be successful. Backlighting or sidelighting is preferable when photographing buildings from the air. Unless the color of the building really makes it stand out from its surround, shadows are necessary to give the subject dimension. When the sun is behind the photographer, the results will be flat.

Because helicopters fly more slowly and can hover, they are frequently preferred but are usually more expensive. A small, high-wing plane may work just as well, though it will have to circle more frequently. Explain to the pilot exactly what you are trying to do and work out a communication system so that he can follow instructions when you are airborne. Also, have clear directions to the site. Things look very different from the air. Both helicopters and light planes have windows that are openable or even removable. There is a lot of wind noise when the doors are off. I don't recommend it for anyone who is the least bit uncomfortable with heights. Make sure that you and your equipment are securely fastened but free to move within limits.

Don't use a lens shade unless it is very firmly attached. A skylight filter may lessen haze and protect the front elements of the lens without reduction of film speed. Keep any extra lenses in pockets, not on the seat. Take plenty of film; it's the least expensive component of the assignment.

Beforehand, check to see if flying is banned at particular times or if there are restrictions on minimum ceiling in the location of the shoot. Ascertain that you can get a downward view that will be uninterrupted by any part of the aircraft, and decide ahead of time which side of the plane feels most comfortable to shoot from.

At ground level, both the size and layout of this complex off Long Island Sound in Stamford, Connecticut, made it possible to shoot only one section at a time. To get good overall views, I suggested aerials. I had excellent weather conditions for photographing.

The fifth and final block of the development was still under construction when I took these photographs. The eighteen-acre peninsula is the site for buildings that house corporate offices, professional suites, retail shops, restaurants, covered parking areas, and an extensive marina. The latter enables the new facility to preserve and recall something of the original character of the former boatyard.

I timed the flight so that the adjacent facades of the major blocks had good contrast with the sun coming from the southeast. I used a 35mm F 2.8 Nikkor lens on my Nikon FE. Kodachrome 64 film was exposed at 1/1000 of a second at $f/4$.

Harbor Plaza is the work of architect Do H. Chung, Yankee Planning, for the Collins Development Corporation.

The Schlumberger Cambridge Research Center is a notable example of collaboration between architect and structural engineer. Seen to particularly good advantage from above, the roof material is Teflon-coated fiberglass. Its whiteness made the angle of the sun more critical.

The weather was unpredictable and my schedule tight, so I opted for an earlier flight than I had planned. At least twenty minutes were wasted waiting for clouds to pass. The viewpoints for the two top photos left are very similar, but the backgrounds are different. In the left-hand image the lighting is superior, but the steel supporting frame is lost in the dark foliage behind the building, and the factory beyond. For the right-hand picture, I would have preferred afternoon light; then, the sun would have thrown some light on the left, west-facing facade. The form of the roof is clearer in the left-hand view. Both these pictures were taken with a Hasselblad and the 80mm *F* 2.8 Planar lens. I used Ektachrome 64 Professional exposed at 1/500 second at *f*/5.6.

The lower view shows the roof best of all but is less descriptive of the building. I used a 105mm *F* 2.5 Nikkor lens on a Nikon FE-2 for this. Exposure for Kodachrome 64 was 1/1000 second at *f*/4.

The Schlumberger Cambridge Research Center was designed by architects Michael Hopkins and Partners, with structural consultants Anthony Hunt Associates and Ove Arup and Partners for the roof membrane. Photographed for the 1986 annual report, the building is seen also on pages 147 and 168.

This is an anomalous photograph. I wanted to do an aerial but no aircraft was available. Nor was there a high vantage point. To obtain this pseudo-aerial view for an annual report, I had to climb up the framework of an eighty-five foot folding mobile crane lugging my camera with me. To add to my discomfort, the temperature was 110° Fahrenheit in the shade. I had the rig located to obtain the best overview, combined with a background typical of the Omani desert.

I used a Hasselblad 500CM with a 50mm *F* 4 Distagon lens. Exposure with Ektachrome 64 Professional was 1/250 second at *f*/8 to 5.6. To house Schlumberger's field engineers, French architect Jean-Michel Regnault used prefabricated portacabin units arranged around a series of landscaped minicourtyards, separated by shaded walkways and plantings. Schlumberger's Wireline Base is 250 miles south of Muscat, Oman. Taken for an annual report.

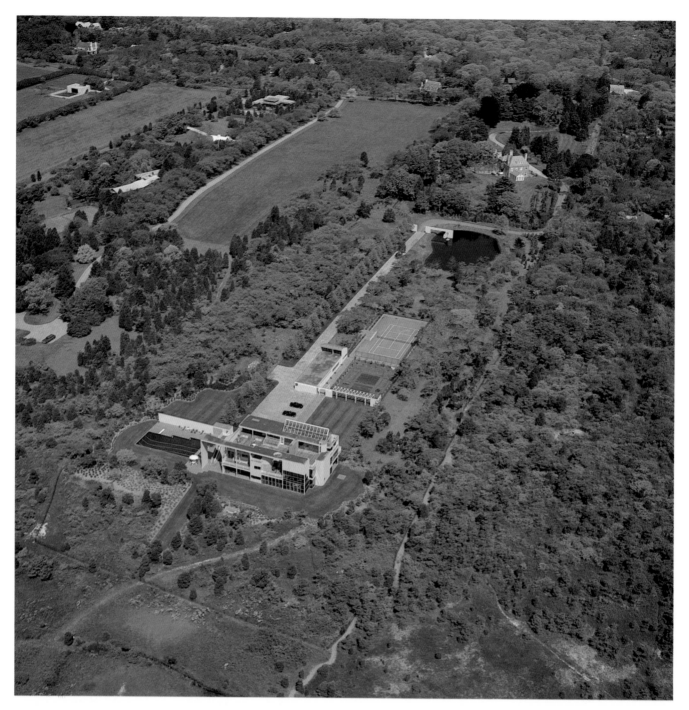

Other photographs of the de Menil house appear in Chapter 8. Because of the high degree of integration between the house and its landscaping, it lends itself to aerial views: The viewer has no trouble separating the built elements from the background.

I took this series early in the summer while everything was fresh and green. I feel that this three-quarter view of the ocean facade is flattering to the architecture and shows the whole layout well. The approach past the pond and through the pink portal to the formal, tree-lined allée is clearly illustrated. Also shown is the way the garage unit with attached apartment is inte-grated with the tennis court, the combination vegetable/ flower garden and the grape arbor. Details of both the roof and south facade are captured from this angle. I used an 80mm F 2.8 Planar lens on a Hasselblad 500CM. Exposure with Ektachrome 64 Profes-sional film was 1/500 second at f/4.

This is not a good aerial photograph of the De Menil house. Taken on a low pass over the house, I was too much above it. This is closer to a plan view. The height is minimized, thus changing the proportions. The sun was directly aligned behind the helicopter, and thus there are virtually no shadows to give depth to the subject. The shadow of the plane shows on the front of the house. The result is a bit like a camera-mounted flash portrait. The figures and furniture do convey the large scale of the mansion. The camera, film, and exposure combination were similar to the above.

Taken from the southwest, the view below is from a much lower angle. The house and pool are clearly the focus now; the other elements, are related but definitely less important. The inclusion of the horizon does provide the viewer with a greater appreciation of the basic Long Island setting. I used a Pentax 6×7 camera with a 75mm *F* 4.5mm Takumar lens. Exposure was 1/500 second at *f*/4.5 with Ektachrome 64 Professional film.

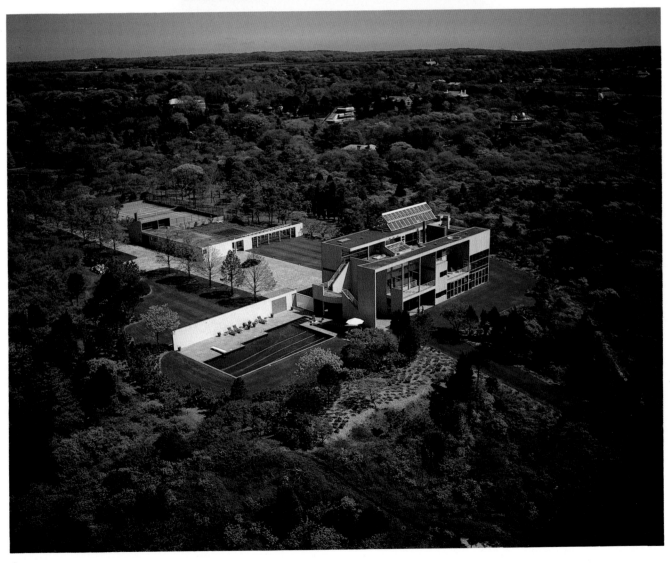

Incompatible Light Sources

Inevitably, situations arise that force the photographer to correct for one particular light source and accept the consequences of the inaccurate rendition of those remaining. Only experience can help to determine just what area to filter out and what to ignore. The lack of full control or not having a specific piece of equipment can create the necessity for compromise. As a general rule, I try to avoid a color rendition that is overly cool, that is, bluish or greenish. A photograph with an artificially green cast is unappealing and, almost equally, so is a blue one. The human eye can more readily tolerate a result that is overly warm, that is, more red or yellow than is normal. This should be kept in mind when the filter selection is made.

Dusk views of buildings with significant amounts of fluorescent lighting in combination with other sources are a problem. Almost any situation with a mixture of systems which include either mercury vapor or metal halide will be difficult to handle photographically. These two types require extended warm-up time to reach their normal operating color temperature. On page 42 the reader will find a table of suggested filters for use with a range of fluorescent tube types and other artificial light sources.

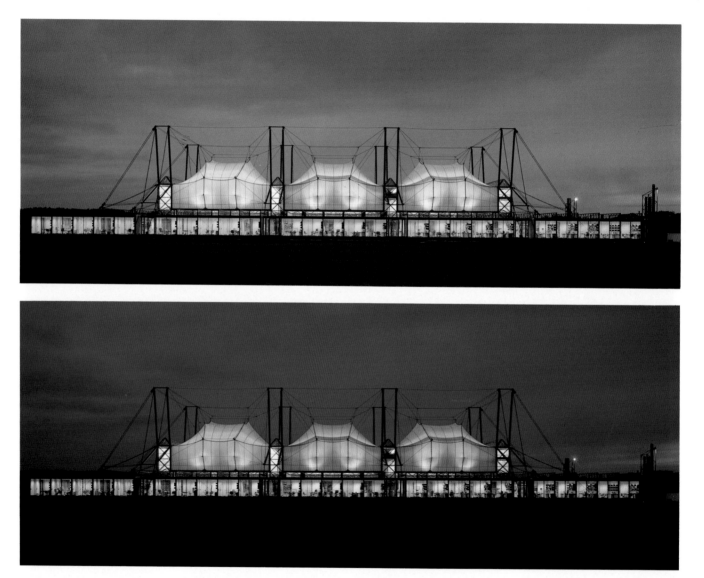

Illustrated earlier in this chapter and in Chapter 8, these two photographs are of the Schlumberger Cambridge Research facility. The strip of offices is lit with fluorescent illumination, and the large interior spaces behind them with quartz fixtures bounced upward into the translucent roof membrane. The whole building glows at night.

The top photograph was taken with Ektachrome Type B film with an 85B daylight correction filter. The line of offices looks as though the walls are green. For the shot below, the filtration was changed to 40R plus 10M to correct the office lighting. The penalty is the overly warm tone of the superstructure and a violet evening sky. I still prefer the lower view. I used a 120mm F 8 Super Angulon lens on the Sinar F. Exposure was approximately 30 to 40 seconds at $f/16$.

The panels in each box are illuminated by a single light source. The nine on the right are essentially incandescent, the six on the left are fluorescent. They are set up to demonstrate the variations in temperature and quality of different, widely available commercial bulbs and tubes. The photograph is a two-part exposure with an average fluorescent source correction for the left-hand group and none for the other, since I was using a tungsten-balanced film. The 40R plus 10M filter pack required a one-stop increase in exposure. The display is part of an experimental light room developed by Douglas Baker for Fashion Institute of Technology's interior design department in New York City.

The two photographs on this page of the Continental Center in New York City, show that there are limits to corrective filtration. Switching the two highly noncompatible light sources was out of the question. At the top of the escalators, around the elevator and service core, the lighting is incandescent. I used Type B film for my advance tests. The mercury lamps used for the main lobby produce the extremely green color. A 28mm F 4 PC Nikkor lens was used on a Nikon FE-2. Ektachrome Professional Type B film was exposed at 1 second at f/8.

Swanke Hayden Connell with Der Scutt, partner in charge of design, were the architects.

Taken in the same area as the above view, this photograph shows the space frame which supports the glass enclosure at the base of the tower. This was the best I could do with this situation. Beneath the bronze-colored space frame is a row of sodium vapor fixtures which produce an orange color regardless of filtration. The final correction for this shot was 90R plus 50Y. The lens and camera combination was the same as above with an exposure of 8 seconds at f/8 for Ektachrome Professional Type B film.

Architectural Models

Model photography is a highly specialized branch of architectural documentation. Some projects never get past the model stage. But the scale model is a particularly useful tool to aid the client in evaluating the design. Nonprofessionals frequently have trouble interpreting plans and elevations. Translating them to the mental image that is second-nature to the designer is elusive to many. The model and photograph of it can bridge this problem.

There are times when the photograph may be more useful than the model itself, because it can direct the attention of the viewer in a precise and particular way and offset the awe that a beautifully crafted model can evoke.

For best results, the photographer needs the full control that is normally possible only in a studio. The two main problems are lighting and background. To simulate sunshine, a strong point source is necessary. This is then combined with general illumination to simulate that of the sky, which is omnidirectional. Backgrounds can vary from simple, sky-colored, no-seam paper to elaborately painted clouds or landscape, depending on the effect desired.

A major factor in the success of the photography will be the scale and quality of workmanship of the subject. Tiny flaws are magnified and rough surfaces are transformed to out-of-proportion textures.

Some of the most realistic model photography is created with wide-angle lenses, since they are so commonly used for the real thing. The perspective will be more familiar and, thanks to the shorter focal length, the depth of field is less critical. Of course, the larger the format, the longer the focal length required to obtain the necessary coverage. The most successful lenses are likely to have extended aperture ranges for increased depth of focus. For 35mm, the perspective control lenses are especially useful.

Interior models are even more difficult to photograph because, to preserve reality, the viewpoints have to approximate eye-level. Creating a lighting system that provides even illumination without looking artificial in cramped dimensions is tricky. The degree to which a model can be disassembled may be critical. Don't rule out shooting outside if it's practical. Real sun and sky are difficult to simulate.

Wolfgang Hoyt, one of the most skilled and experienced photographers of architectural models working today, provided the photographs used here to illustrate model photography. His comments serve as captions to the five photographs in this section.

Courtesy Wolfgang Hoyt. © Esto Photographics Inc.

According to Wolfgang Hoyt, "In the area of model photography, there is a strong relationship to exterior as well as to interior photography.

"Essentially, model photography tries to create an illusion of reality. To the architect, the model is often the ideal building. To the client, more often than not, it is an effective selling tool. Great amounts of time and money are spent in model construction and photography. Often the budgets are more than those for finished photography. In a sense, these photographs are used as advertisements for the architect to convey the design to the owner, and for the owner to sell the building to the potential tenants.

"In order to photograph a model, one is required to have a strong understanding of architecture, and perhaps even more important, a strong sense of light. Theoretically, I try to light a model with one source light. This simulates the sun and helps to sustain the illusion of reality. Often, though, I have to supplement the "sunlight" with fill light. The fill lights open the shadows and create more interest. Shadows define volume and create depth. Materials also must be convincingly rendered. For instance, a model of a glass building requires reflective light, while a mansonry model requires direct light.

"I have found that some model makers are better than others. Plexiglass models are preferable to in-house paper models, although I photographed well-constructed study models with good success."

The interior model in the photograph above is of the 1986 addition to The Museum of Modern Art in New York City. The exterior model of Battery Park City in Lower Manhattan is seen right.

"There are models that require both direct and reflective light. This was the case with Cesar Pelli's model of Battery Park City in Lower Manhattan [shown here, right, and on page 171]. The problem was how to light a series of four granite and reflective-glass towers. Stone requires direct light; glass needs reflective light. Consequently, I lit the granite with one direct source light that simulated sunlight. The glass, on the other hand, was lit by bouncing lights into large blue cards with clouds painted on them, which in turn reflected onto the glass. The result is a subtle interplay between the solid stone and the reflective glass.

"Since I do a great deal of exterior photography, I try to bring an honest perspective to the studio. It is important not to fall into the clichés of artificial lighting or overly dramatic perspectives. A balance between exterior and model photography helps achieve this integrity.

"Although I have shot models on location, it is preferable to photograph them in a controlled studio situation. Since tungsten lights are used, an absence of daylight is essential. For the background, I use a large piece of stretched canvas, painted blue. Clouds may be airbrushed if necessary. Canvas is preferable to seamless paper because it is consistently smooth and does not show imperfections. This is especially true when using small aperture settings. The background sky is lit by a series of lights which simulate the horizon. This heightens the sense of reality, as well as providing depth to the photograph.

"For the main light, I use a 500- or 1000-watt quartz lamp. Spotlights are often used to enhance small details, such as entrances or the tops of buildings. Nevertheless, the illusion is that only one source is illuminating the model."

The photographs left are of the model for Skidmore, Owings & Merrill–New York's Columbia Presbyterian Hospital in New York City.

INDEX